IMAGES
of America

THE MORELANDS
AND BRYN ATHYN

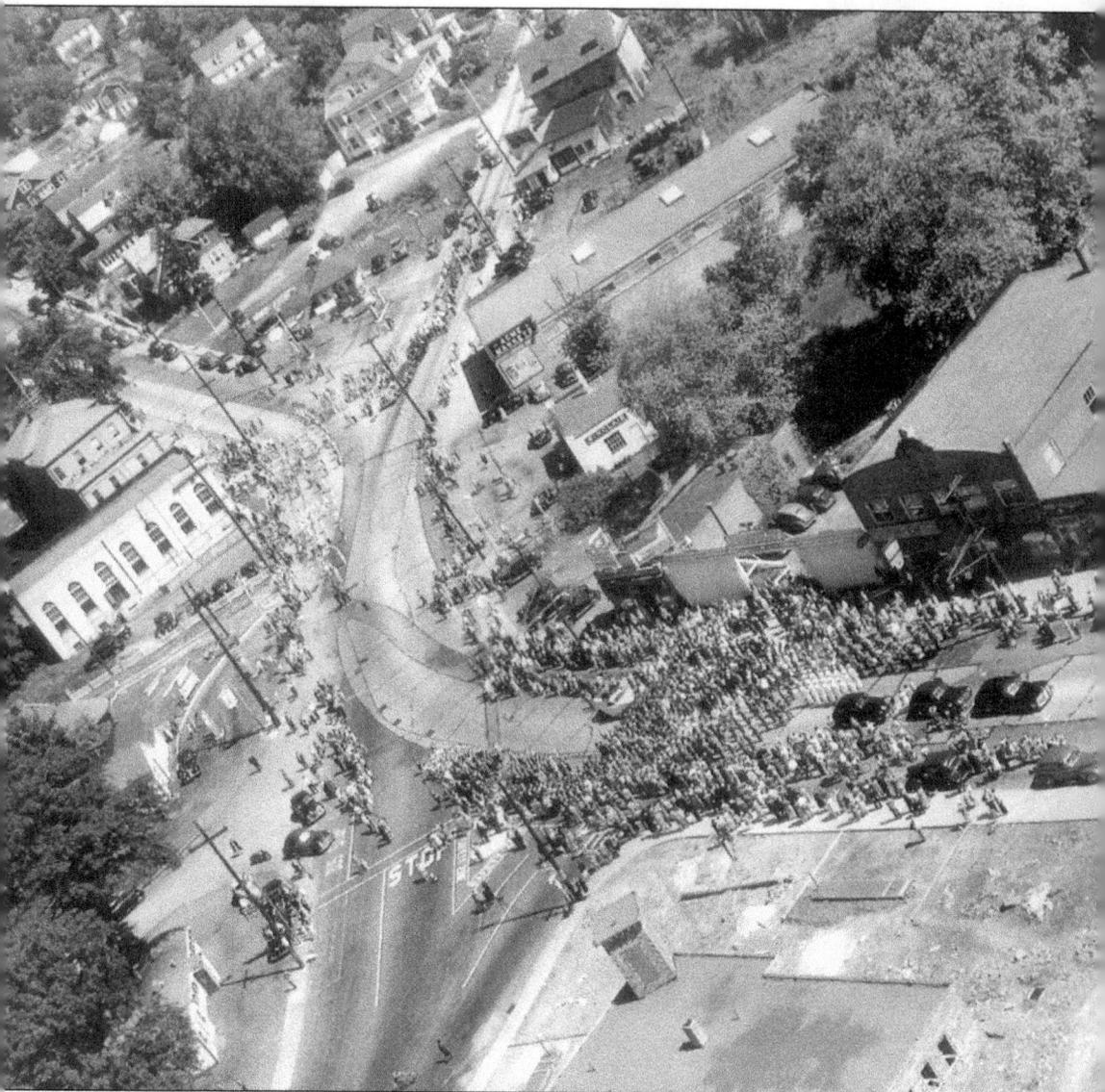

The junction of Old York and Easton Roads has been at the heart of Willow Grove since the roads were first laid out in the 1700s. However, it was the advent of the trolley lines to Willow Grove in 1895 that brought the development for which the town is renowned. The initial lines ran out of Philadelphia to the resort town and were later joined with the trolley lines that came down from Doylestown, thus connecting the eastern portion of the Delaware Valley. Old York Road is on the right while Easton Road is on the left, the two briefly joining before they resume their separate courses. The occasion is Memorial Day 1946 at the World War II Roll of Honor, which lists all those who served from the area. The honor roll was located just north of the Ehrenpfort Block, a building that still stands, although few others from the time remain. On the near corner, construction for the Gulf station is just beginning; the Willow Grove Park buildings having been cleared.

IMAGES
of America

THE MORELANDS
AND BRYN ATHYN

Old York Road Historical Society

ARCADIA
PUBLISHING

Copyright © 2002 by Old York Road Historical Society
ISBN 978-1-5316-0734-0

Published by Arcadia Publishing
Charleston, South Carolina

Library of Congress Catalog Card Number: 2002110454

For all general information contact Arcadia Publishing at:
Telephone 843-853-2070
Fax 843-853-0044
E-mail sales@arcadiapublishing.com
For customer service and orders:
Toll-Free 1-888-313-2665

Visit us on the Internet at www.arcadiapublishing.com

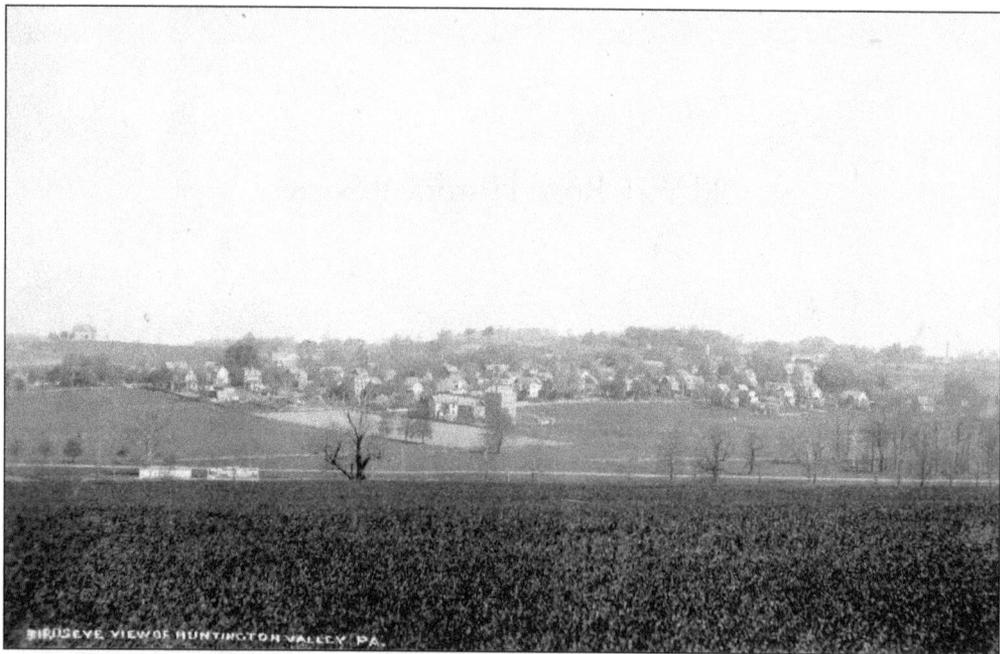

Huntingdon Valley appeared as a small town in the midst of farmland when photographed in the early part of the 20th century. Huntingdon Pike, the township's eastern north–south access, runs up the middle of the buildings clustered in the valley. The house on the hill is the Israel Hallowell House, a building that still stands on Hallowell Drive. The valley has changed much in the intervening years, yet some sites remain the same.

CONTENTS

PREFACE

With the publication of *The Morelands and Bryn Athyn*, the Old York Road Historical Society completes its series of three books covering the communities along and adjacent to the Old York Road in eastern Montgomery County. All three books, including *Abington, Jenkintown, and Rockledge* (2000) and *Cheltenham Township* (2001), further the society's goals of promoting and encouraging an interest in local history and disseminating historical materials found not only in its extensive collections but also in many private and institutional collections.

The Old York Road Historical Society was formed in 1936 to study and perpetuate the history and folklore of the communities along and adjacent to the Old York Road, from Rising Sun in Philadelphia to New Hope in Bucks County. Over the years, the society has offered a wide variety of programs and scholarly publications covering this area. In its collecting, the society has focused primarily on the communities in eastern Montgomery County, specifically the townships of Abington, Cheltenham, Lower Moreland and Upper Moreland, and the boroughs of Bryn Athyn, Hatboro, Jenkintown, and Rockledge. This book, covering Bryn Athyn, Hatboro, and Lower and Upper Moreland Townships, completes one phase of our published coverage of the communities central to the society's collecting and research focus.

In order to ensure that our collections remain the primary resource for historical study throughout the area, the society is always interested in receiving materials to augment its collections. From photographs and postcards to business records and family manuscripts, the society is able to offer the communities it serves an impressive collection, thanks to the generosity of those who have made donations in the past. Any additions you can make to our collections will be well cared for and most appreciated.

Please feel free to visit the society on the web at www.oyrhs.org or on the lower level of the Jenkintown Library. The archive is open to the public on Monday evenings from 7:00 p.m. to 9:00 p.m., Tuesdays from 11:00 a.m. to 2:00 p.m., Wednesdays from 11:00 a.m. to 3:00 p.m., or by appointment. You may telephone us at 215-886-8590. We hope you enjoy this book and we appreciate your support.

INTRODUCTION

Bryn Athyn, Hatboro, and Lower and Upper Moreland Townships originally were all within the boundaries of the Manor of Moreland. In 1682, William Penn granted to Nicholas More 10,000 acres of land. More's property began at a small frontage on the Poquessing Creek and spread to include a large section of northeast Philadelphia between the areas of Bustleton and Byberry, and then northwest to include the territory that is the focus of this book. After two miscalculations of the county line between Philadelphia and Bucks Counties, which comprises the area known as "the strip," the courts created the Township of Moreland out of More's Manor in 1718. When Montgomery County was carved out of Philadelphia County in 1784, the Township of Moreland was split into two sections, each referred to as the Township of Moreland in their respective counties. After Philadelphia consolidated all political subdivisions into the City of Philadelphia in 1854, the eastern portion of the original manor lost its separate identity.

More died in 1689, seven years after taking claim to his land, and his debtors soon moved to have some of his land holdings liquidated. The breakup of the Manor was complete by 1713 when the last More descendant sold his last piece of ground. The sale of the land and the laying of roads were early catalysts in the development of the region. Old York Road was laid out in 1711–1712, extending north from Jenkintown and Abington on to Howell's Ferry at Center Bridge above New Hope in Bucks County. That same year Welsh Road was laid out, running from Spring House to Huntingdon Valley. The line of Horsham Road and Byberry Avenue was run in 1720, following the establishment of the Horsham Meeting in 1714. County Line Road opened two years later.

The roads connected people, from meeting to meeting or from farm to mill. Mills flourished along the banks of the Pennypack Creek. Following the creek from its entry into the Delaware River, mills were established from east to west. The first mill in the area was Thomas Austin's gristmill (1707) located on the Pennypack where today Terwood Road ends at Welsh Road in Lower Moreland. The second was Samuel Davis's mill in Upper Moreland Township, and the third was Emanuel Dungworth's in Hatboro. Roads and mills were important to local farmers earning their livelihood from the land, and milling was an important enterprise throughout the 18th and 19th centuries.

Travel too was a catalyst for growth. The stage lines out of Philadelphia passed along the early roads, with villages developing where roads crossed or where one day's travel ended. Early inns, like the Crooked Billet or the Sorrel Horse, were popular resting places. The settlement of various villages in the area is attributable to the progress of local development. Hatboro claims to be Moreland Township's first settlement of importance, founded where roads and creek converged. John Dawson, a felt-maker from England, came north from Abington in 1712. He likely settled in the area prior to his first purchase of land in 1719. A home followed a few years later, around the same time Dungworth built his mill where the Pennypack Creek flowed by the intersection of Old York and Horsham Roads.

By the middle of the 19th century, villages were established in Hatboro, Willow Grove, Morganville, Shelmire Mills, Yerkesville, and Huntingdon Valley. Named for the Morgan, Shelmire, and Yerkes mills, the three mill towns no longer survive, for once milling ceased to be economically viable, the mills closed and the villages disappeared.

The advent of the railroad brought dramatic changes to the area. The first rail line north out of Philadelphia was laid in 1856 and went through Glenside to Gwynedd. Fifteen years later in 1871, the North Pennsylvania Railroad ran a branch from Glenside north to Willow Grove and Hatboro and on to Hartsville (1874) and New Hope (1891). The same year that track was first laid, Hatboro incorporated as a borough, the first political subdivision of Moreland Township

since the formation of Mongtomery County. A few years later in 1876, the Reading Railroad laid its Bound Brook line from Jenkintown through Bethayres on to New York. In 1878, the Philadelphia–Newtown Railroad ran a line through Fox Chase up past Huntingdon Valley and Bryn Athyn into Newtown. Along the first two lines through Moreland Township, small industry developed, especially in Hatboro along Jacksonville Road.

The Philadelphia–Newtown, which was the last line to run, brought excursion travelers from Philadelphia to enjoy the bucolic environs of the Pennypack. Among those who frequented the banks of the Pennypack were a group from Philadelphia who were followers of the writings of Emmanuel Swedenborg (1688–1772). Eventually, the group resolved to come to the area to establish a school and community in which they could learn and live out Swedenborg's teachings. The leader among them was industrialist John Pitcairn. In time, he would purchase the surrounding countryside and largely fund the building of first a school, and then a cathedral.

In 1895, another enormously important development occurred that would forever change the local landscape; the trolley came to Willow Grove. The trolley line along Old York Road terminated in Willow Grove at the intersection of Old York and Easton Roads. The following year, Willow Grove Park opened, and thousands were drawn to the area. By 1898, a trolley line ran to Doylestown with a spur to Hatboro in 1901, and the line up Easton Road was operating in 1904. It is interesting to note that the railroad developed Alnwick Grove—the site that attracted the Swedenborgians to the area in the 1880s—as a destination spot to boost rail traffic, and later the traction companies used the same method of enticement to bring the masses to Willow Grove Park.

Willow Grove Park fueled the development of the immediate area, and suburban homes began to spring up almost overnight. However, the development was fairly concentrated. Unlike other areas in the region, the railroad did not bring the ascending, middle-class office worker to the area to live. Aside from the two areas of industry, the surrounding land was surprisingly unaltered, remaining primarily farmland. It would take the wide acceptance of the automobile and the housing boom of the post-World War II period to significantly alter the landscape.

In 1916, the Swedenborgian community that had firmly settled into Bryn Athyn petitioned for independent political status and was made a borough. Willow Grove also petitioned for borough status, but that was tabled while the citizens of Moreland Township considered a split. By the end of the year, the township was officially divided into Lower and Upper Moreland Townships. Political boundaries have remained fixed since, although there was an effort in 1949 to increase Bryn Athyn's boundaries, which resulted in Lower Moreland seeking first-class township status to prevent the change. Upper Moreland had achieved first-class status in 1930.

The open farmland attracted the wealthy to the area. While older families like the Hallowells continued to maintain their family lands, newcomers like John Pitcairn and W.W. Frazier, and later George W. Elkins, bought large tracts of land. The wealthy also established their clubs in the valley, including Philmont Country Club (1906), the Huntingdon Valley Hunt (1914), and Huntingdon Valley Country Club (1928). Much of the remaining Frazier land would be developed while great stretches of the Pitcairn land would remain undeveloped.

The advent of the automobile furthered the trend toward suburban housing, but it was not until after World War II that a great residential housing boom changed the face of the area. The development of land, such as the Justa Farm and Albidale developments, brought many new people to the area and removed many of the old, and sometimes original, landmarks.

Recent efforts to maintain the open stretches of land and a sense of place have proved successful, particularly along the Pennypack Creek, a resource that all who live in the former Moreland Township share. These open areas not only make for a high quality of living and protect the natural environment but also remind us of the beauty that attracted many to this area before us. It is our hope that through the images and history on the following pages, you too will come to appreciate the beauty and rich heritage we share.

—David B. Rowland, President
Old York Road Historical Society

One

HATBORO

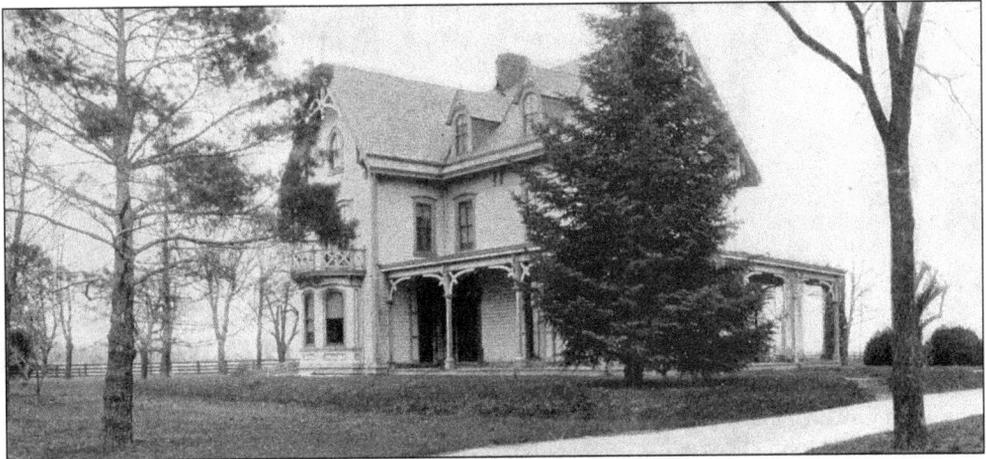

Built in 1871 for Samuel Swayne Thompson, Bonair Villa was located on the southeast corner of County Line and Old York Roads. Thompson was one of the founders of the Hatboro National Bank and later served as president. He was an executive with Mitchell, Fletcher & Company, a wholesale and retail merchant. The house was owned by Conrad Kruse in the early part of the 20th century and has since been demolished.

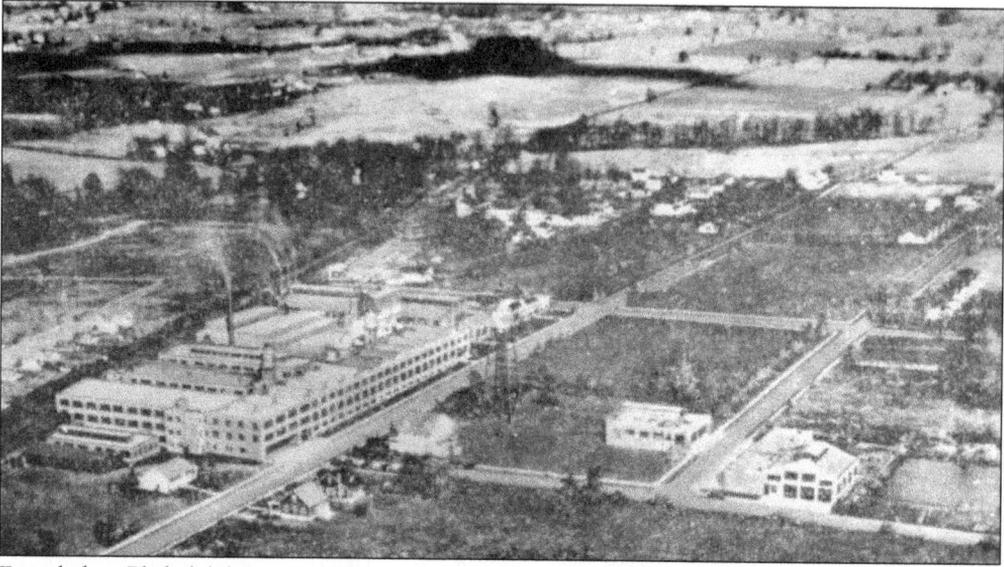

Founded in Philadelphia in 1865, the Roberts & Mander Stove Company moved to Hatboro in 1918, occupying the site that was once the Hatboro Foundry. The company was famous for its high-quality kitchen ranges. The factory was located between the railroad tracks and Jacksonville Road, south of Meadowbrook Avenue. In March 1938, the factory experienced a labor riot, an act that would be replayed later that year at the hosiery mill. Despite the labor setbacks, the 1940s witnessed an industrial boom in the greater Hatboro area, a boom that included the Brewster Airplane factory and Fischer & Porter.

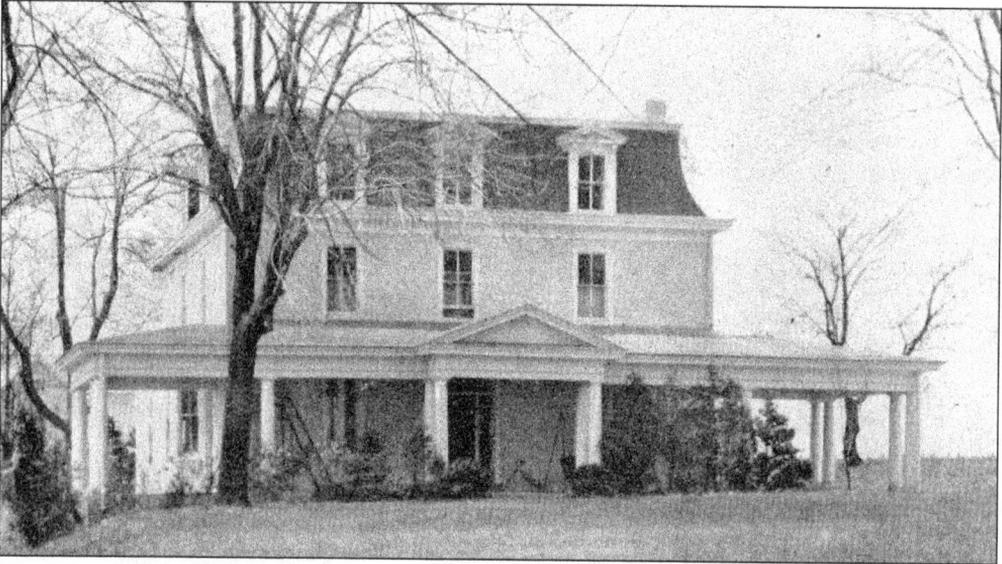

The John Gilbert House, located on the southwest corner of Old York and Home Roads, was used by General John Lacey as his headquarters prior to the Battle of the Crooked Billet. Lacey's encampment was several hundred yards directly in front of the house on the opposite side of the road. The house dates to the mid-1700s, although it was significantly altered during the later half of the 19th century. The house was the main residence on a large farm that extended west over the Hatboro line. For many years the home was an apartment building, but was demolished in September 2002.

The Crooked Billet Battle Monument was dedicated in 1861 to the memory of those who lost their lives during the Revolutionary War's Battle of the Crooked Billet. In the winter of 1777–1778, the British were based in Philadelphia, and the Continental army in Valley Forge. In order to stop the flow of supplies to the British from local Tory sympathizers, General George Washington gave orders for General Lacey to cut off the supplies. Lacey's success prompted the British to dispatch a small force of British regulars. On May 1, 1778, the British surprised the American troops, killing a number of Americans but failing to capture Lacey. The monument was removed from the northeast corner of Old York Road and Monument Avenue on April 11, 1967, and reset on the grounds of the Crooked Billet Elementary School on Meadowbrook Avenue.

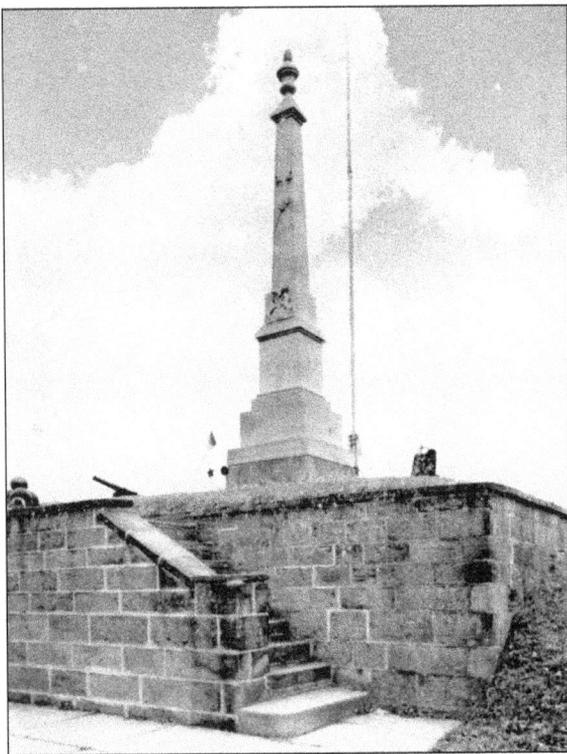

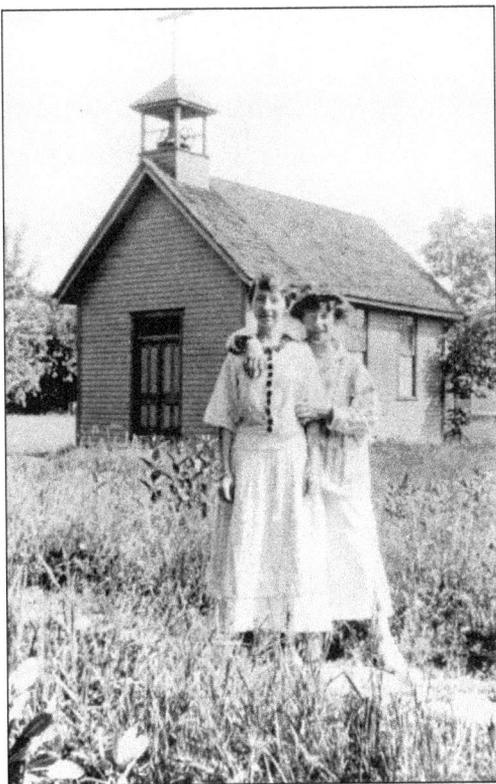

The St. Louis Chapel was located on the south side of Montgomery Avenue west of Penn Street. The chapel was started as a mission by Father Rufe of St. Anthony's Church in Ambler. Two masses per month were held in the chapel until 1892 when parishioners traveled to Willow Grove. In 1915, the chapel was reopened as a mission from St. Luke's in Glenside, moved to Willow Grove the following year, and shortly thereafter opened as St. David's Church.

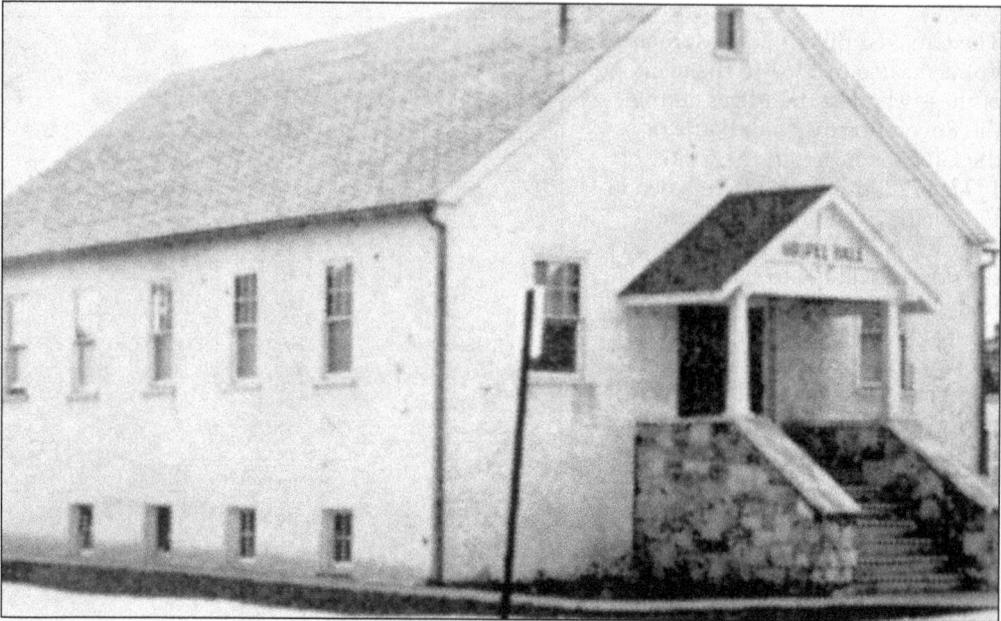

Located on Montgomery Avenue just east of Old York Road, Gospel Hall started in 1928 as the result of tent meetings held that summer. Services were conducted by local brethren and visiting evangelists; there was no formal minister. Initially, the group met in a store on Montgomery Avenue, but by c. 1941, they were able to build their own hall.

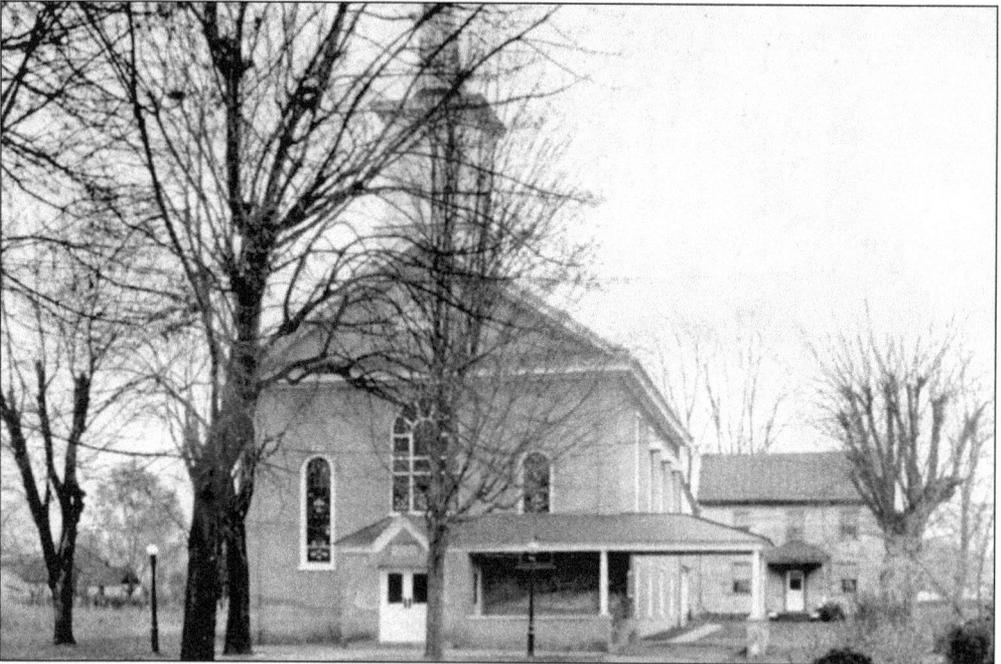

Hatboro Baptist Church was organized in 1835 and initially met at Loller Academy. A building was erected in 1839 and 16 years later was greatly enlarged to meet the growing needs of the congregation. The church cemetery began in 1840 and is still in use. The building was again improved in 1907. In 1954, the Sunday school wing was added, and the present façade was completed.

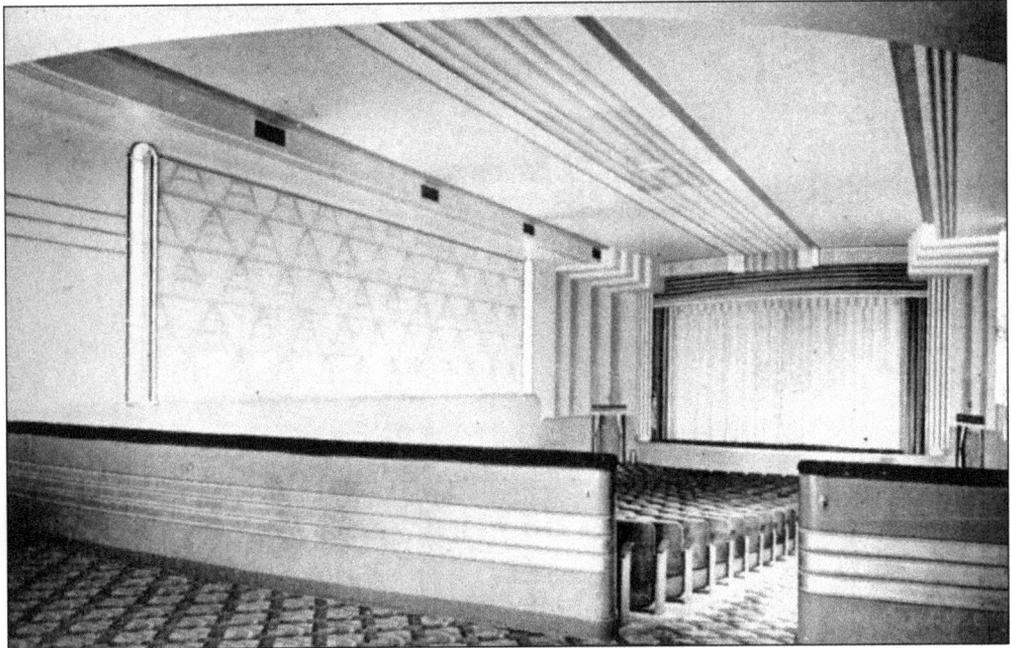

The Hatboro, which sat 500, was the first motion picture theater in the borough. It was built by Herman Bornstein of Philadelphia and owned by his father, Benjamin, operating under the name of the Hatboro Amusement Company. The latest in sound and projection equipment was installed, and it was the first theater in the area to be fully air-conditioned. The theater opened on Thursday evening, January 27, 1938. The interior design and decorations were done by noted Philadelphia theater architect David Supowitz.

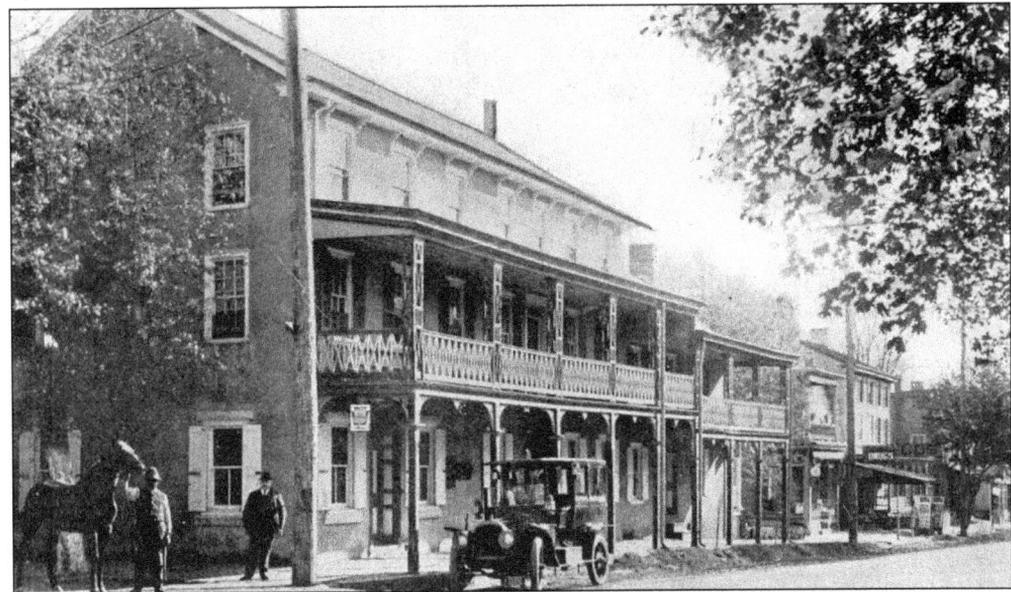

The Railroad Hotel was located at the southeast corner of Old York Road and Moreland Avenue. It was so named by the railroad construction workers who stayed there while laying the train tracks in the early 1870s. The building later housed the Hatboro Fruit Market, before it was torn down in the late 1920s.

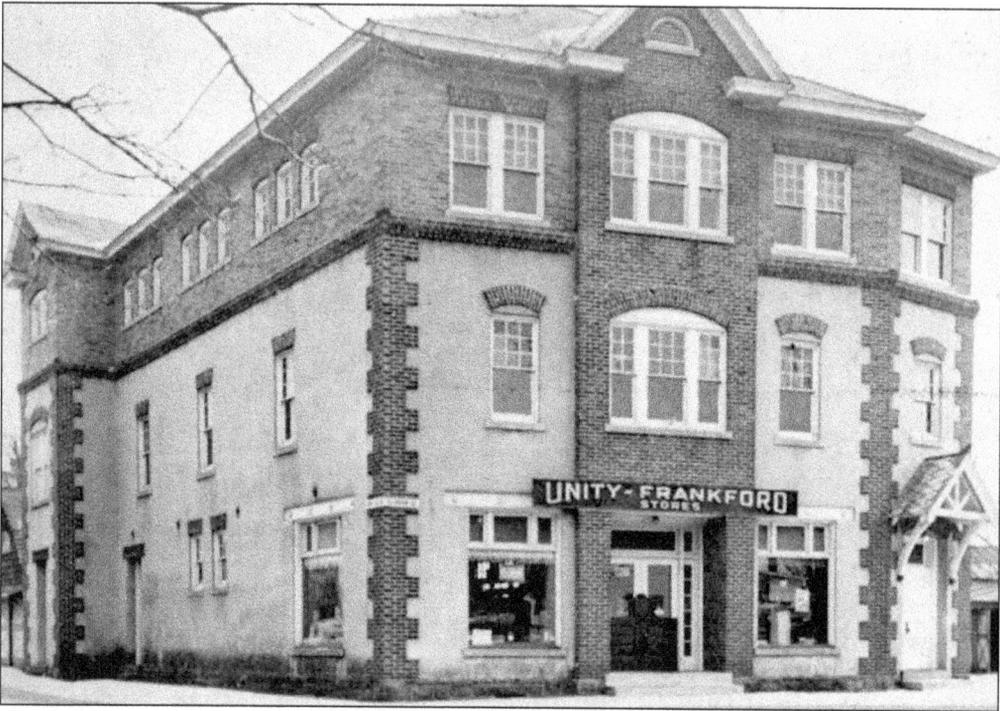

The Wilgus Building was built in 1916 on the southeast corner of Moreland Avenue and Penn Street, following a fire that destroyed the prior structure. The building served as home to the W.K. Bray Masonic Lodge No. 410 and the Unity-Frankford Store, owned by Anna M. Kenney. The Lodge was constituted in 1868 and is still active.

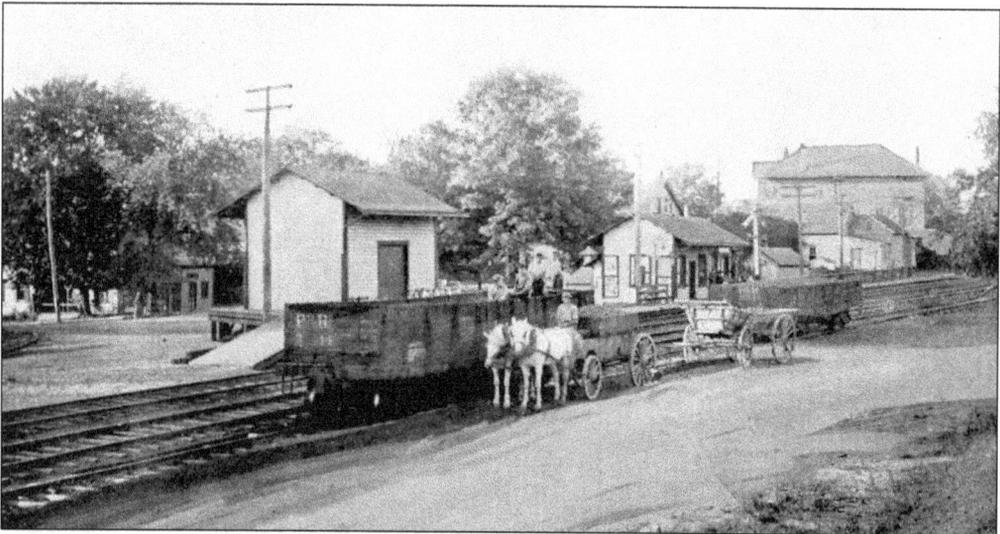

The North East Pennsylvania Railroad Company was formed in 1870 and began laying track from Glenside to the county line in 1871. Regular train service commenced on December 18, 1872. In 1879, the railroad company became part of the Reading Railroad Company. A small station was built and later replaced with a stone building in 1935. The later building is still in use. The first electric train ran on July 20, 1931. Today, SEPTA runs trains through Hatboro on its R2 Warminster line.

Walter Rothwell started work in Dr. Markley's drugstore on Old York Road, later becoming owner of that drugstore and 15 others in different parts of Philadelphia and the suburbs, including Jenkintown and Willow Grove. He was instrumental in the early development of both the Hatboro Trust Company and the Hatboro National Bank. After having served as a drugstore for many years under other names, the building was demolished.

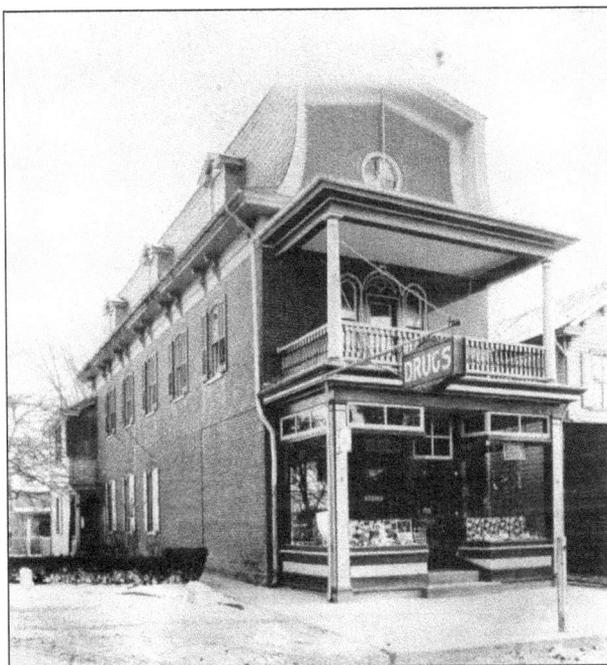

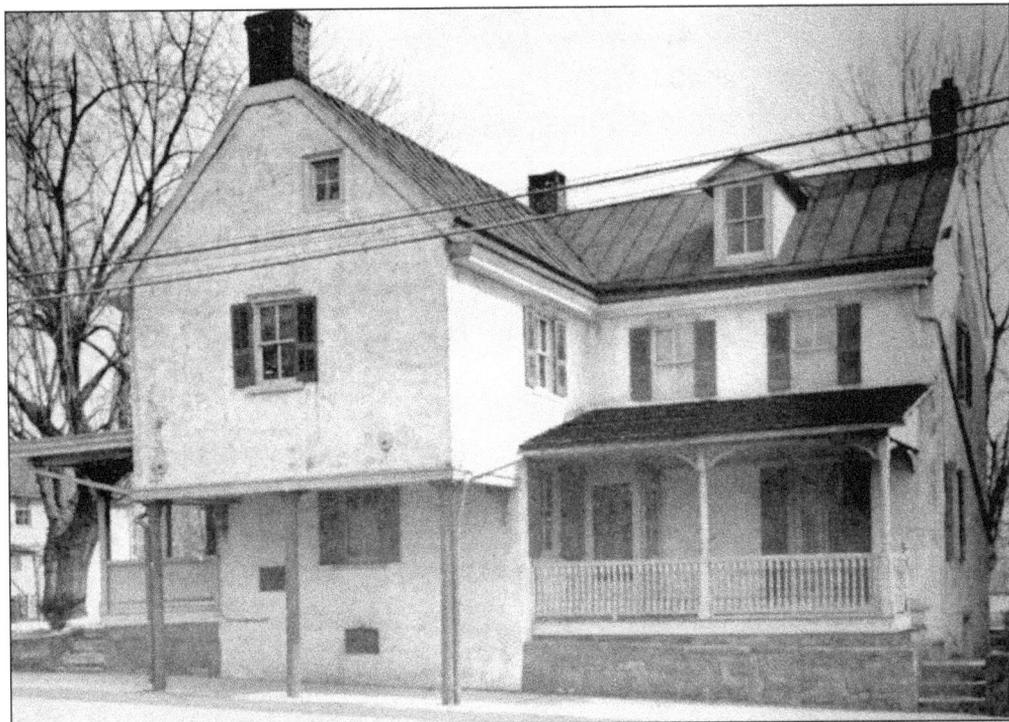

The Crooked Billet Tavern was built c. 1726 by John Dawson, an early settler of Hatboro, as a private residence. A few years later the tavern opened. In 1755 the Union Library was organized here, and in 1777, George Washington stopped at the tavern. When Old York Road was widened in the 1920s, the first story was cut away to allow room for the sidewalk. The building, located on the east side of Old York Road, was demolished in 1954.

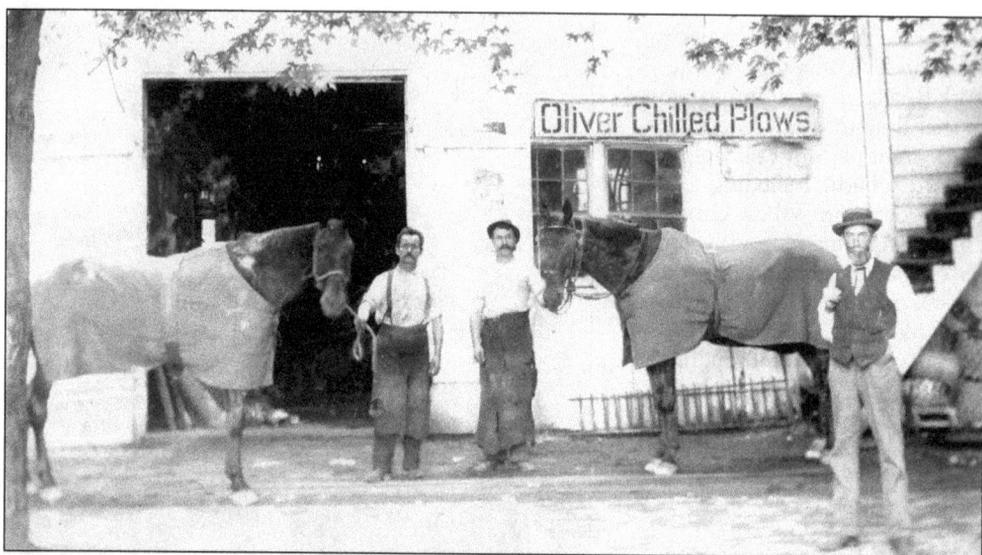

Photographed in 1888, Edmund Mottershead, Joseph Runkle, and John Jamison stand outside Mottershead's Hatboro Smithy, the local blacksmith shop. In the 1930s the property was inhabited by Mason's Garage. The Gamburg Furniture Store now occupies the site.

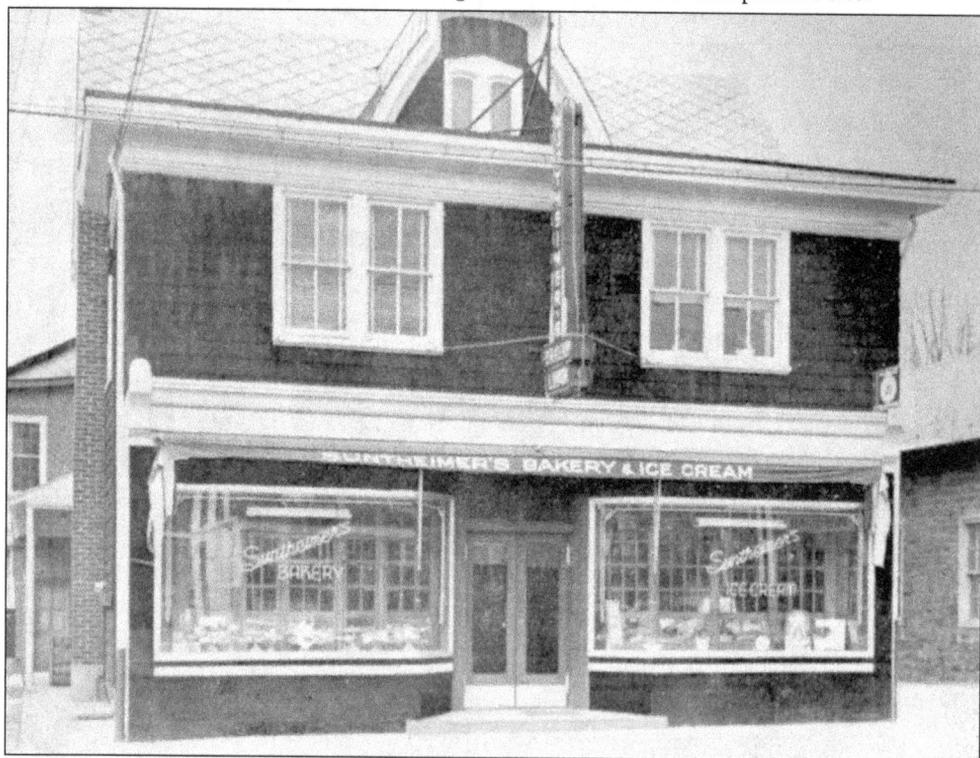

In 1923, Frank Suntheimer emigrated from Germany and settled in Hatboro, purchasing the bakery operated by F.L. Wright and originally founded in 1880 by Daniel Stone. The store was renovated in the mid-1930s, and by 1939, the bakery had 16 trucks and 45 employees. Suntheimer served on Borough Council and was active in civic and bakery industry affairs. The building still stands and is currently a jewelry store with the rear section the Red Barn Mall.

The Enterprise Fire Company of Hatboro was founded in 1890 and shortly thereafter authorized the purchase of a fire truck, which was delivered early in 1891 after a firehouse had been built. In 1898, the building was remodeled with the addition of a hose tower. In 1911, the company bought its first motor apparatus. The company erected a modern hose tower in 1940 and by the 1950s decided to seek larger quarters. After one move, the company settled down on Byberry Road in 1971.

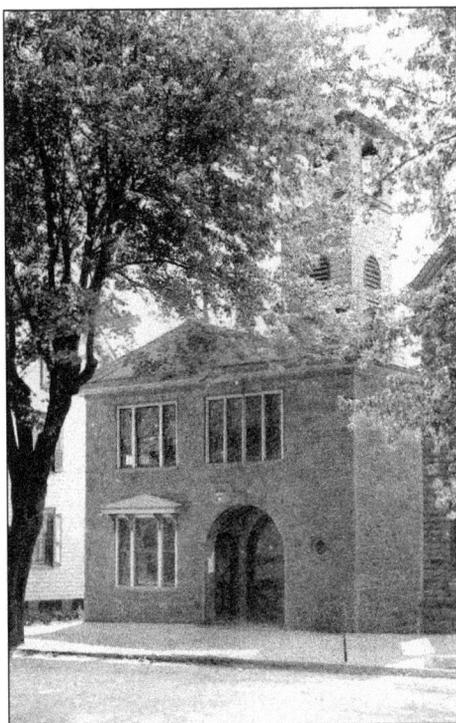

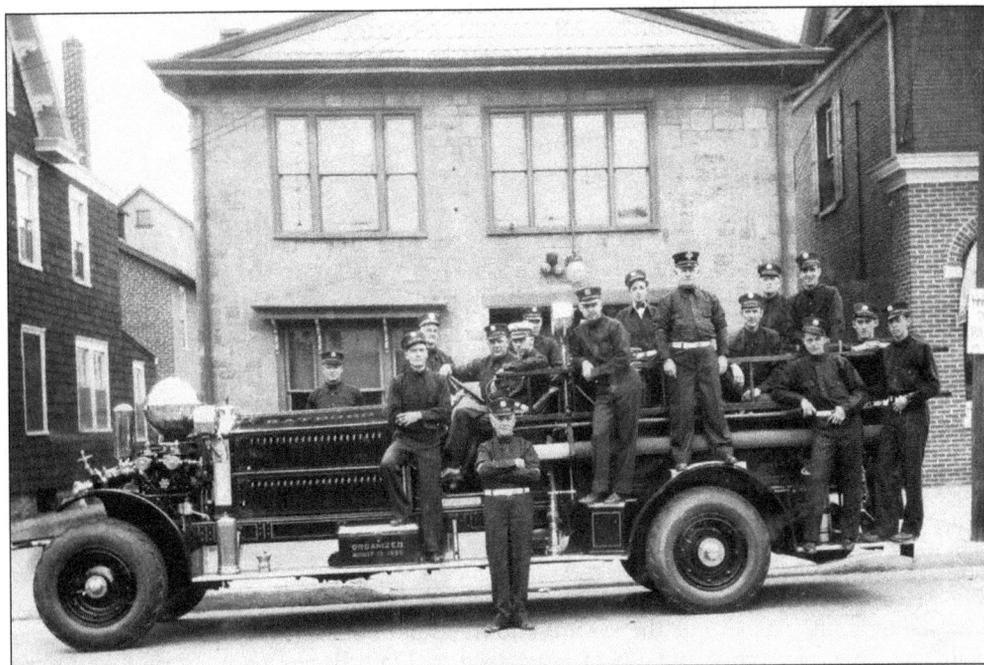

The active members of the Enterprise Fire Company show off their new 1926 Ahrens-Fox 750-gallon pumper. From left to right are Adam Bustard, Russell Duckworth, Clarence Butterworth, Warren Kramer, Charles Yerkes, Alvin Winner, Chester Winner, Wesley Campman, John Marks, Ervin Amber, Charles Shultz, George Duncan, Norman Winner, Harry Morris, Charles Stourenburg, and Calvin McNeil.

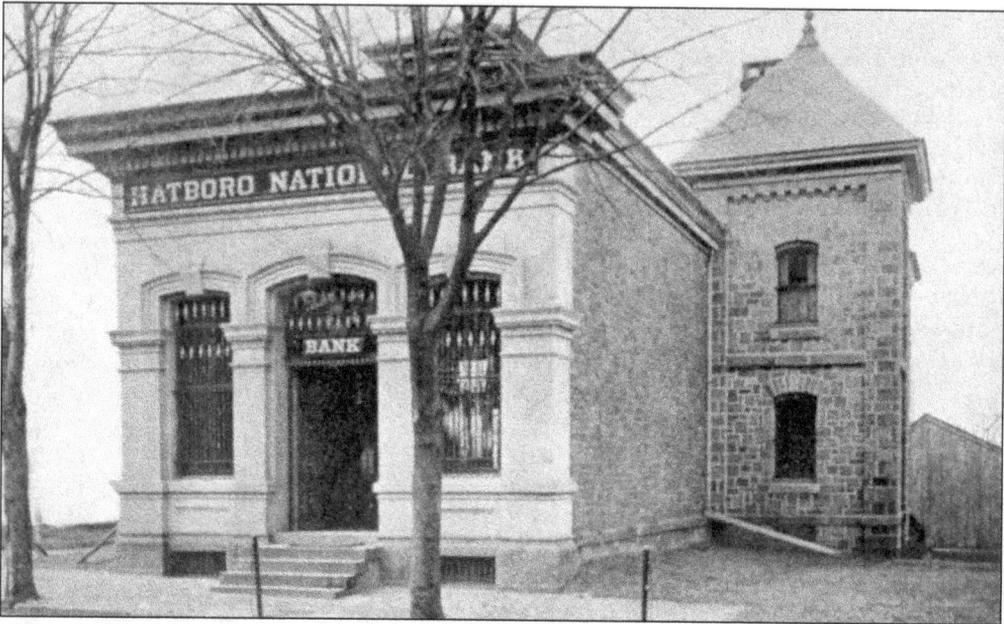

The Hatboro National Bank, established in 1875, was located on the west side of Old York Road opposite the intersection with Byberry Road. The bank purchased its building from S.C. Ball, who had constructed a banking house the year before. The original building was enlarged in 1923 according to the plans of architect Adam Oscar Martin and modified again in 1939. The building still serves as a bank branch, currently for First Union.

The Joshua Potts' School was the second known school building in Hatboro. The first was built near Byberry Avenue and Warminster Road in 1730. Beginning c. 1750, Rev. Joshua Potts started a private school, which was located near Old York Road and West Monument Avenue. The first Methodist Sunday school in Hatboro was held in this building. Years later, the structure was moved to the site later occupied by the residence of L. Earle Bennett on West Monument Avenue. The building was demolished to make way for the Bennett home in the early 1920s.

18

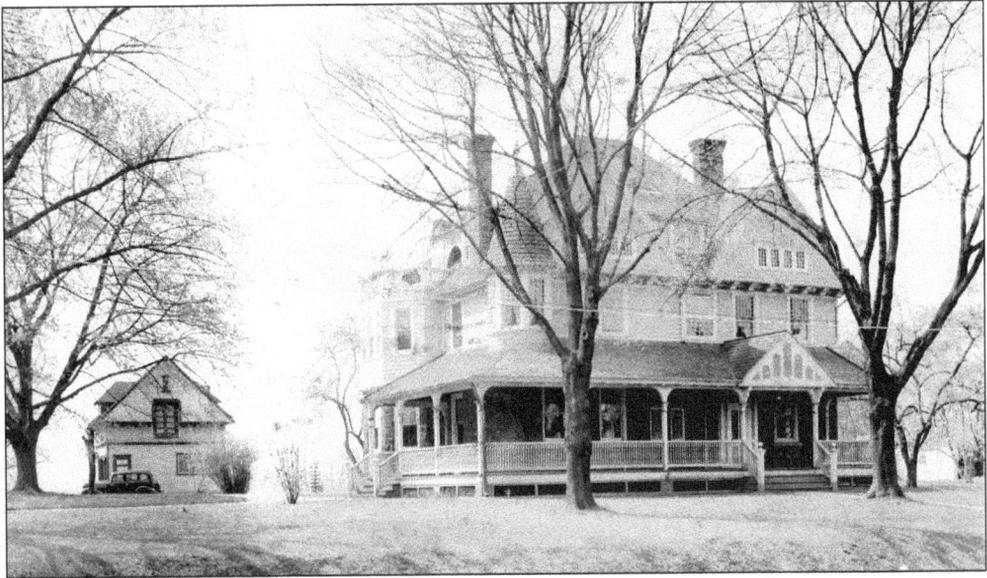

Birdlyn was the home of Dr. J.B. Carrell, a renowned medical doctor who spent much of his long life dedicated to keeping alive local history. The house was built in the 1890s when the south side of Byberry Road was opened for development by the Rorers. Originally, the Markley family lived there. The house was eventually demolished, and the Enterprise Fire Company's firehouse is now on the site.

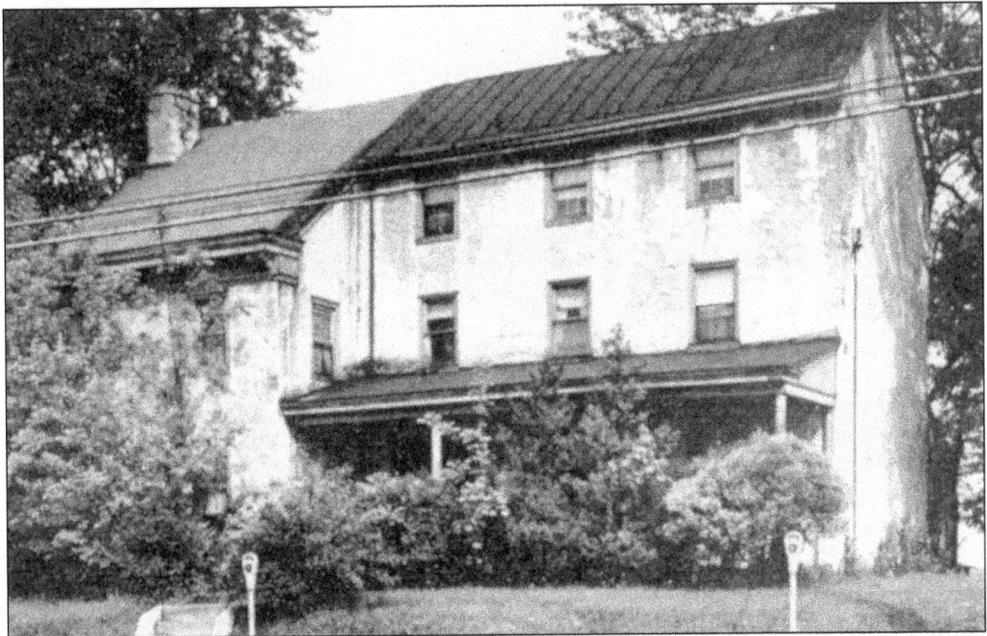

John Harrison, grandson of Nicholas More, built his home in 1742 on the east side of Old York Road just below the intersection of Byberry Road. The Rorer family owned the house along with 90 acres, which extended back to Warminster Road, for many years in the late 1800s. The house was purchased by the Hatboro Federal Savings and Loan Association in 1950 and remodeled the following year. The bank was organized in 1941 and continues to occupy the building.

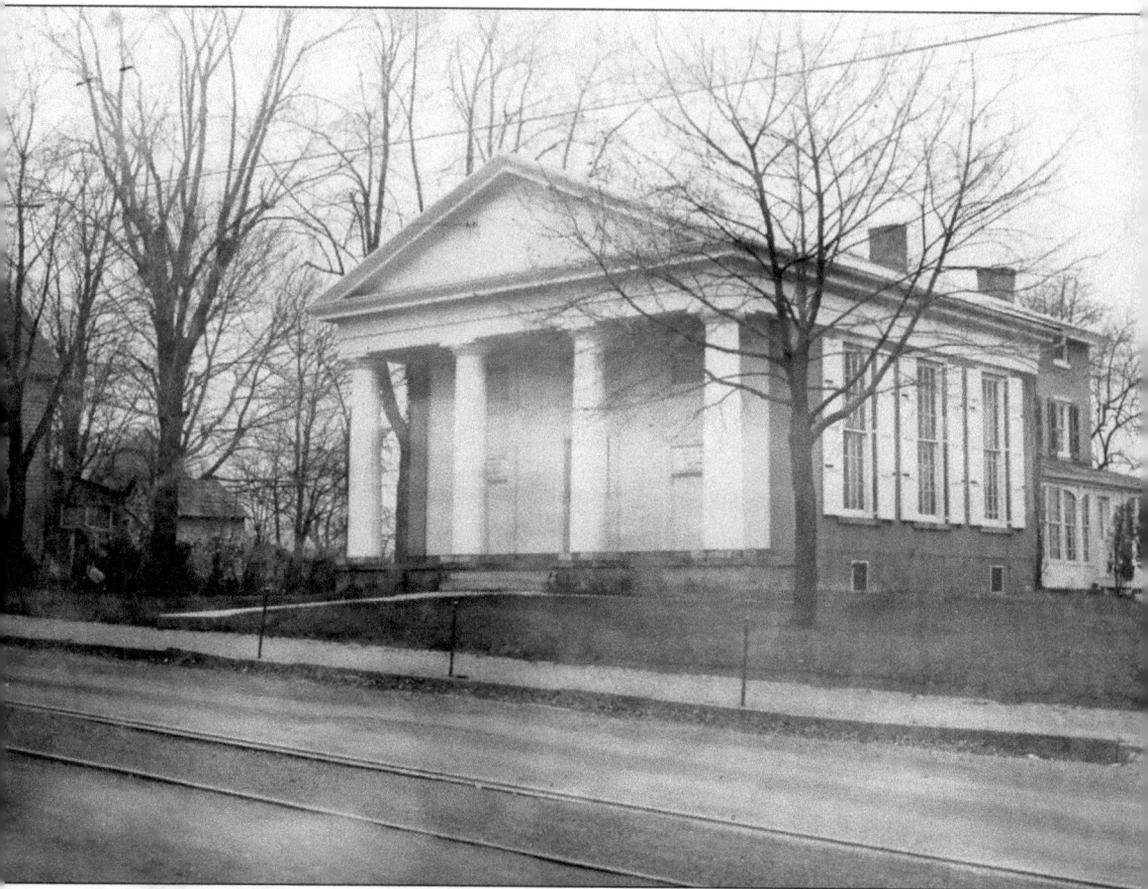

The Union Library Company of Hatborough was organized in 1755 and initially operated under an "instrument of partnership." In 1787, Robert Loller took steps to have the company incorporated, which was accomplished on March 28, 1787. The first shipment of books ordered from England arrived in 1756, and for many years the practice was for the current librarian to store the books in his home. In 1805, a lot was purchased for the construction of a building, but more than 20 years passed before a building was erected that included a room for the library books. However, the company could manage, and the property was rented. In 1848, shareholder Nathan Holt of Horsham died, leaving the library a sum of money to purchase ground and build a permanent home. In 1850, the Greek Revival–style library building opened, designed by Edwin Mitchell, son of the library's then treasurer. The rear of the building contained an apartment for the librarian. In 1992, the library added a community reading room onto the back to the building and, in 2000, the library completed a sizable addition for a children's room.

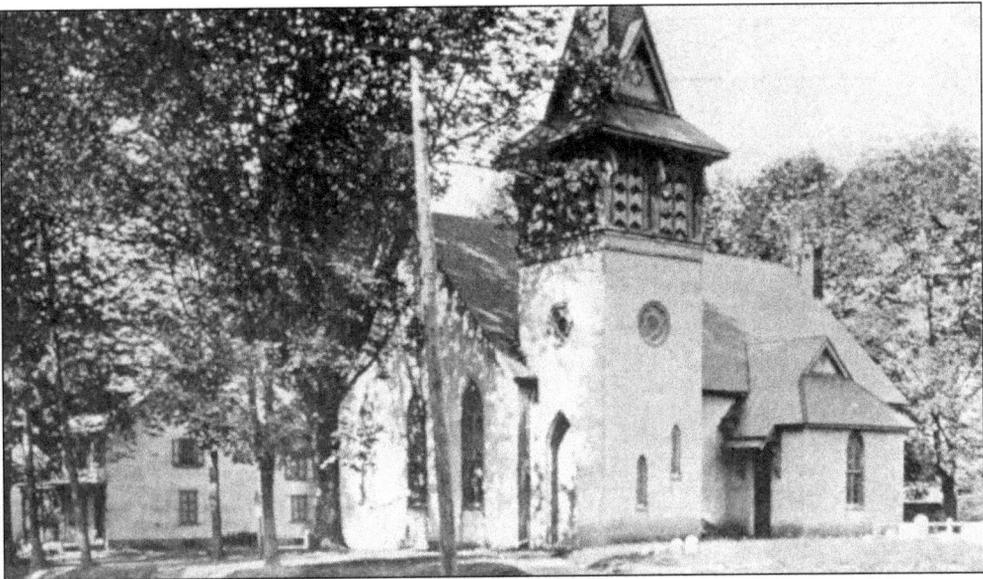

The Lehman Memorial Methodist Episcopal Church was the first church building in Hatboro. The church took form out of a Sunday school run at various locations by local ladies. The congregation attracted the attention of Joseph and Deborah Lehman of West Philadelphia. They purchased land from Robert Radcliffe in 1836 at what is now the southwest corner of Old York Road and Lehman Avenue (Lehman Avenue had not been cut through at the time). A church building was soon built and dedicated on May 22, 1837 as a memorial to the Lehman's son who drowned as a child in the Wissahickon Creek. A parsonage was erected in 1843. The Rev. William K. Goentner was the first pastor. The church was rebuilt in 1879 in a Gothic design that included the addition of a Sunday school room and the steeple. Other additions have been made to the building over the years.

"The Neighbors" Christmas Dinner

1916

VanDyke's "Christmas Prayer"

Soup	Relish
Origin and Customs of Ancient Christmas	Music

Goose
Sketch from Dickens' "Christmas Carol"

Music

| Christmas Story | Riley's "Who Was Santa Claus" |

Salad
Music

Plum Pudding
"The One-legged Goose"

Nuts and Raisins	Coffee
Christmas Jokes	

The Neighbors of Hatboro was an influential women's civic organization. Founded in 1910, the organization was active in community affairs for over 90 years before dissolving in 2001. Meetings were originally held in the Hatboro Baptist Church but later moved to the Lehman church. Virtually all of the membership was composed of residents or former residents of Hatboro.

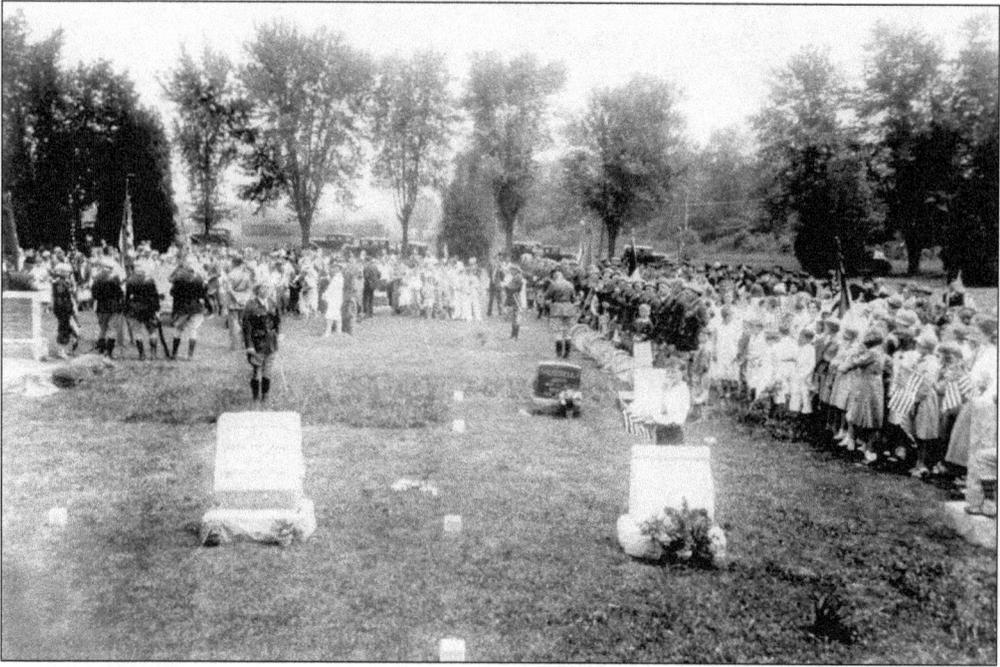

The Hatboro Cemetery is located on the south side of Fulmor Avenue. The cemetery was founded in 1876 by the Yerkes family. Pictured are the 1934 Memorial Day ceremonies.

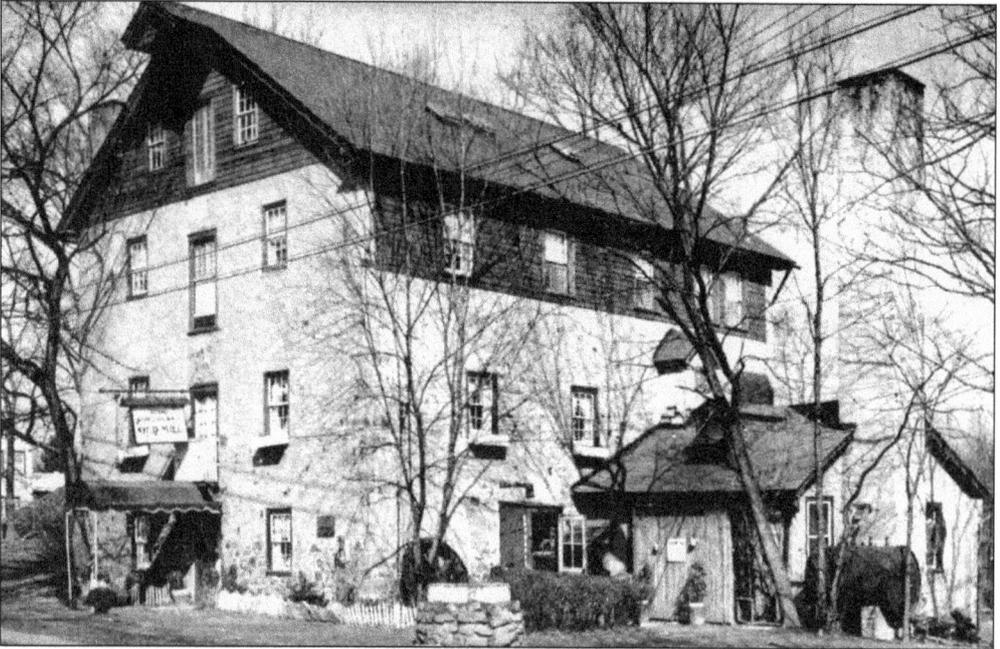

Emanuel Dungworth built a gristmill in 1724 along the Pennypack Creek at the intersection of Old York and Horsham Roads. The building is the oldest surviving building in Hatboro. The mill remained in operation until 1912. After a few years as a machine works, it was turned into a tea shop. In the 1930s, the building was renovated and opened as a restaurant, a function it continues to the present day.

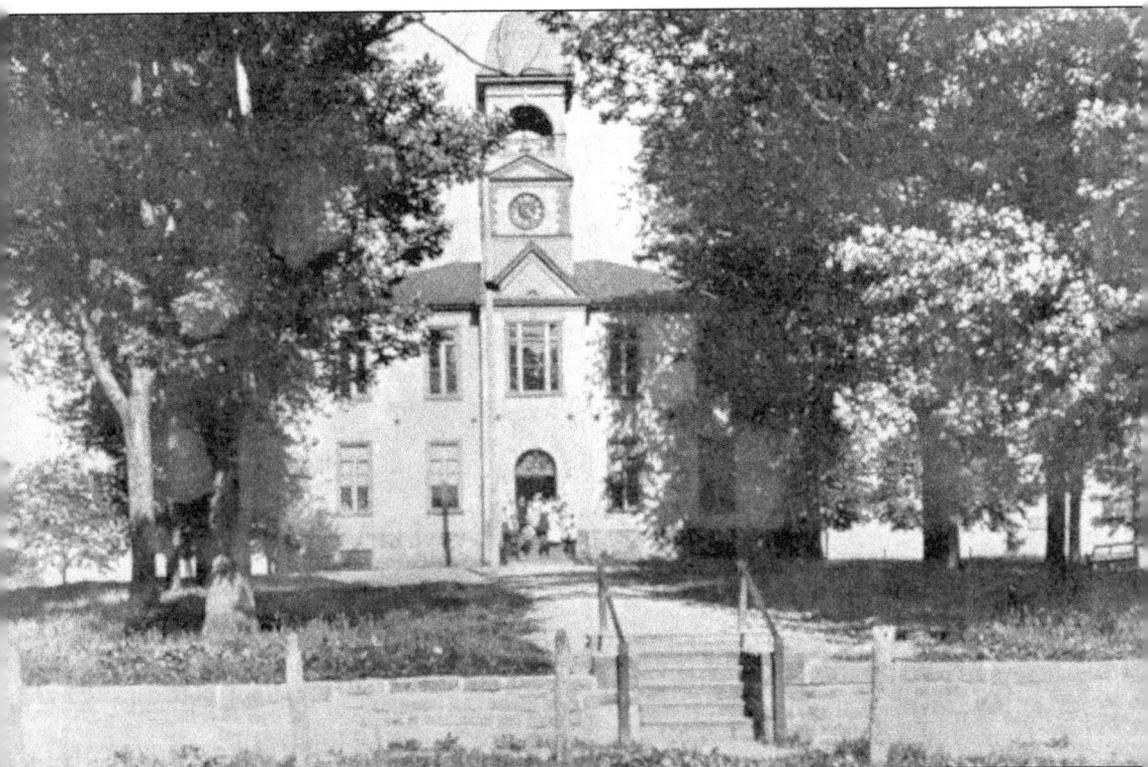

Robert Loller, veteran of the Revolutionary War and member of the state assembly, died in 1808 leaving his estate to be held in trust for the building of an academy of learning within one mile from the center of Hatboro. Nathaniel Boileau, Loller's neighbor to the south whose house is now home to the YMCA, was named trustee. Construction of the academy began in 1811 and was completed the following year. The building was located just north of Loller's former residence. In 1812 Isaiah Lukens, one of the founders of the Franklin Institute, installed a clock in the tower that still functions. It is one of three that Lukens built, another being the tower clock at Independence Hall in Philadelphia. Loller Academy was a private school for boys. When Hatboro voted in 1848 in favor of public schools, the academy accommodated both public and private classes. In 1873 the academy was purely a public school. From the time the high school was built in 1927 until the building ceased to be a center of learning in 1960, the academy building was used as an elementary school. The building still stands and houses the borough offices.

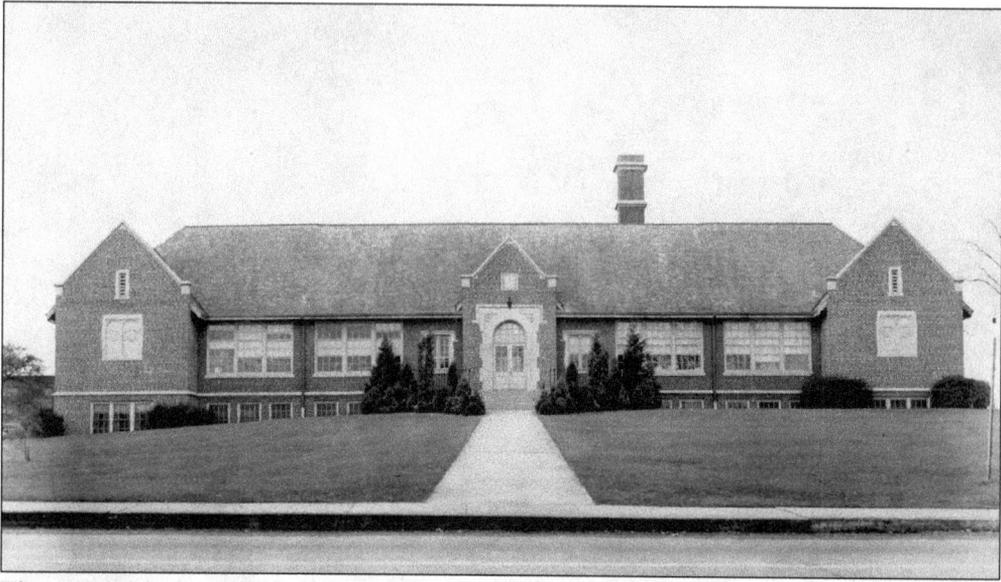

The original home of Robert Loller was demolished to make way for Hatboro's first public high school. The architectural firm Heacock & Hokanson designed the building, which was dedicated on November 29, 1927. In 1950, the Hatboro and Horsham schools combined, and the building served first as a high school and then as a middle school. It was closed in 1981 and is now the Penn Independent Office Campus.

There were two Hatboro tollhouses on Old York Road. The northernmost was just below the county line on the west side. The southernmost lay just below the boundary of the borough but nonetheless was identified with the town. Located near the present-day intersection of Mill, Old York, and Warminster Roads, the tollhouse stood just south of Ashland Farm. Old York Road was a turnpike road until the state freed it in 1918.

Two

UPPER MORELAND
TOWNSHIP

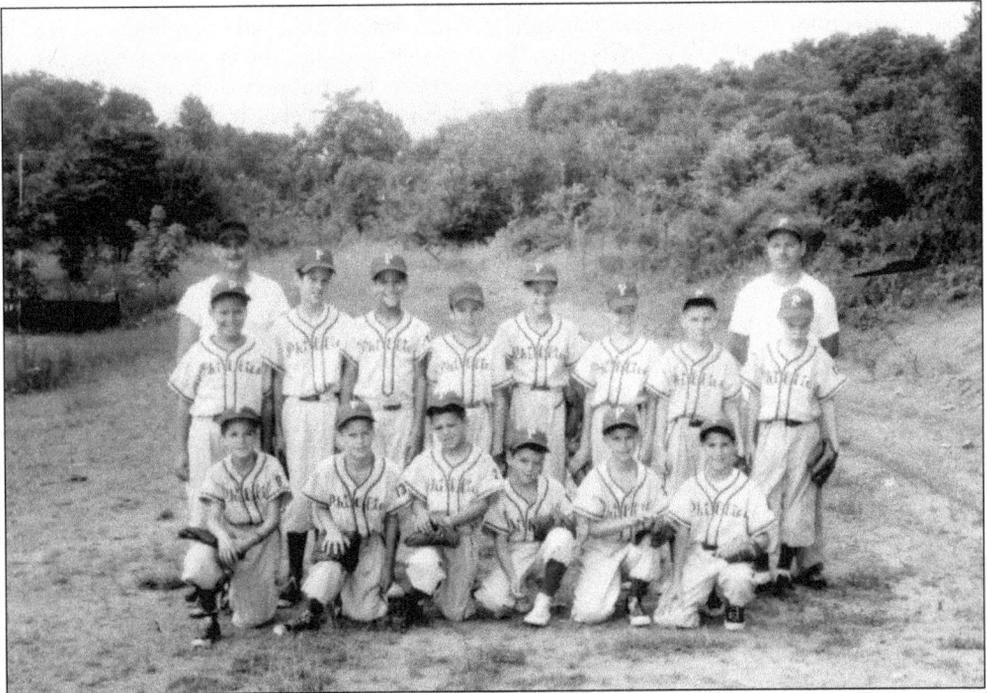

There were three divisions in the Willow Grove Little League: National, American, and Major. For the youngest players, there was the Junior League. With the season almost over in 1958, the Kiwanis were champions of the Major league with a 13-5 win-loss record, the Orioles led the American league with a 12-1 record, the Dodgers had a 6-2 record in the National league (the Phillies were in fifth place), and the Eagles of the Junior League were the leaders with a 7-1 record.

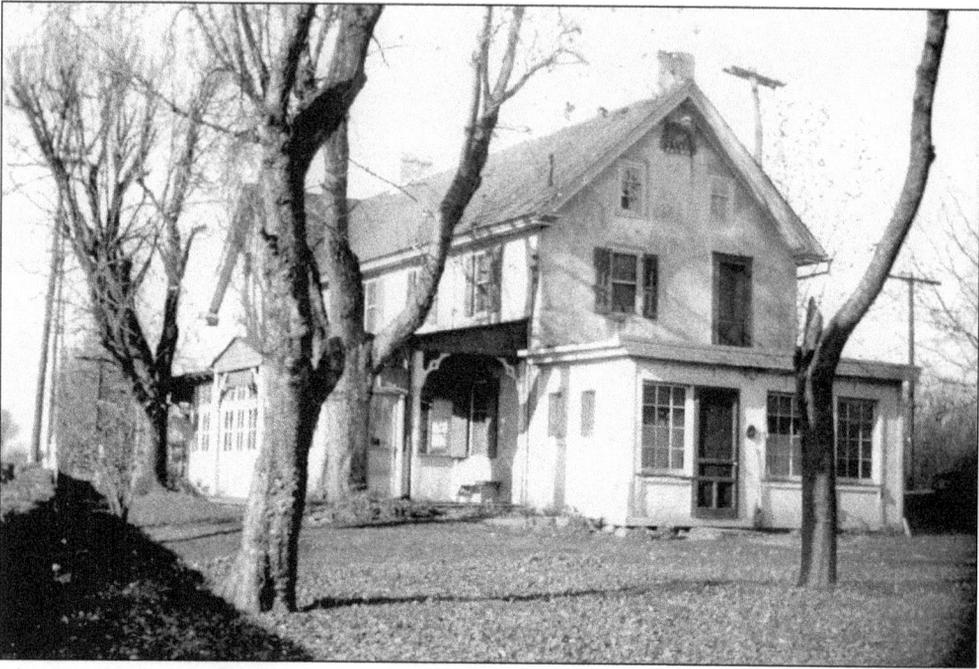

The Continental Villa was on the east side of Easton Road, within the triangle at the Mill Road intersection. The first section was built in 1717, with a larger addition built c. 1818. It was named Continental Villa c. 1876 when it was modernized with the latest conveniences. In 1910, the owner, Elizabeth S. Roessler, changed the name to Continental Farm, and it became a private home. The Alderfer family occupied the house in the 1940s. It was later demolished, and a gas station was built on the site. This photograph dates from the 1930s.

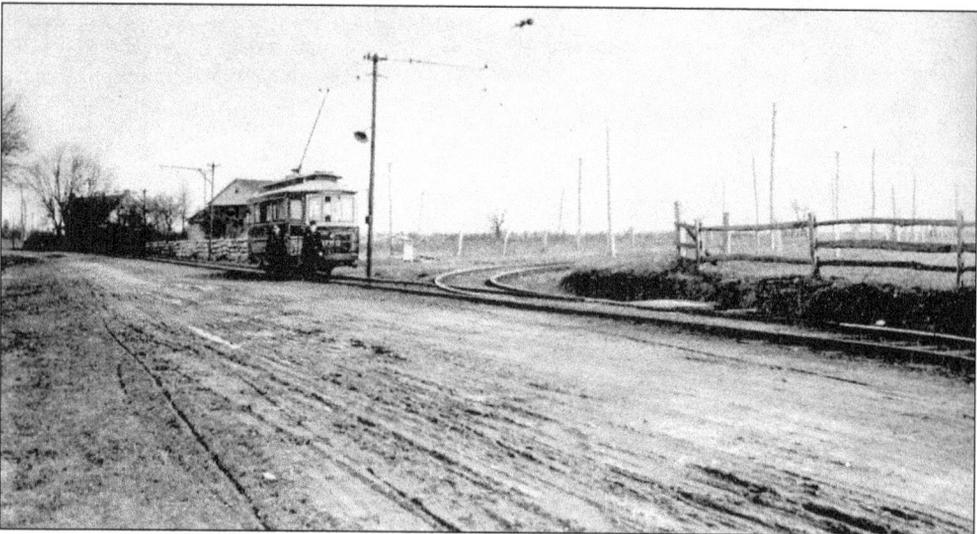

In 1901, the Hatboro line, a branch of the Willow Grove and Doylestown trolley route, opened. Looking north toward Doylestown, the tracks to Hatboro curve to the right. The junction was just south of the Continental Villa, about one mile north of Willow Grove. The Hatboro National Bank raised the funds needed to purchase the necessary right-of-ways. The trolleys stopped running on February 15, 1931, and were replaced by Philadelphia Rural Transit Company buses.

Construction of the Pennsylvania Turnpike cut a wide swath through Upper Moreland in the early 1950s. It was the first turnpike road in America, and the first section, from Carlisle to Irwin, was completed in 1940. The section from Irwin to Valley Forge was completed in 1950 and the westward section to the Ohio border in 1951. The Willow Grove interchange was completed, and the 16.6-mile road opened for traffic to Valley Forge on Monday, August 23, 1954. The east and final leg to the Delaware River was opened in October. The half-house, still standing but soon to disappear, illustrates one small aspect of the profound change to the township.

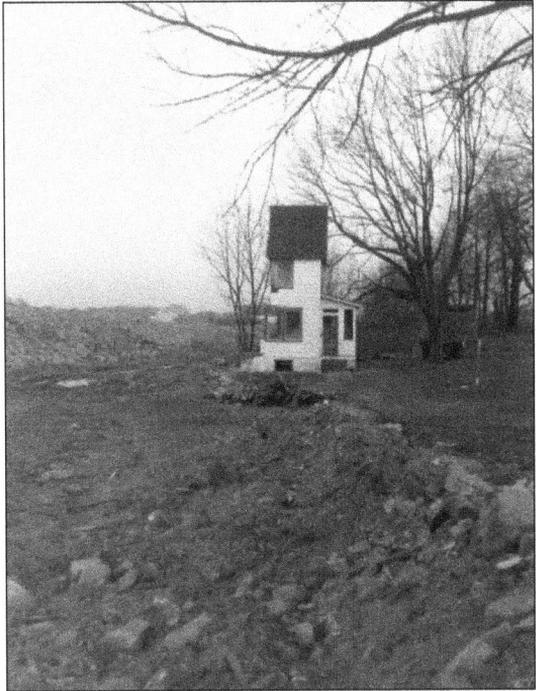

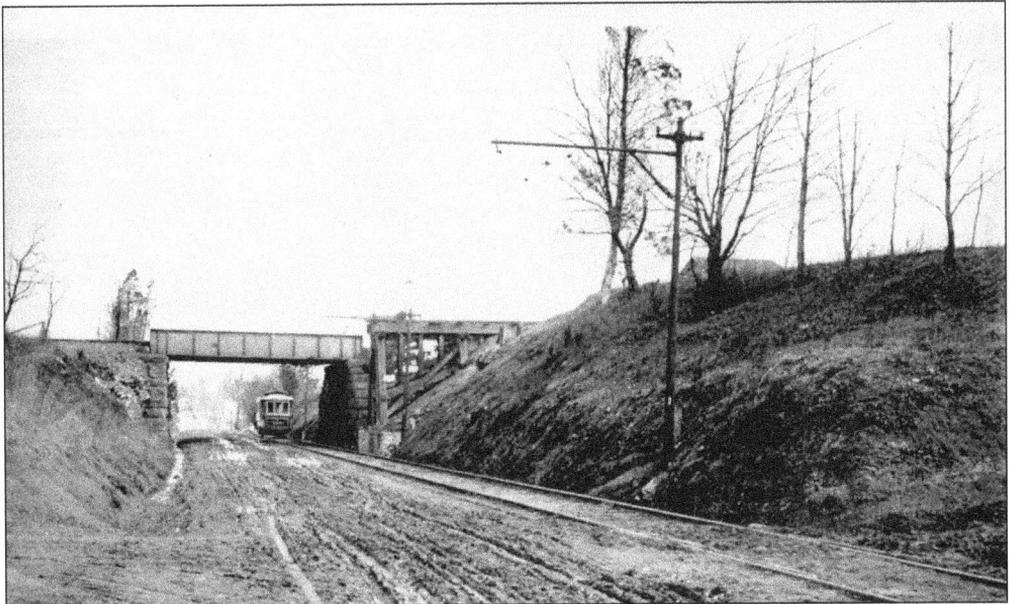

The Pennsylvania Railroad built the Trenton Cutoff in 1891–1892. It was the last major railroad line built in Montgomery County and was constructed to ease freight traffic by bypassing the congested Philadelphia area. It was built according to very high engineering standards, with grade separation at all intersecting railroads and at most roads. The 45-mile-long cutoff began just west of the Delaware River crossing north of Philadelphia and rejoined the main line near Glen Loch. In Upper Moreland, it crossed both Easton and Old York Roads just south of the turnpike. The trolley pictured here is traveling under the Easton Road overpass in 1909.

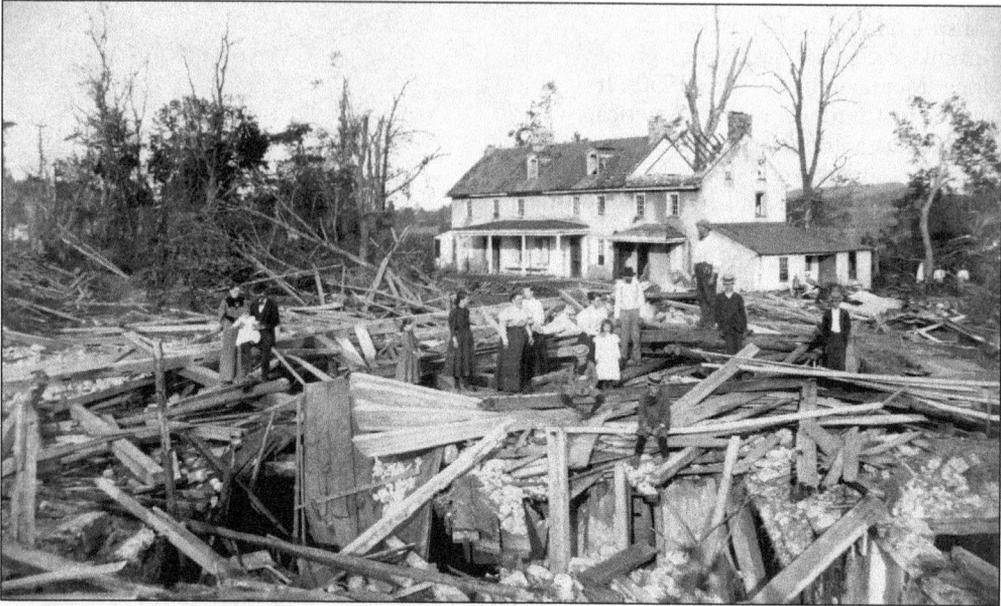

The John K. Bready Farm sustained heavy damage from a cyclone that swept through the area on May 28, 1896. While the house suffered some damage, the barn was completely destroyed. The farm was located on 147 acres that extended between Easton and Blair Mill Roads. Willow Ridge Dairy was on the property later, and the land is now used as a cloverleaf for the turnpike, Abington Hospital Outpatient Clinic, and the Marriott Courtyard. The Bready house is still standing behind the Marriott.

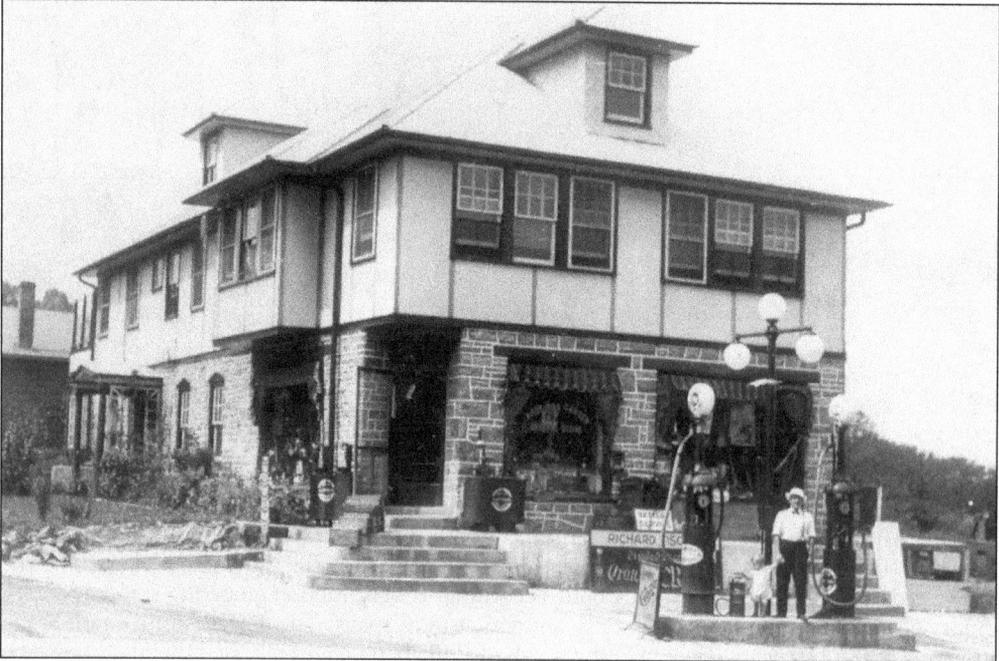

Richard Fischer's gas station and general store was located at the northwest corner of Easton and Fitzwatertown Roads. Pictured in 1927, it remained standing until c. 1992. Soundex now occupies the site.

The Community Presbyterian Church was founded in June 1920, and its first building was completed by October. This building was on the corner of Easton and Barrett Roads, where the permanent church was later built in 1930. The church expanded in 1954 and 1967. After a split in the congregation in September 1936, the members who remained chose the name of First Presbyterian Church of Willow Grove; those who left organized as Calvary Presbyterian Church and eventually settled across the street.

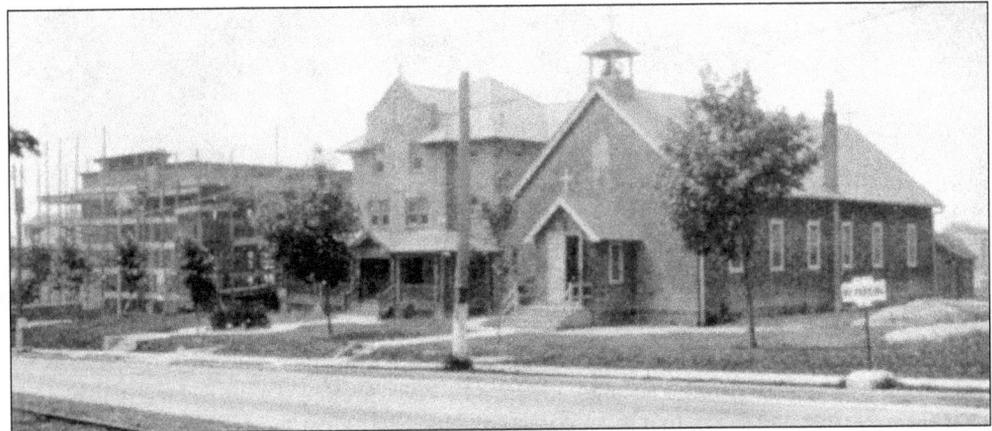

In 1916, David Nolan, a Willow Grove storekeeper, donated much of the labor to build the first chapel of St. David's Catholic Church. The church was located on the west side of Easton Road south of Summit Avenue and was a mission station of St. Luke's in Glenside. In 1919, the chapel gained parish status and was named St. David's. Sisters of the Immaculate Heart came in 1920 and held school classes in the chapel and then in a newly built rectory south of the chapel. The first school building was started in 1926 at the northwest corner of Cedar Avenue and Easton Road. In July 1951, ground was broken for a new church building next to the old chapel near Summit Avenue. The building was dedicated on December 7, 1952, and the old chapel was razed.

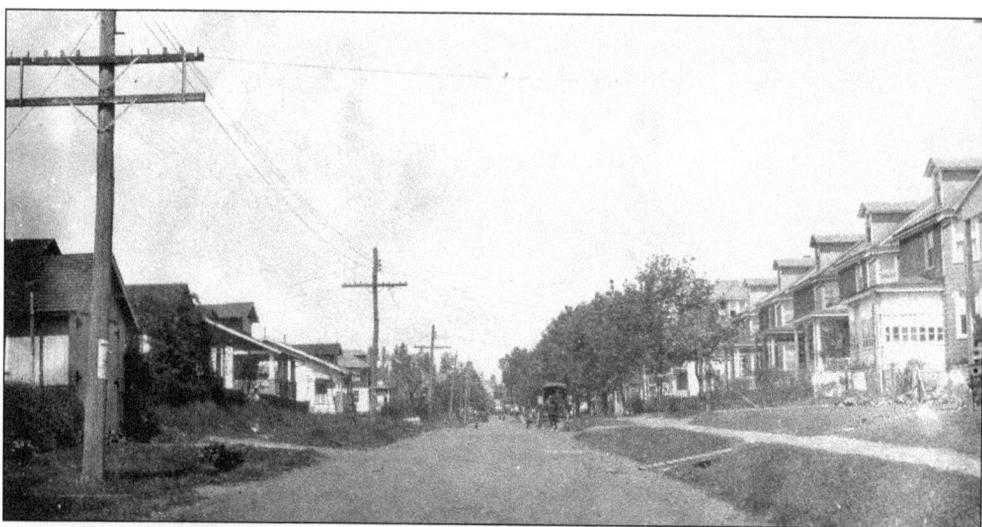

Center Avenue was open by 1916 and ran through land formerly owned by Samuel Keightly. Cedar and Summit Avenues were also new streets. The Keightly development area extended from Park Avenue north to the south side of Allison Road. The view above looks north from Moreland Road toward Easton Road and dates from after 1925 when most of the houses on the east side of the street were built.

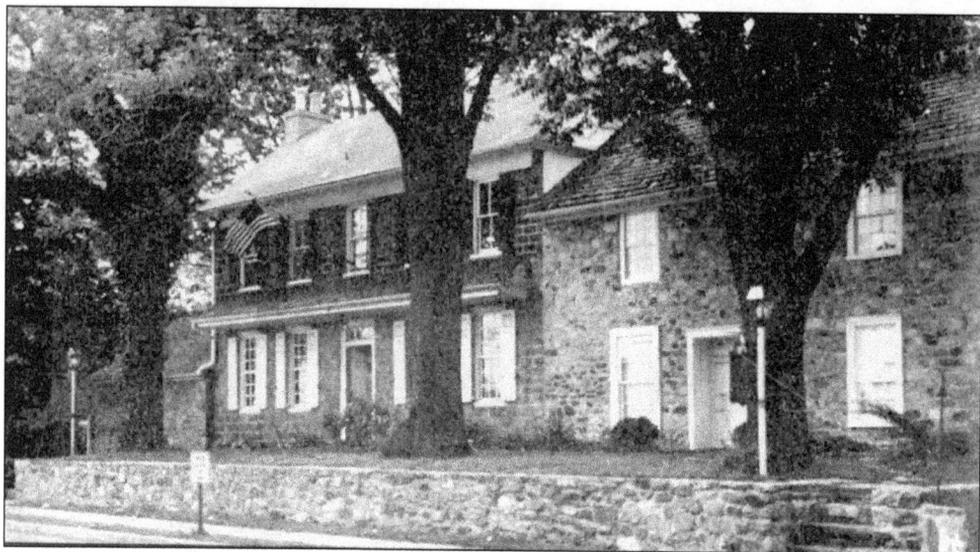

The Dubree Manor House was located at 117–119 Park Avenue. Jacob Dubree and his son James owned the 300 acres that now comprise most of the center of Willow Grove. The first part of the house was built c. 1730; the second was present by 1746. There were several later owners, and the property was split in two. By 1809, Samuel Potts owned both pieces of land. It passed through several more owners until 1932, when at the death of owner Phoebe Wolfe it went to her sister, Emma MacCartney, and then to MacCartney's daughter, Phoebe E. MacCartney. Phoebe MacCartney Patterson and her husband, Harry B. Patterson, restored the house, making extensive repairs. It was sold to Upper Moreland Township in November 1950, with the understanding it would be preserved as the township building. The township met opposition when it tried to raze it in 1962, but in 1967 the new township building was completed next door and the old house was demolished for a parking lot.

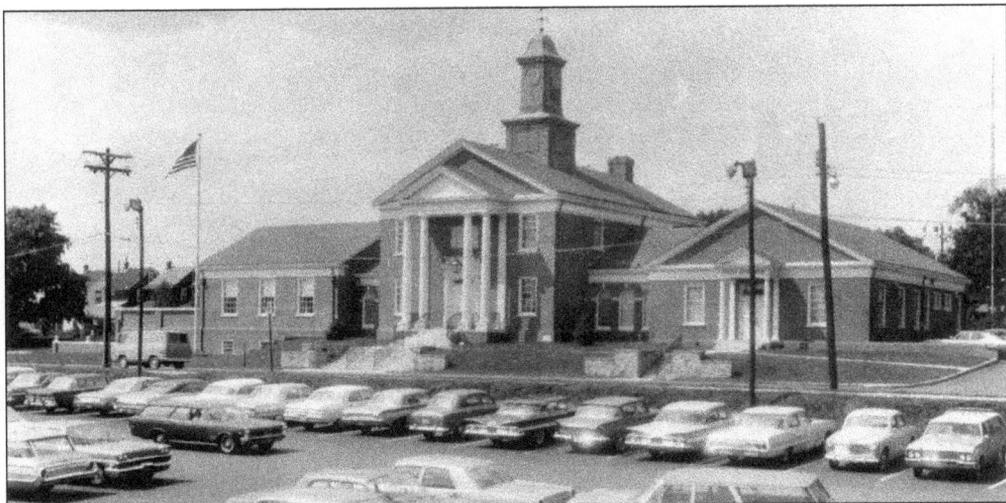

The Upper Moreland Township Building is located at 117 Park Avenue. With first-class township status in 1930, the government needed to enlarge and form a police department. Township officials were located in several buildings over the years, including the Willow Grove Community Memorial Hall in 1939, the Hart Building (the former Willow Grove Trust Building) at Easton and York Roads, and the Dubree Manor House on Park Avenue. This modern building was dedicated on May 30, 1967, and is located next to the site of the old Dubree House. Originally the government offices were in the center section, the police on the right, and the township library on the left.

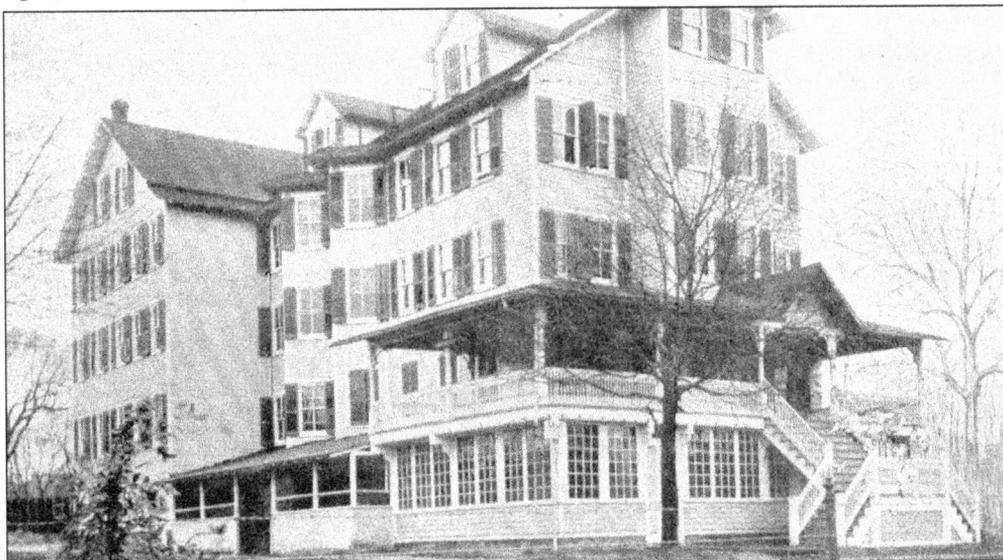

The Parkside Boarding House is still located just east of Moreland Road on the north side of Park Avenue. It was built in 1901 to accommodate guests and performers at Willow Grove Park. A large lawn and flower gardens surrounded the 40-room house, and there was a restaurant on the ground level. It was built by J. Catherwood Robinson, who lost it at a sheriff's sale in 1915. The property reverted back to Ridge Avenue Building and Loan Company, which operated it until 1924. Milton and Edith Fleming bought it and continued to run it as a boardinghouse. During World War II, it housed men looking for work in local war plants. It is now an apartment house.

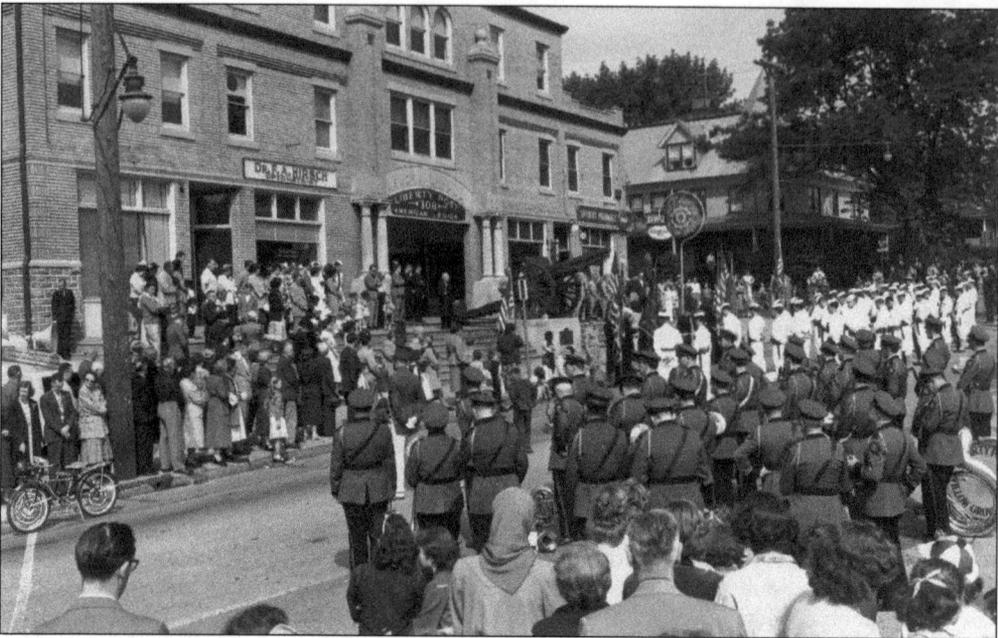

Willow Grove Community Memorial Hall was at the southwest corner of Park Avenue and Easton Road on land that had been purchased from Willow Grove Park for $6,000. Plans for the building were discussed in 1922, and construction started. The part of the building shown here was completed and dedicated in 1925. Its permanent tenants were American Legion Post No. 308 and the Woman's Auxiliary. In 1939, it housed the Upper Moreland Township government offices. The building was demolished after it was badly damaged by a fire c. 1972. The photograph dates from Memorial Day of 1951.

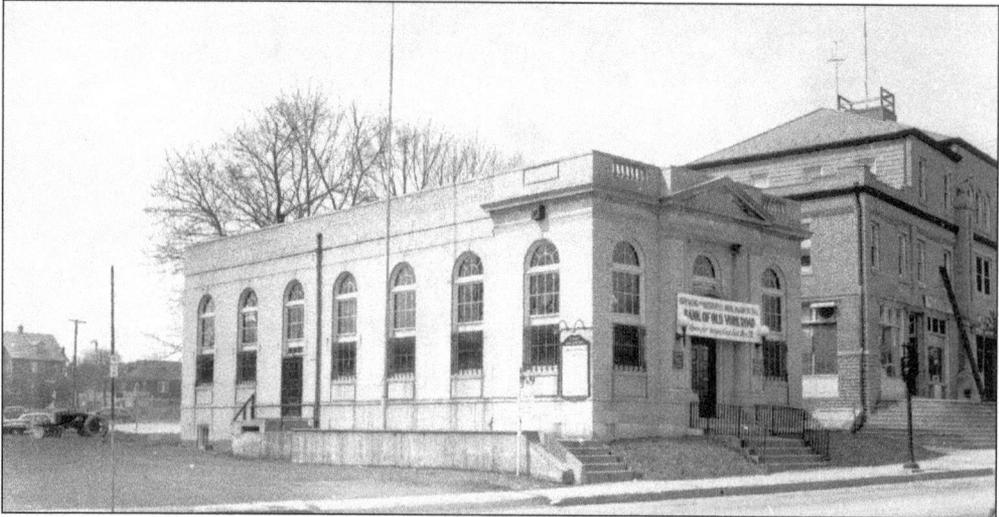

The Willow Grove Trust Company was established in 1920 in this building south of Park Avenue on the west side of Easton Road. The bank went bankrupt in the 1930s. The building was renamed the Hart Building during the 1940s and housed township offices and a real estate and insurance company. The banner on the building proclaims the reopening of the building as the Bank of Old York Road in 1952. A PNC Bank branch is now at the site. The Parkside Boarding House is in the left background.

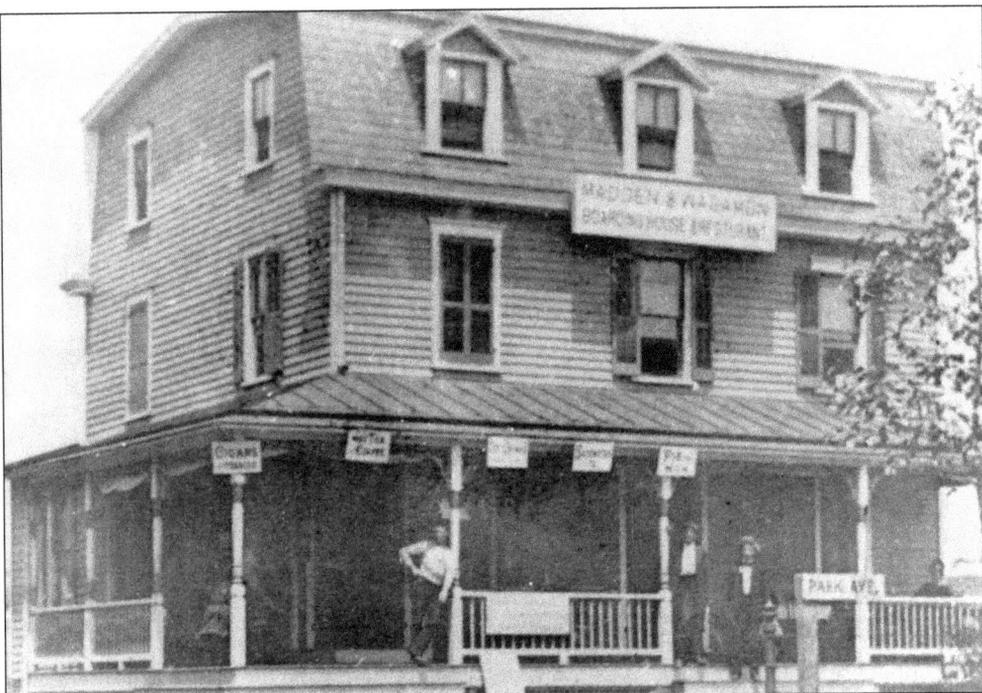

The Madden & Wagamon Boarding House and Restaurant was on the northwest corner of Park Avenue and Moreland Road. One of many boardinghouses in the area, it was built about 1895 and frequented by both transportation workers and guests visiting Willow Grove Park. A storefront was added in the 1920s that operated as Smitty's Lunch for several years into the 1930s. The building was demolished in the early- to mid-1960s.

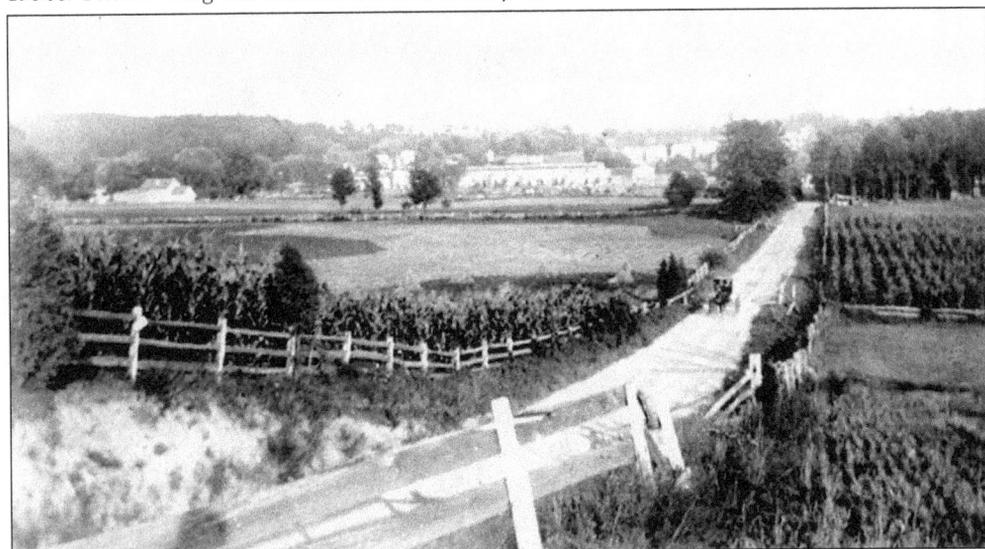

New Welsh (now Moreland) Road was just a country road in August 1896. Looking east, Abington Township is on the right and Upper Moreland on the left. The George R. Berrell Farm is in the left foreground, and the large building in the distance is the trolley car barn at the entrance of Willow Grove Park, which occupied more than half of the block on Davisville Road between Easton and Moreland Roads in Willow Grove.

Silver Lake Dairy Farm was located on the west side of York Road south of where Fitzwatertown Road intersects and becomes Terwood Road. The farm operated from the early- to mid-1950s. The farmhouse is at the left and faced York Road. The lake on the property is still there, and a few of the many old willow trees remain. The Willow Lake Assisted Living facility is now on the site.

The Silver Lake Apartments were located near the northwest corner of York and Fitzwatertown Roads, and were in the former farmhouse of Silver Lake Farm. Many older homes became boardinghouses or apartments as land was increasingly devoted to residential and commercial development. The Silver Lake Bowling Alley, now Thunderbird Lanes, is on the site. This photograph dates from c. the 1950s.

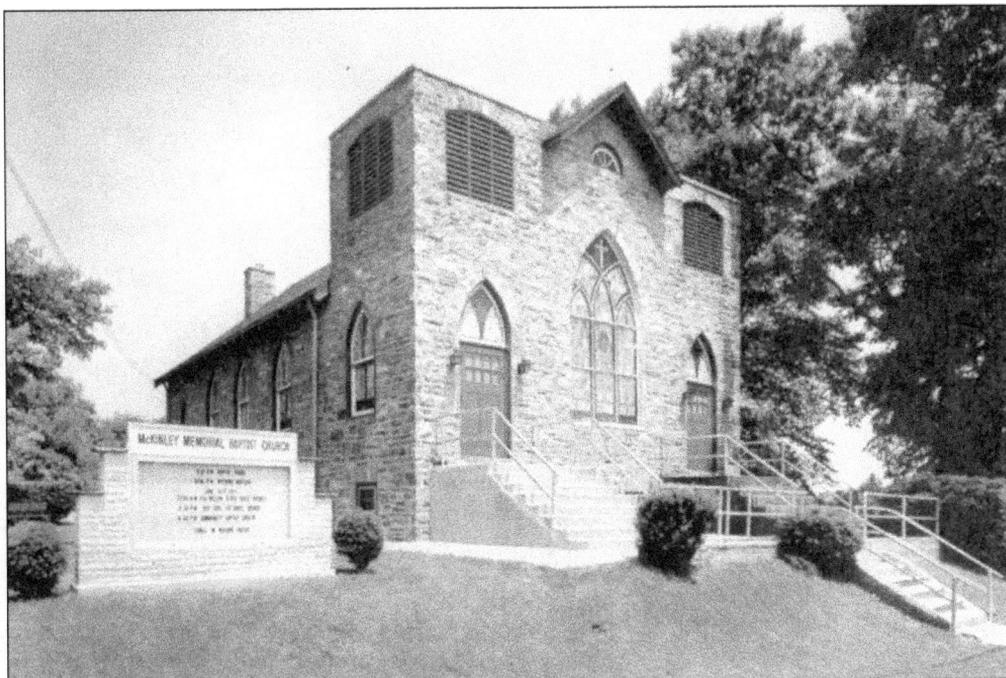

In 1901, members of Salem Baptist Church in Jenkintown formed a Prayer Band in Hatboro and the following year officially organized as the McKinley Memorial Baptist Church. The church, named in honor of President William McKinley, moved to the Kentner Building on Moreland Road in Willow Grove in 1904. It later moved to an old building on Welsh Road and then, in 1908, to its present location at 214 Cedar Avenue. The first minister, Rev. F.P. Diggs, served from 1902 to 1906. In 1993, the John R. Winters Wing was added to the church.

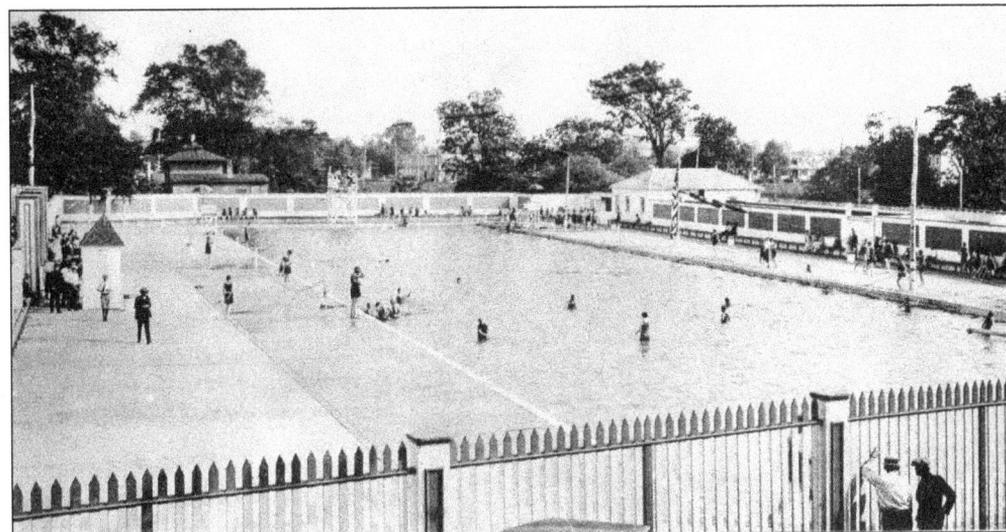

The Willow Grove Pool was owned by the Philadelphia Natatorium Corporation and was at this site on the south side of York Road in 1926. Under the direction of J.M. Christian, the company owned three other pools in Philadelphia, Camden, and Wilmington. The property later became the site of Upper Moreland School tennis courts in the 1950s. Home Depot is now at the location.

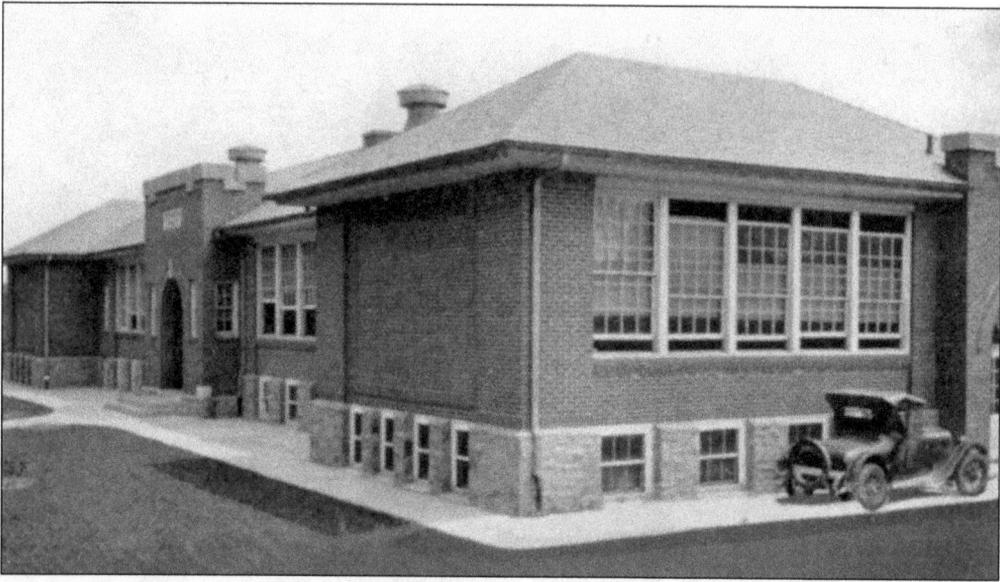

The Upper Moreland School was on York Road one block north of the York and Easton Road split, on the south side. Ground was broken for the school on July 19, 1920, and it opened in 1921 as Willow Grove Junior High School for grades seven through nine. Older students went to Abington schools. It had only four classrooms, but the original plans made provision for future expansion.

In 1926, the township expanded the school to include the higher grades, and the first class was graduated in 1929. In 1930, with the help of the Public Works Administration program, a classroom wing, auditorium-gymnasium, athletic field, and concrete stadium were added. By 1940, it was the only school in Willow Grove, as the Davisville School had been outgrown. In 1959, a new senior high school opened to accommodate grades nine through twelve. Grades six through eight remained in the older school, after new schools were built to accommodate the elementary grades. After the school closed, the Hankin family bought the site and sold it to Home Depot in 1993.

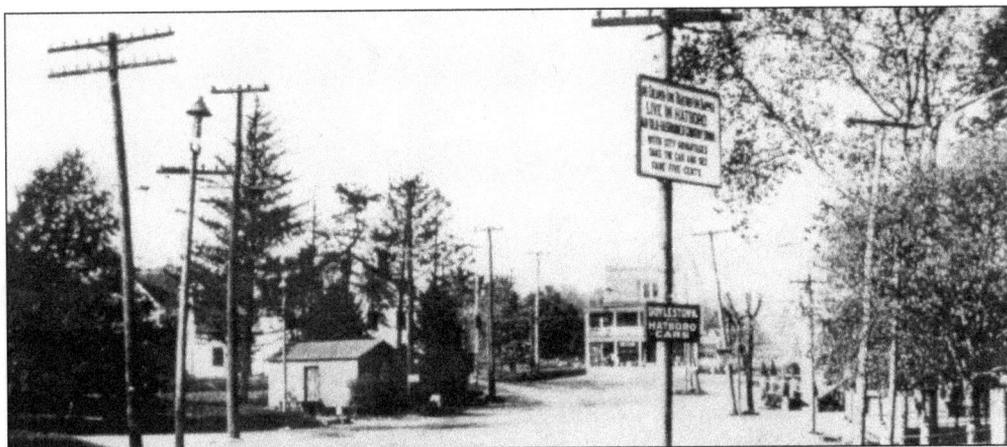

David Nolan's first store was at the northern triangle intersection of Easton and York Roads adjacent to the old Red Lion Inn. On November 18, 1906, both buildings were destroyed by fire. This 1913 photograph shows the second store on the site, completed by June 1, 1907. This store was moved north on York Road to its present site c. 1926 and turned to face the road. In 1934 the store became the Willow Inn. After Nolan died (1944), his heirs sold the inn to Leonard Deane in 1946, and the triangle location in 1951 to Esso Standard Oil Company. Deane changed the inn's name to Hickory House Hotel and Cabaret. In 1949 he sold to Joseph and Anna Morrone, and the name was changed back to Willow Inn. In 1953 the building was sold to the DeMarzio family. It continued as a bar and restaurant, and the DeMarzios' son Jerry now operates the inn. The Manhattan Bagel store is on the triangle site.

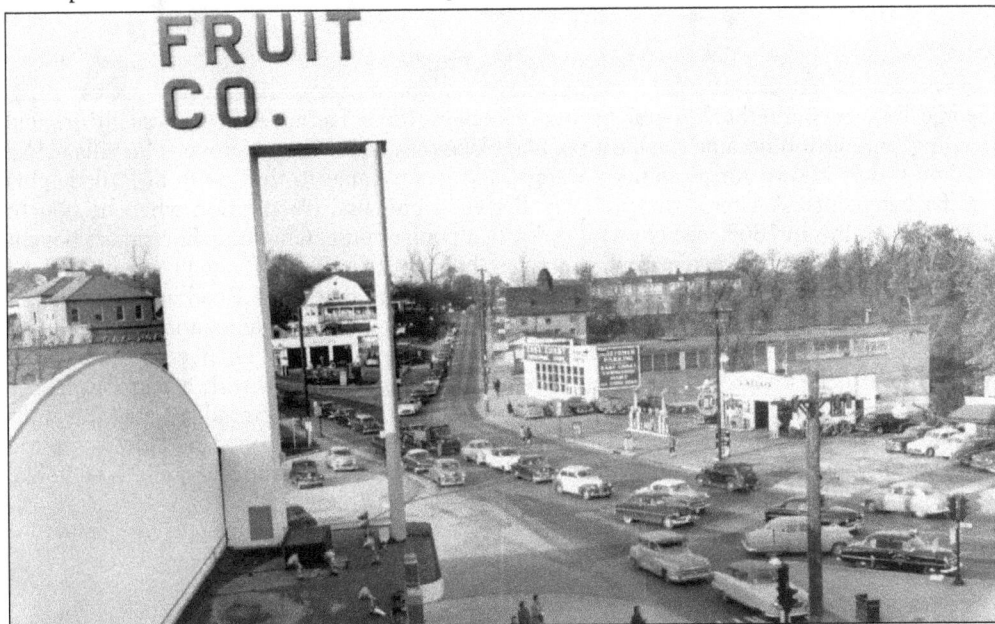

In February 1959, the Penn Fruit Company market was on the west side of Easton Road where it curves to the southwest away from York Road. The Bank of Old York Road and the War Memorial Building can be seen at the left. Across the road at the triangle is Lefty Stickler and Charles Loughery's Esso station, and beyond it the Willow Inn. Coming back south on York Road is the school building, the barn of the demolished Mineral Springs Hotel, the East Coast Furniture Mart on the site of the Mineral Springs Hotel, and Jack Caulfield's Sinclair station.

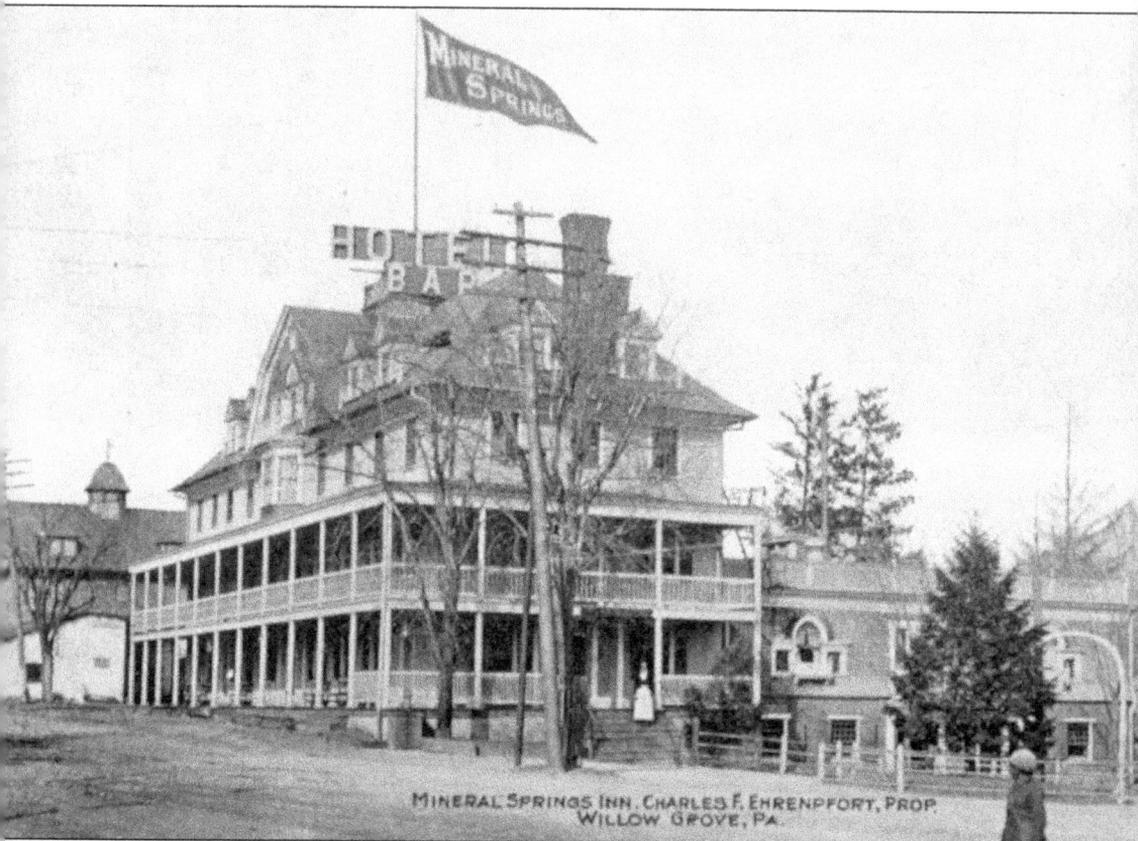

MINERAL SPRINGS INN, CHARLES F. EHRENPFORT, PROP.
WILLOW GROVE, PA.

George Rex Sr. built the Mineral Springs Hotel in 1803. He added to the small original building, and his inn became the most popular place to stay in Willow Grove. The village had become widely known for its mineral waters, and guests came to the spa from Philadelphia and farther points. A later owner, John E. Berrell, eliminated competition when he bought the Red Lion Inn in 1868, and closed it down as a public house. Charles F. Ehrenpfort bought the property in 1890, and it remained in the family until 1936. He renovated the building and enlarged and improved the grounds, which extended along both York Road and the railroad and encompassed 30 acres. The coming of the trolley brought further renovations by architect Horace Trumbauer in 1895. The changes included interior work, a change in the exterior roofline, and large additions, including an ell built of colonial brick with a barroom in the basement and a dining room and kitchen above. Electric lights were added and the walls painted yellow with white-and-green trim. Newspaper accounts tell of being able to see the hotel for miles around because of the many lights that made the building and grounds seem like a wonderland. Ehrenpfort also built his own power plant in 1898.

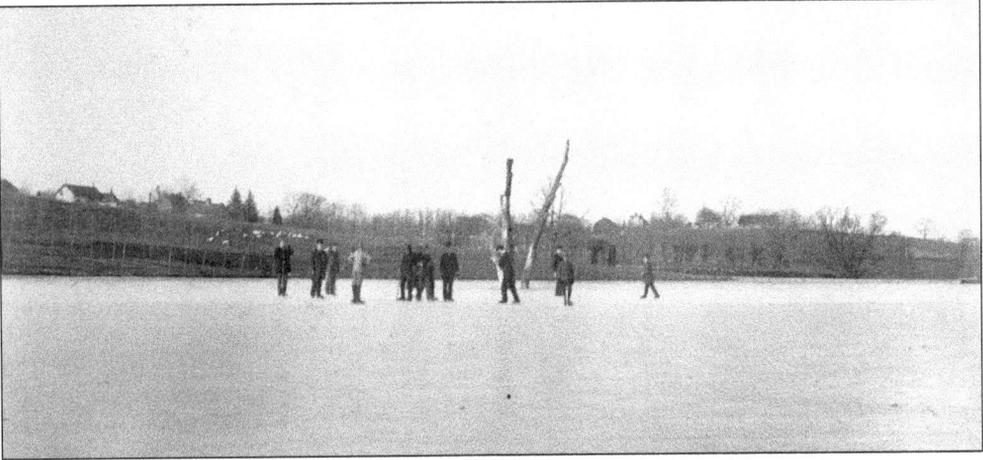

Another improvement Ehrenpfort made to the grounds was the large lake that became the site of both summer and winter recreation. The skaters here seem to be hockey players taking a brief respite from their strenuous play. The lake gradually silted up and filled in.

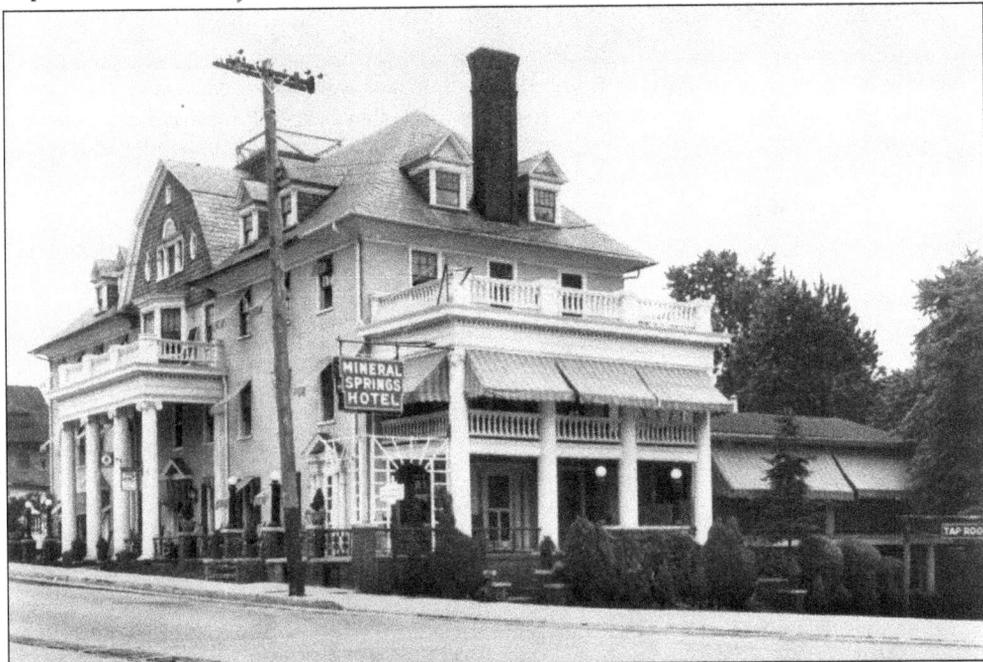

Henry Specht Jr., a local builder, did a major renovation of the Mineral Springs Hotel in 1913, completely gutting the interior, creating a new lobby, removing the porches, building the side veranda, adding a grand new façade, and putting in all modern utilities. The hotel continued to operate until it was sold in 1926. Nine acres of the grounds were sold to the World War II Association for a memorial park, which later became part of the township park system. There were several owners of the inn site, until Frederick E. Ehrenpfort bought back the property in 1935, and in 1936 sold it to the West Chelten Corporation. The building, by now decrepit, was razed in the winter of 1937–1938. American Stores (later Acme), and a gas station, among others, were on the site. The property was split in 1946, and in 1952–1953, Moe Hankin bought both pieces. Hankin sold them as one in 1982 to U. S. Realty Inc., which in turn sold the now vacant site to Bally Fitness in 1983. The Bally Total Fitness Spa opened in February 1985.

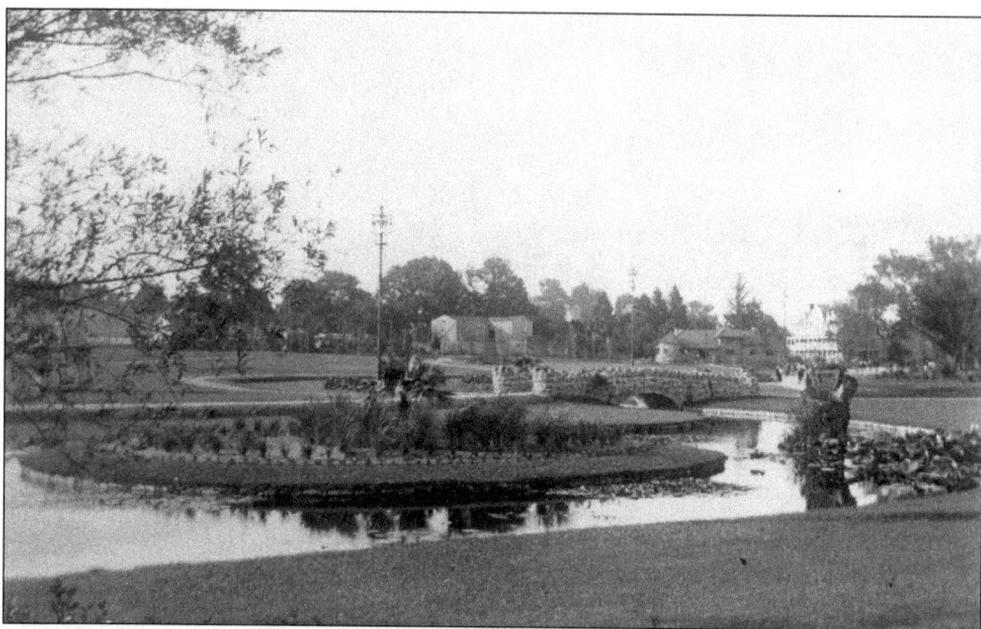

This August 1896 photograph looking northwest from just west of the Moreland and Easton Road intersection shows the extensive and beautifully landscaped gardens that comprised the northern entrance area of Willow Grove Park. The lily pond with its stone bridge is in the foreground, and the Superintendent's Office is beyond. In the far right background is the Mineral Springs Hotel.

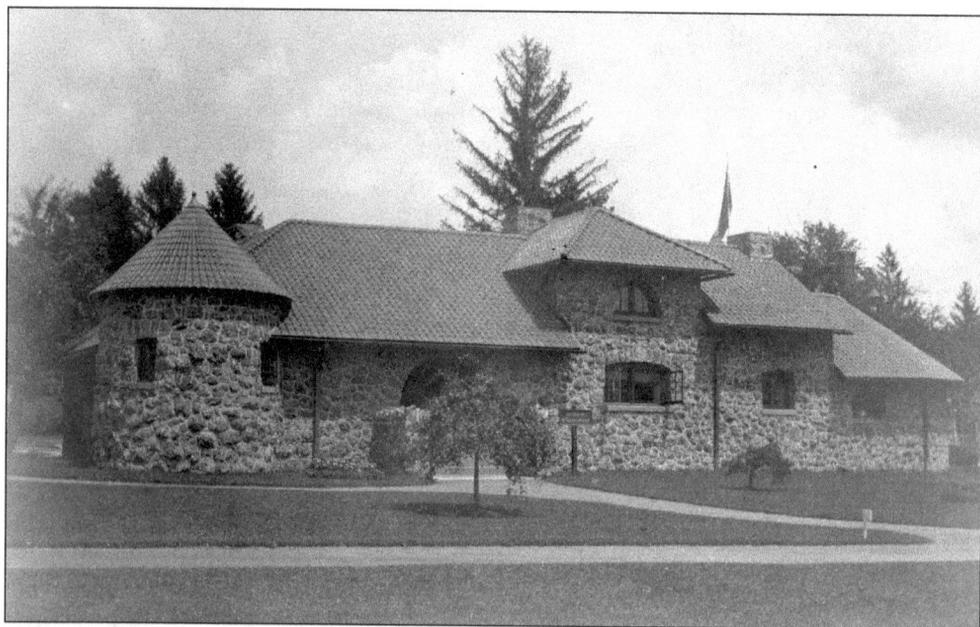

Horace Trumbauer designed the Superintendent's Office at Willow Grove Park, and it stood at the northern point of the park near Park Avenue. It had a wide tower, Romanesque arch, and limestone slabs for window sills. The walls were of red sandstone and supported a tile roof. In the 1930s and 1940s, the building was used as a jail and church before being razed in the 1950s to make way for a row of stores.

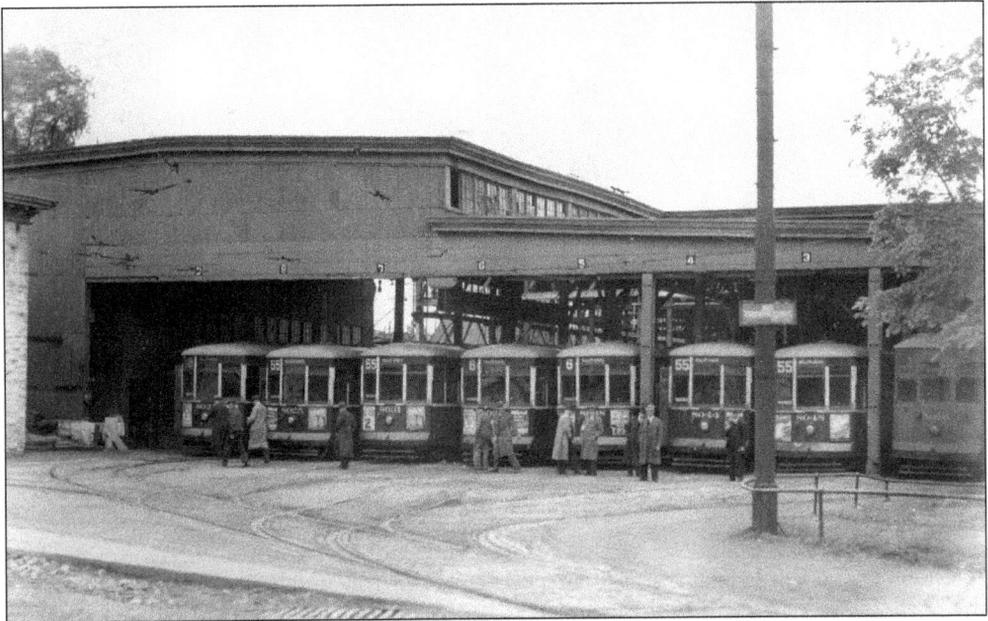

The huge trolley barn faced Easton Road and extended south on Davisville Road for half a block. Both the Old York Road (Route 55) and Easton Road (Route 6) cars are shown here. The tracks coming out of the barn circled around to the northern curve of the park and then looped around its circumference. This was the original trolley route into the park. The trolley barn had disappeared by 1936, and an Atlantic station was on the site. An A & P grocery store was at the location in the early 1970s.

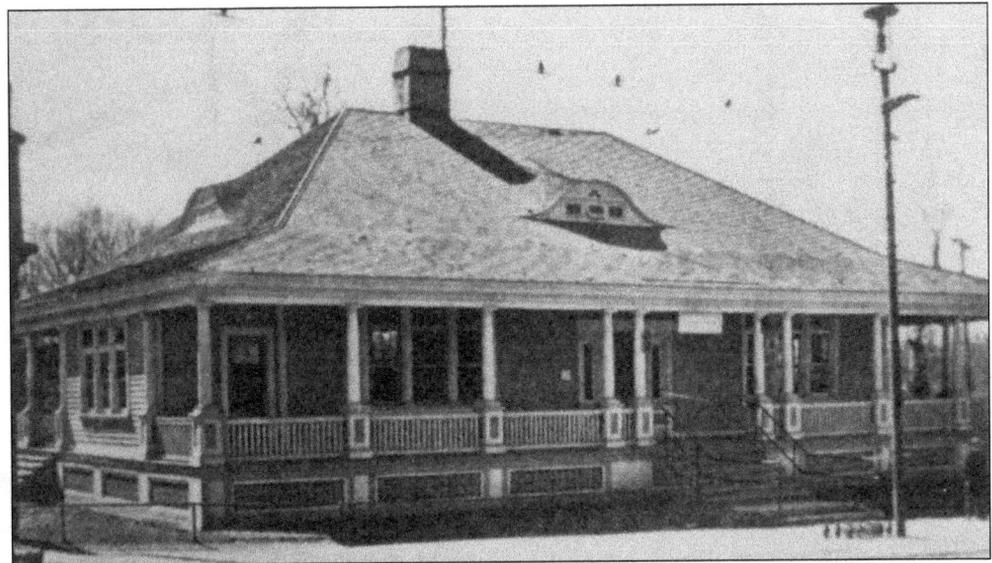

The waiting room and station for the Philadelphia Rapid Transit was located at York and Easton Roads next to the car barn in Willow Grove, at the site of the present Burger King. The large pleasant-looking building with the long lazy-looking porch and important center chimney was a very noisy place, with the clanging and screeching of the many trolleys. The waiting room was built when the park opened but was demolished by 1946. Eventually, a Gulf station was built on the site.

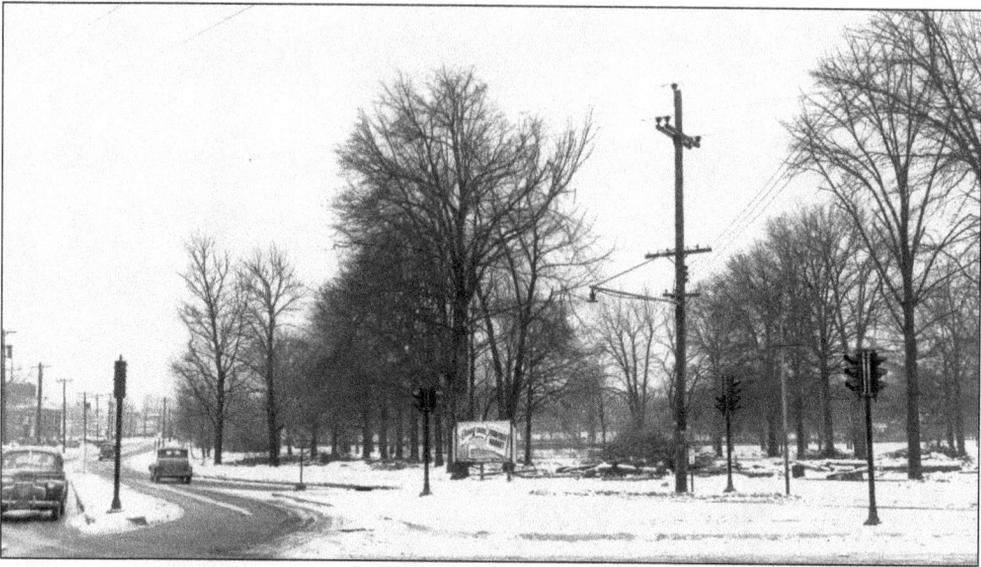

A sign on the vacant land at the northwest corner of Old York and Easton Roads is advertising the coming of a new Penn Fruit supermarket in this photograph, taken in January 1948. In that month the Hankin family purchased the northern part of Willow Grove Park, which was encompassed by Easton and Moreland Roads and Park Avenue. They planned a combination of the food market and other large and small stores along both Easton and Moreland Roads. Penn Fruit opened in January 1949.

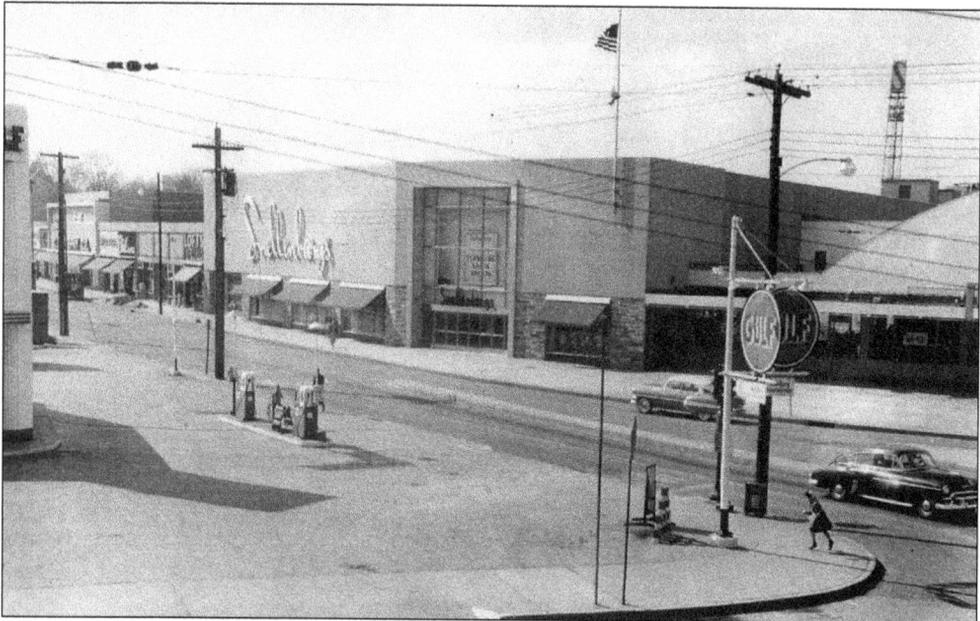

Snellenburg's Department Store opened in October 1953. The building abutted the Penn Fruit store at the right and extended west on Easton Road, along with a series of smaller shops. Snellenburg's closed its Philadelphia store in 1962, and the branches were sold to Lit Brothers. When the Lit's store closed, the building and the supermarket were demolished, and smaller stores were built. In the 1980s, the whole block was again rebuilt and is now the Willow Grove Shopping Center. The photograph dates from c. 1955.

In the late 1950s, the Hankin brothers razed the old park superintendent's building and remade the northern end of the park. A series of small business stores appeared on Easton Road, and the area behind them extending to Park Avenue became a huge parking lot. In this early 1970s photograph, the Bank of Old York Road is just beyond the driveway that runs into the parking area, with Memorial Hall farther north on Easton Road. These stores were replaced in the 1980s by new construction, with the entrances facing the parking area of the Willow Grove Shopping Center.

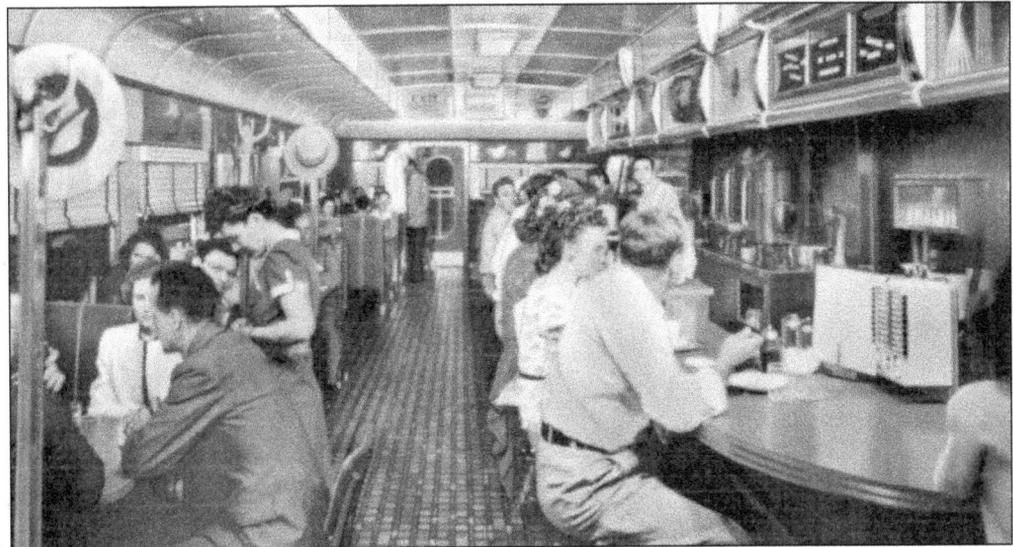

The Willow Grove Diner and Dining Room faced Easton Road behind the site of the former trolley waiting room at Old York and Easton Roads from 1953 to 1958. A newspaper advertisement of the time stated that their coffee was still 5¢ a cup, a slice of pie was 15¢, a roast turkey dinner was $1.35, and a combination seafood platter, consisting of flounder, crab cake, shrimp, a fried oyster, French-fried potatoes and coleslaw was $1.00. In 1958, the diner was moved to New Jersey. A Gulf station had replaced the old waiting room at the corner in 1947, and a Burger King is now on the site.

43

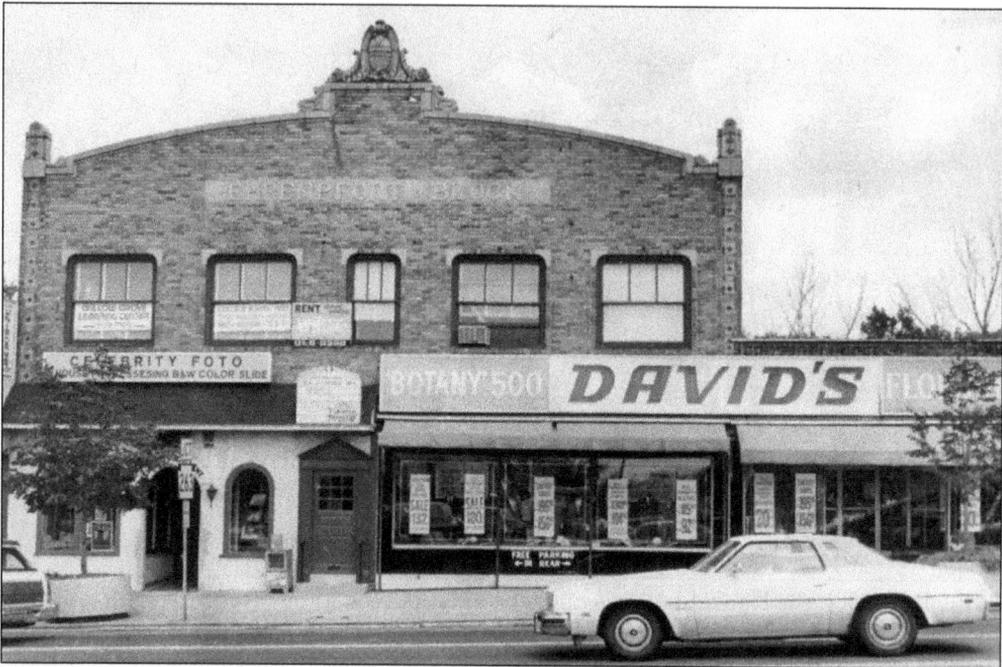

The Ehrenpfort Block was a series of connected stores on the east side of York Road, extending from Easton Road south to the railroad station. The block was built in the early 1920s and was all one story except for the main building. David's was a well-known men's store that occupied almost all of the separate storefronts in the Block from the late 1950s until the early 1990s.

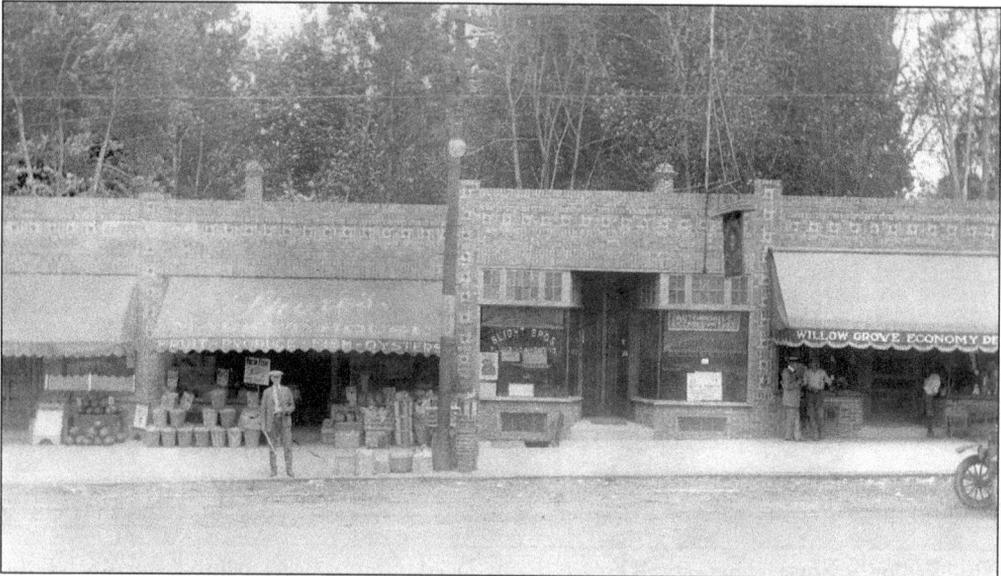

This 1922 photograph shows the original design of the Ehrenpfort Block. The building was of a unified design with an Art-Deco motif, even though the individual stores were of widely divergent character. Shore's Market House remained a popular produce and fish market into the 1940s. Slight Brothers Plumbing was at this location plus another one in Jenkintown in 1926 but by 1931 had left Willow Grove. Most of these stores were taken over by David's clothing store.

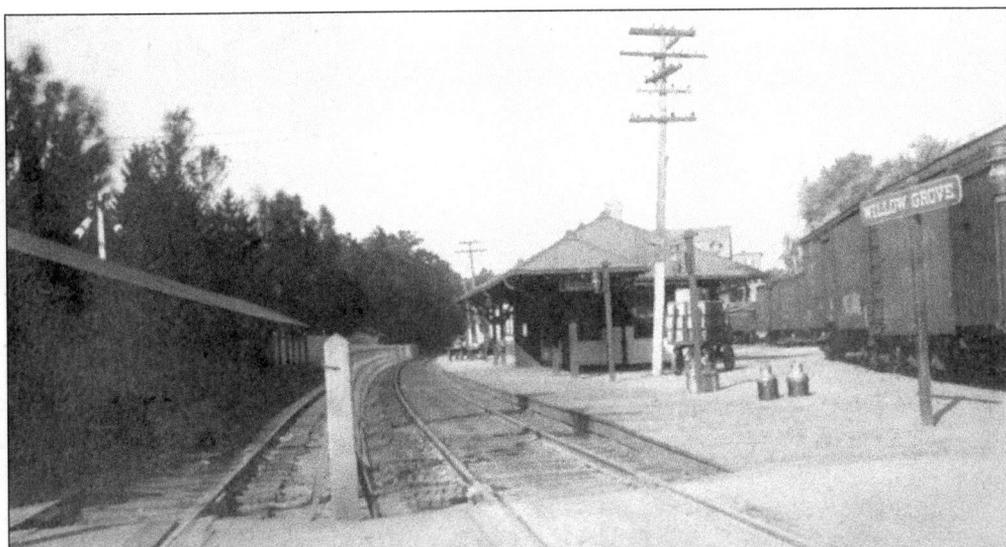

The newly built North Pennsylvania Railroad came through Willow Grove on New Year's Day of 1872, but the first station was not built until 1904. It was a wood frame building with a small parking lot. The rail cars at the right are on a spur that ran north next to Davisville Road to the Creamery and originally was used for the milk cars. The suburbs were expanding rapidly, and the growth of commuter traffic intensified the need for a larger station with more parking. The line from Glenside to Hatboro was completely electrified in 1931, and the present stone station was built in 1935 on the same site.

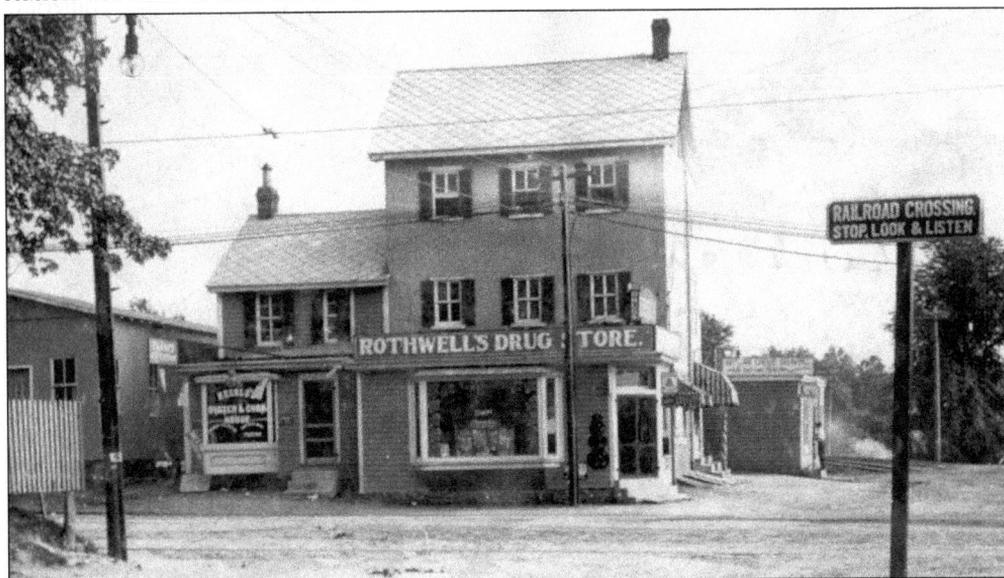

Eugene Rothwell established a drugstore in Willow Grove on the southwest corner of Davisville and Old York Roads in 1910. The storefront had been built on to an older building reputedly used to manufacture shot during the Revolutionary War. The drugstore remained until 1926 when Rothwell relocated across the street. The storefront also housed Keeble's Oyster & Chop House in 1916 and Null's Restaurant in the 1920s. It later housed Slom's Department Store and an air force recruiting office in the early 1960s. The building was demolished sometime after 1976.

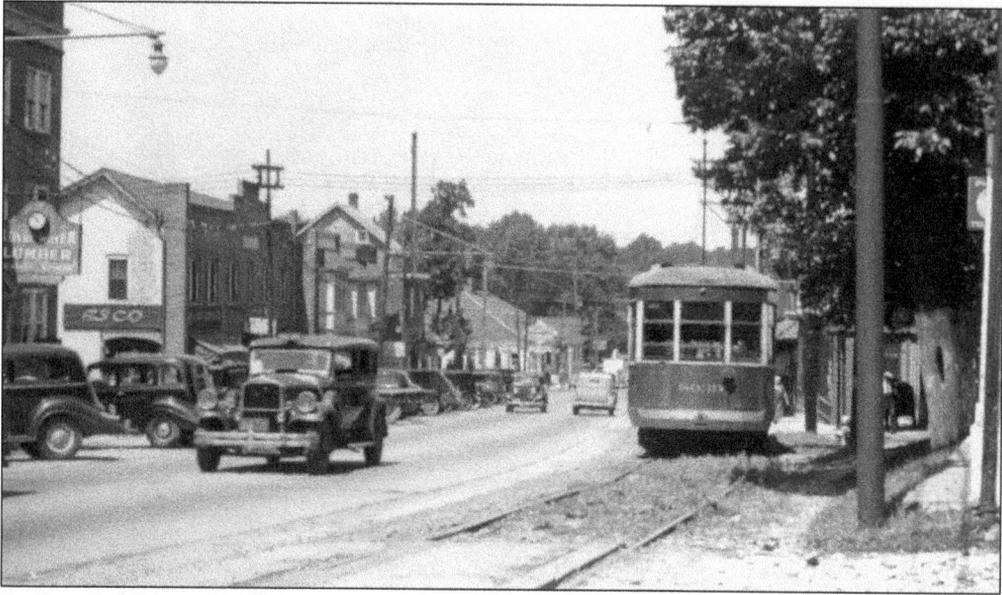

Looking north, in 1936 on York Road, from the left is the Moyer Company Building, an alley leading to the lumberyard, the Murphy Building with the American Store Company grocery store, four small storefronts, and the old "shot tower" building at the corner of Davisville Road. On the far side of the train crossing is an Atlantic Service Station, the PRT waiting room, and the grove of trees at the north end of the Willow Grove Park. The Moyer Building was built in the early- to mid-1920s and the Murphy Building in 1926. Both were demolished sometime after 1987.

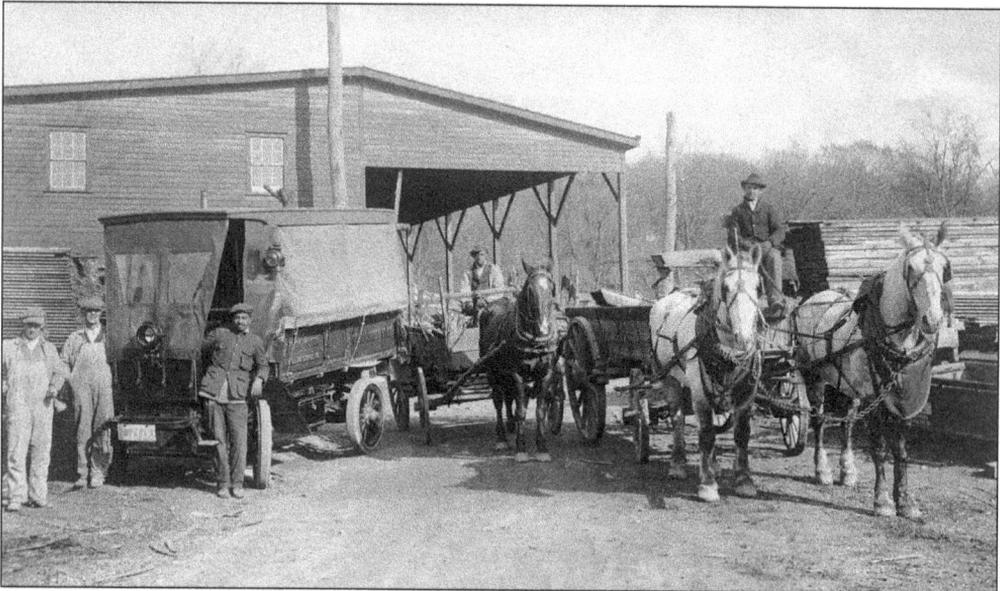

Moyer's Lumber & Coal Yard extended from York Road over to Davisville Road, on the land behind the stores fronting on York Road. There was a railroad spur into the yard from the main tracks. The land was owned earlier by George W. Quigley, who established a coal yard on the property c. 1900. C. Dyer Moyer took it over, expanded the business, and later erected a large building on York Road in the mid-1920s. The photograph dates from c. 1915.

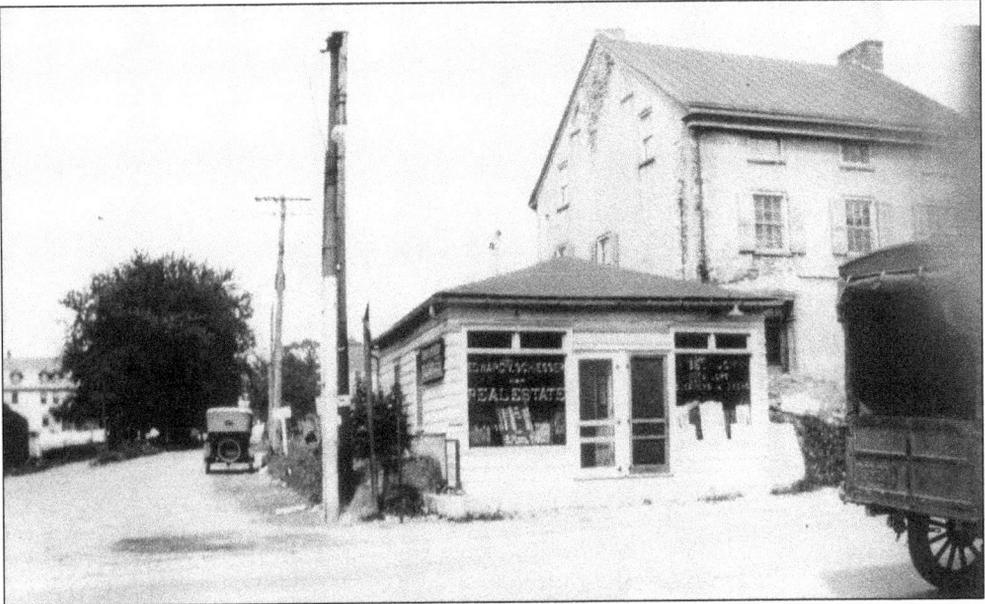

In 1924, Edward V. Schiesser's Real Estate office and a small dry cleaning shop were located in a small one-story frame building at the southeast corner of Davisville and Old York Roads. Immediately south of this building was a Colonial house predating 1788. The Rittenhouse family owned the whole property and the house from 1840 to 1920.

Walter and Eugene Rothwell owned the Rittenhouse site c. 1924, and the house and corner office buildings were moved. The porch of the three-story, stone building was removed, the house was raised onto skids, which were "greased" with Octagon soap, and a small tractor pulled the house east and placed it over a new foundation already dug facing Davisville Road. The smaller frame building was also moved and placed in back of the house. It was the home of Eugene Rothwell until his death in 1931, but his family retained ownership. In August 1984, Three Star Associates purchased the house, razed it, and put in a parking lot.

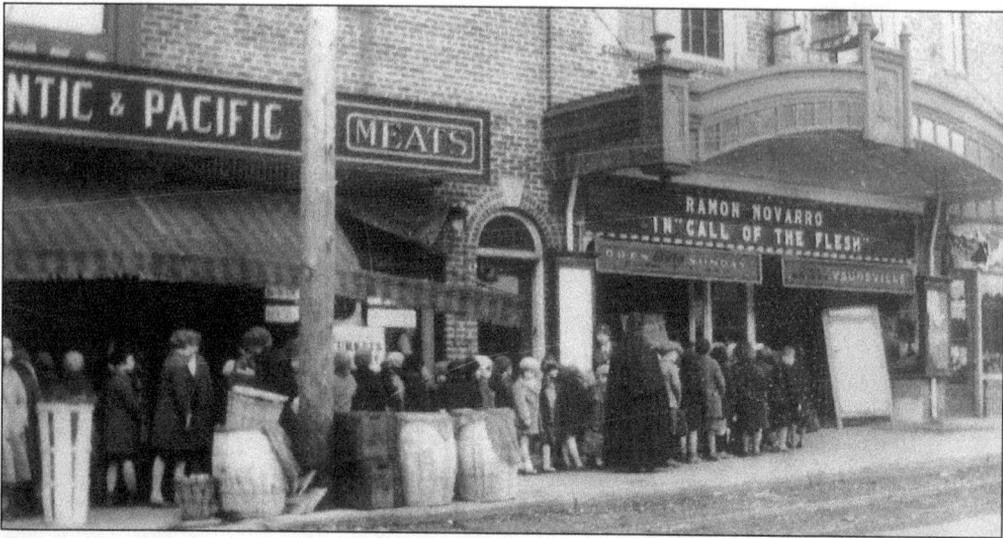

The Rothwell brothers built a new brick two-story building along York Road that housed a pharmacy at the corner, an A & P store, the Grove Theater, and other businesses. The architect was Horace William Castor, and construction was completed in 1926. The Rothwells owned the building until 1972. The theater showed local presentations, vaudeville, and movies. Its layout was similar to the Keswick Theater in Glenside, and it had an organ. The theater closed in September 1961. Florist Charles Kremp's first store was in the corner section of the building until the mid-1970s, while the former theater remained boarded up. By 1982, the theater was demolished, and shortly afterwards the Mandarin Chinese Restaurant opened on the Davisville Road side of the building, with the parking entrance through the old theater front.

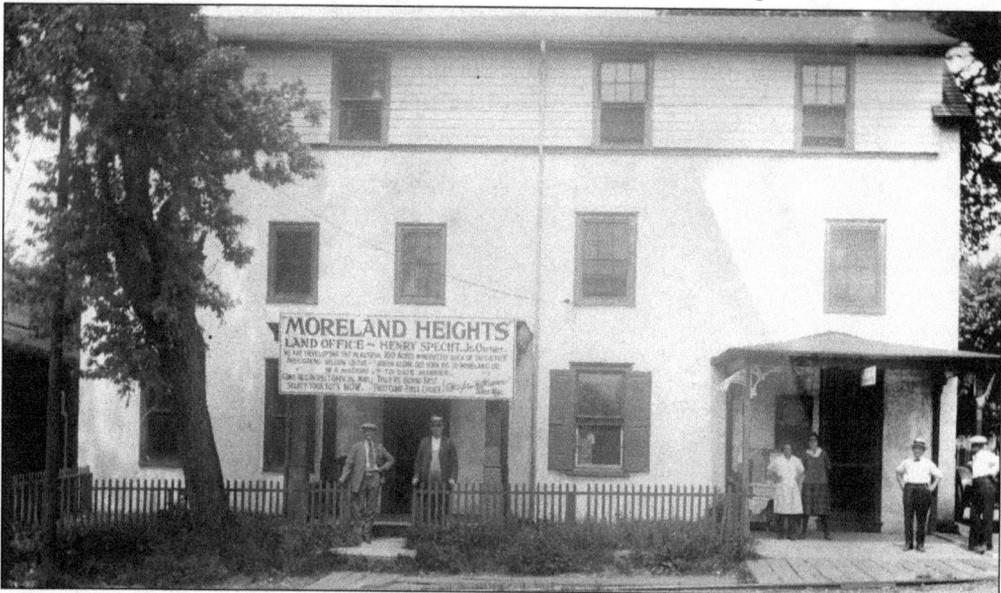

Henry J. Specht Jr. was a well-known local builder and one of the men who contributed to the explosive growth of Willow Grove in the early 1920s. The building was constructed c. 1811 and is still standing at 71–73 York Road. The post office was in this building from 1921 to 1951, and then moved to 31 Easton Road. In 1962, the post office moved to the modern new building at its current location at 611 North Easton Road.

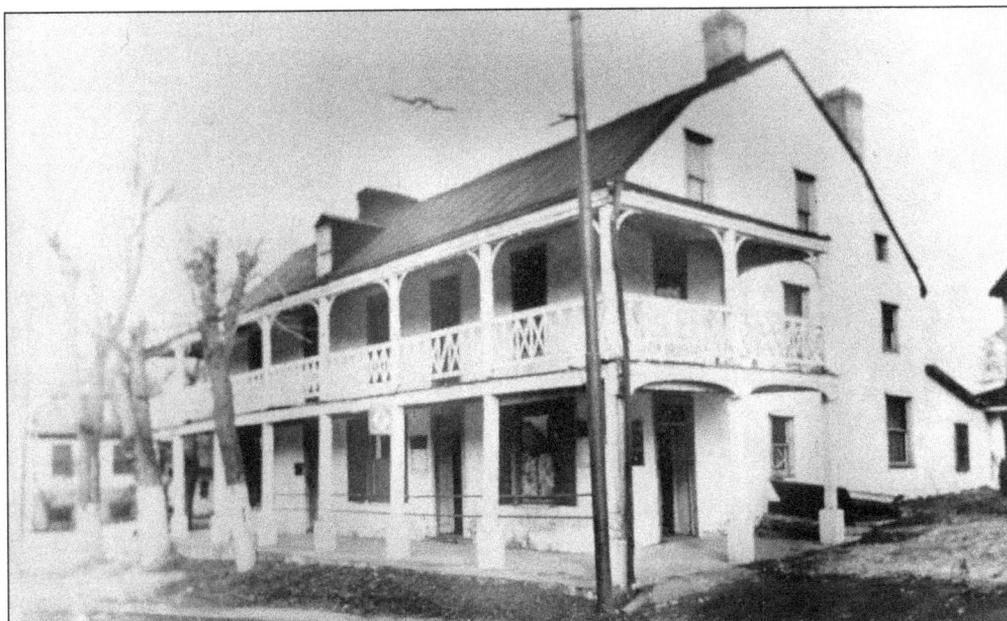

The Fountain House Inn, located on the east side of Old York Road just north of Cherry Street, was built before 1717 at a good location, "one day's ride" from Philadelphia. Constructed of stone and large for the time, it originally had 8 rooms, which later increased to 18, each with a fireplace and solid oak floors. From 1848 to 1851, it was called the Willow Grove Hotel or the J. Lukens Hotel. A man named Hobensack operated the establishment from 1877 to 1884. At one time, the barroom contained a barber's chair, with Fred Shedeker as the first barber. In 1898, the license was transferred from John T. Wood to John McEvoy. When McEvoy died his children made the building their home. It was demolished in 1961.

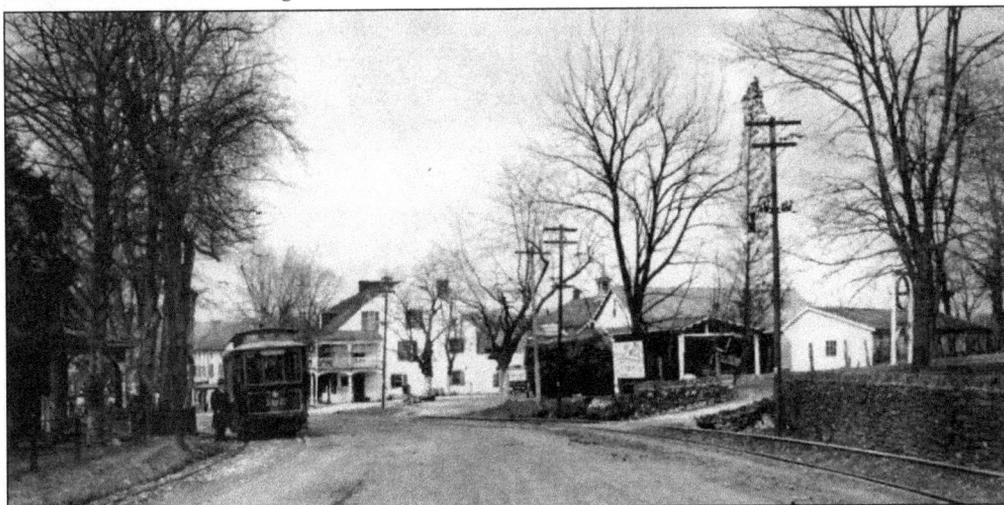

Trolley car No. 182 is in front of Dr. Franklin Watson's home between Cherry and Church Streets in 1911. At the right is the iron wheel that served as the fire alarm in front of the Knights of Columbus building (out of sight to the right), which also served as quarters for the fire equipment and as a bowling alley. The sheds belonged to the Fountain House Inn, which is the white building with the double porch. Beyond is the building housing the post office and the Henry Specht office.

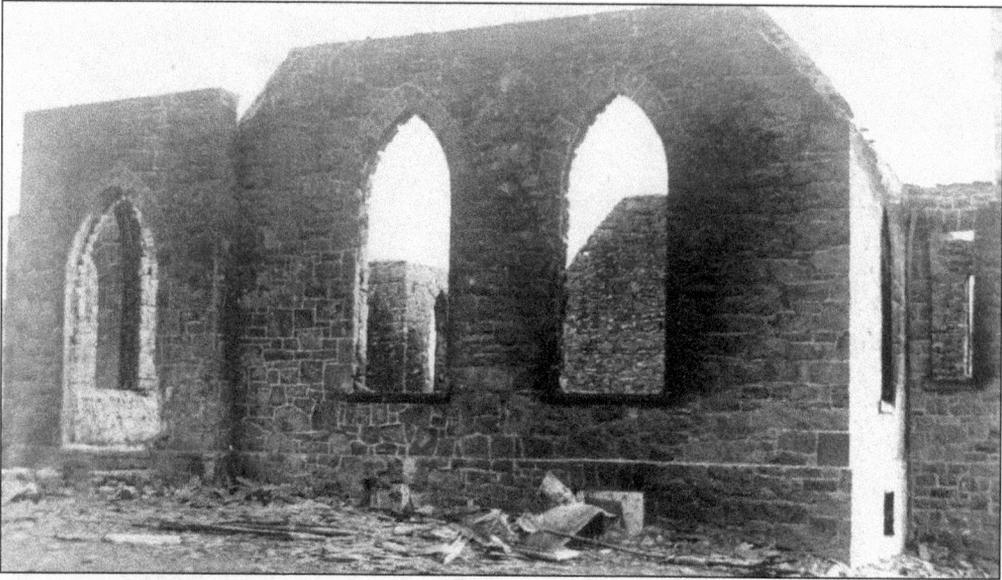

The Methodist Episcopal Church was the first church in Upper Moreland Township. A Sabbath school was started in 1888, though weekly prayer meetings had been held some years before. David Cherry and George W. Quigley led in organizing a formal congregation, and the first service was held on May 20, 1888, in the old Creamery Hall on Davisville Road. Two lots on the northwest corner of York Road and Church Street were purchased from David Cherry on May 27, 1890, and ground was broken on September 9, 1891, for a permanent home. The new building was dedicated on March 6, 1892. An 1894 arson fire badly damaged the church. Three more fires occurred in 1895, and finally a July 27, 1896 arson fire completely destroyed the building, leaving only the stone walls standing.

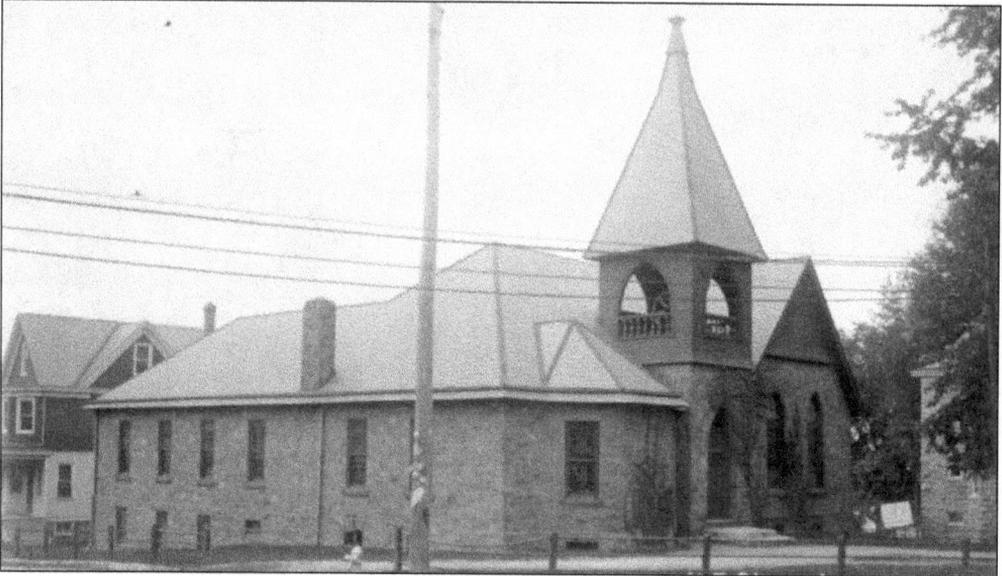

The congregation immediately made plans for a new larger building, which was erected in 1897 on the same foundations as the old. It remained the church's home until the cornerstone was laid for the present building on the same site on October 12, 1958, and the old one was demolished.

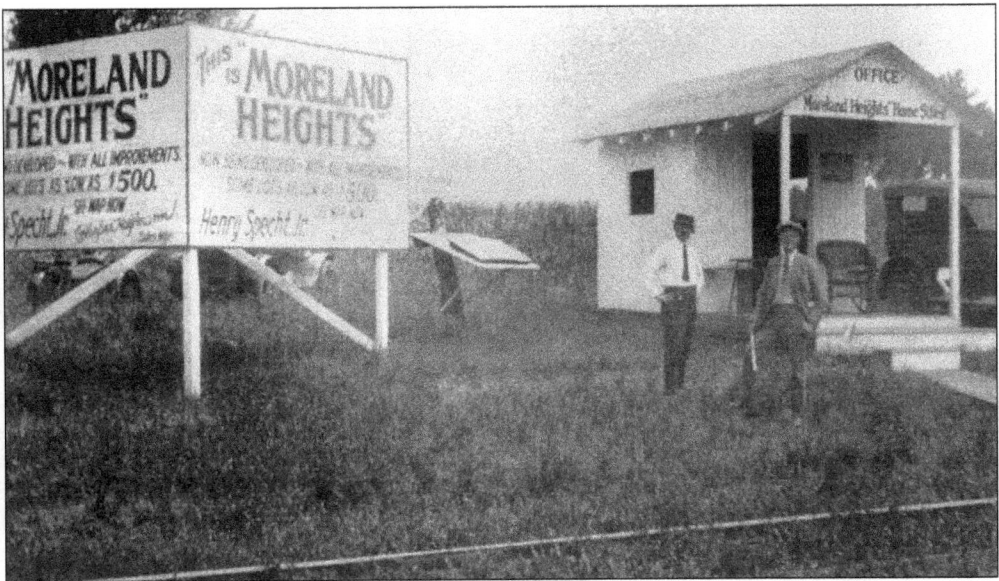

Henry Specht's Moreland Heights development dated from 1923 and included the present Abbeyview, Everett, Forrest, Fern, and Overlook Avenues south of Davisville Road. The development continued south on Division Avenue to Moreland Road and back to Old York Road, curving around behind the older buildings on York Road. The Davisville Road section was finished by 1928. By 1934, Specht opened Evans, Quigley, and Woodlawn Avenues, and Inman and Krewson Terraces. The on-site sales office was at Quigley Avenue and York Road. Russell Shallcross (left) and sales manager C.H. Halfmann are pictured.

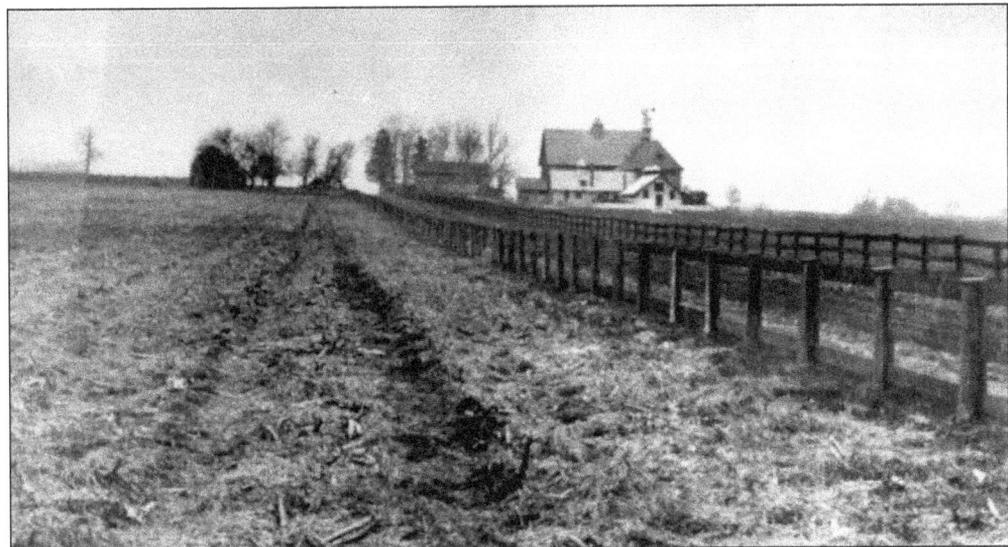

The farm has disappeared but the house still stands on the northeast corner of Division Avenue and Moreland Road, the latter road being the dirt track running between the two fences. All this land, up to York Road, was developed in the 1920s and 1930s. The section west of Division Avenue was known as Moreland Heights. The land to the east became part of the Willow Grove Highlands Plan, which included extensions of Krewson and Inman Terraces, and Woodlawn, Quigley, and Evans Avenues up to Frazier Avenue. J.B. Larzelere owned this land in 1871, but in 1901, it became part of the vast W.W. Frazier holdings.

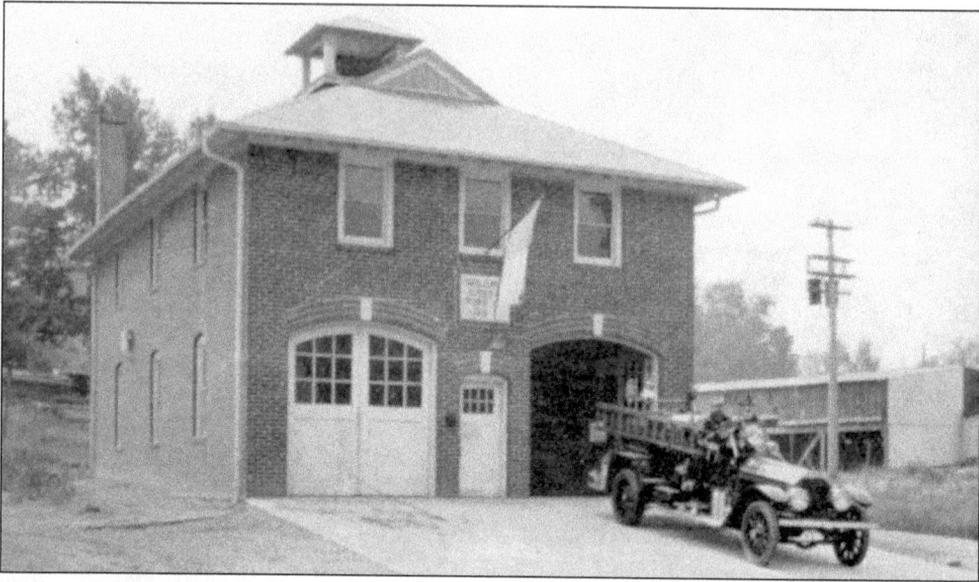

Willow Grove Fire Company was chartered March 6, 1907, the immediate impetus being the fire that destroyed the David Nolan store and the old Red Lion Inn in 1906. There were mentions of fire engines much earlier, in the mid-1800s. The first equipment was a horse-drawn cart kept at the Knights of Columbus Lodge on the east side of York Road between Cherry and Church Streets. Between 1912 and 1924, various makeshift motorized vehicles were used, all kept at the same location. In 1925, a two-story brick building at 45 Davisville Road became the first real firehouse. It was expanded in 1937 and 1949. In 1967, a new larger building was erected next to the old one at the corner of Davisville and Abbeyview Avenue and dedicated in 1968. The old building is still standing.

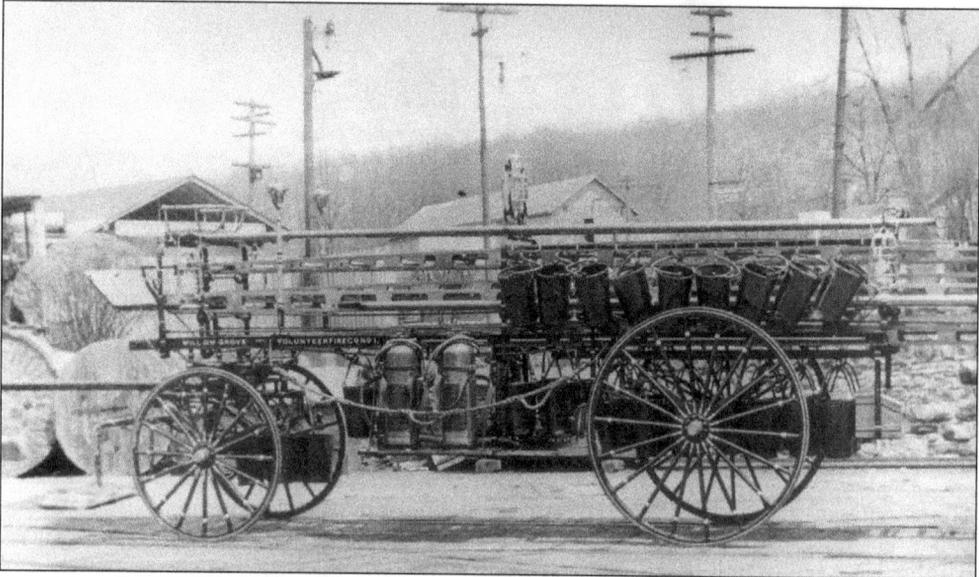

Willow Grove's first fire apparatus was quite primitive. A wagon with leather water buckets hanging in a neat row was the extent of the equipment. Between 1912 and 1924, makeshift mechanized vehicles were added; in 1924, the company purchased the first specifically constructed fire truck and called it Bertha.

52

Although a public school act was passed in 1836, it was not until 1848 that it was enforced throughout the state. Moreland rejected the 1836 act, but in 1839, George Rex, owner of the Mineral Springs Inn, donated a half-acre on the south side of Newton (Davisville) Road for a school. A two-story, stone building was erected, probably housing grades one through six only. The building is still standing at the corner of Everett Avenue.

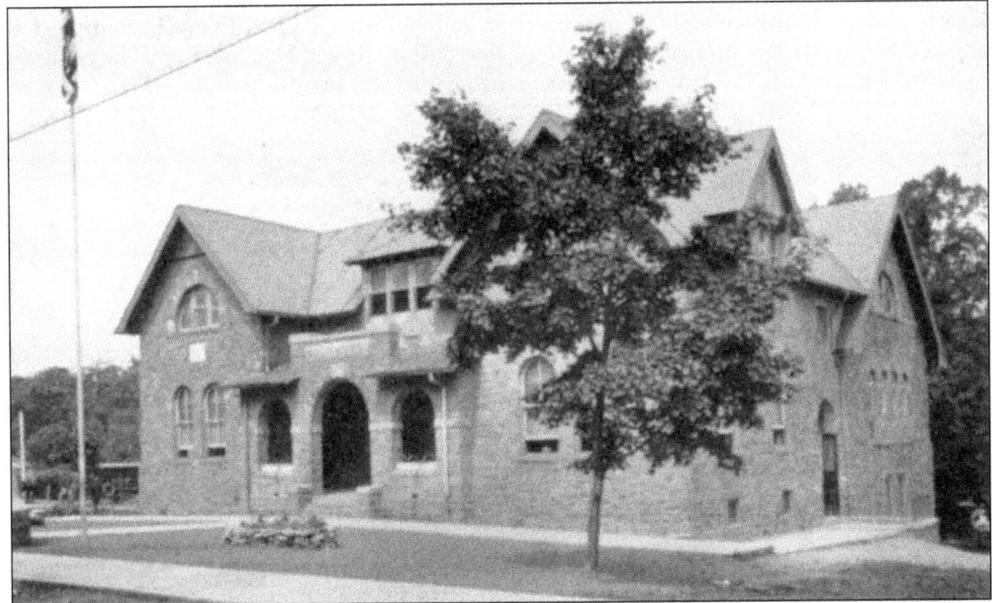

In 1895, the old school was replaced by a larger two-story, stone building across the street. Horace Trumbauer designed the new school, which was built on one half-acre donated by Charles Ehrenpfort, owner of the Mineral Springs Hotel. Grades seven through eight were added, but older students went on to Abington schools. By 1930, this building was so crowded that classes were held in the junior high school and Willow Grove fire hall. The school was closed by 1940. It was used later by the Veterans of Foreign Wars, various restaurants, caterers, and a religious group. It is still standing but changed beyond recognition.

53

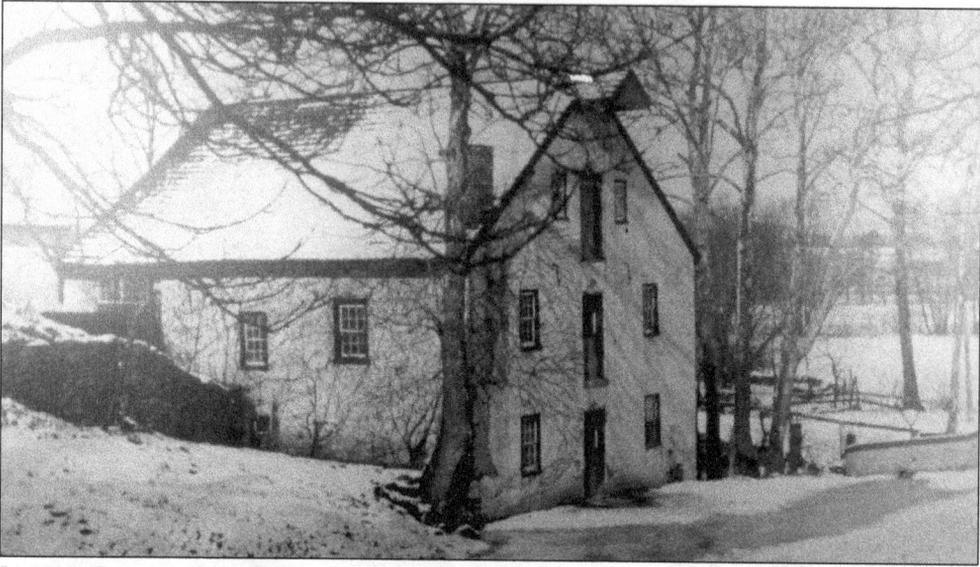

In 1727, Sampson Davis built a small mill at the corner of Davisville and Terwood Roads. The mill was enlarged c. 1731 and was owned and run by John Perry (Parry), who died sometime between 1790 and 1793. It was sold to David Cummings and then to John Jarrett Jr. in 1798. Edward Ely was the owner from 1814 to 1831. After several more owners, Samuel Hart sold the property to Benjamin Morgan in 1847, and it remained in the family for 107 years until 1954. A son became owner in 1888 when Benjamin sold to him, but the son did not continue as a miller. He was manufacturing ice by 1889 and supplying Willow Grove Park in 1898. He continued as an ice dealer past 1916. Morgan's Mill was the first mill on Round Meadow Run. The complex included the gristmill, residence, springhouse, two barns, and ten workers' houses.

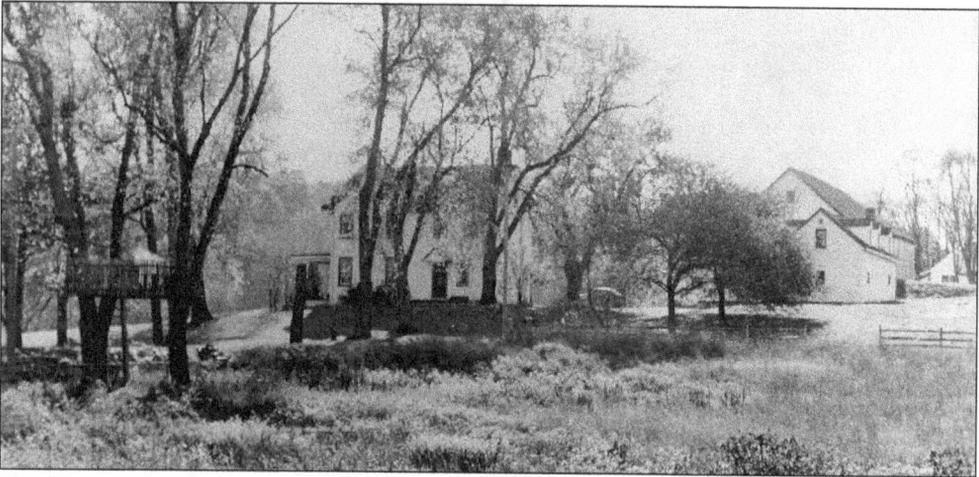

The Huntingdon Valley Hunt was organized in 1914 by several prominent families in the valley. The first clubhouse was the converted farmhouse located on 133 acres of land along Davisville and Terwood Roads that had been owned earlier by John S. Murphy, George H. Burns, and Joseph F. Page. The site was known as Spring Brook Farm. The development of the area soon forced the Hunt to find wider fields, and the club moved to Ivyland. For a few years afterward, they still maintained a presence in the area on the property of E.E. Marshall in Abington Township. The clubhouse and several of the outbuildings still stand, and the site is currently known as Woodpecker Hill.

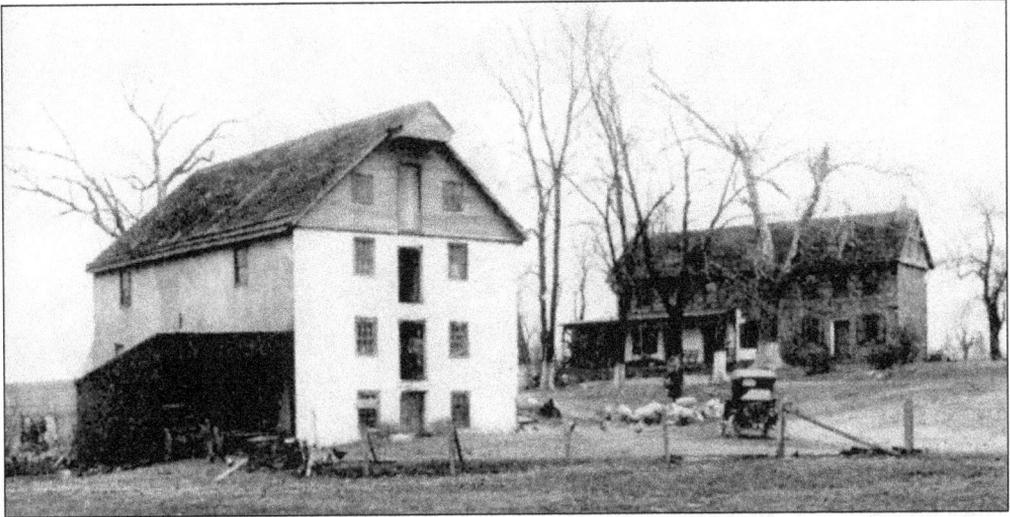

In 1758, Thomas Lloyd sold 27 acres of his large holdings to his second son, Samuel, who built a home c. 1762 near the present Mason's Mill Road. Samuel and his brother James also built a gristmill near the northeast corner of Mason's Mill and Byberry Roads. In 1768, the mill was sold and several land transfers occurred. It is known that Dr. William Hallowell was operating the mill in 1851. George and Walter Mason purchased the house and mill in 1925 from Eileen Woods. The property was sold to the township in 1967 for a park but was used as a trash dump for several years prior to the actual establishment of the park in 1973. The mill was very successful because it sat in a floodplain supplied by several springs and, therefore, the owner did not have to buy water rights from owners upstream.

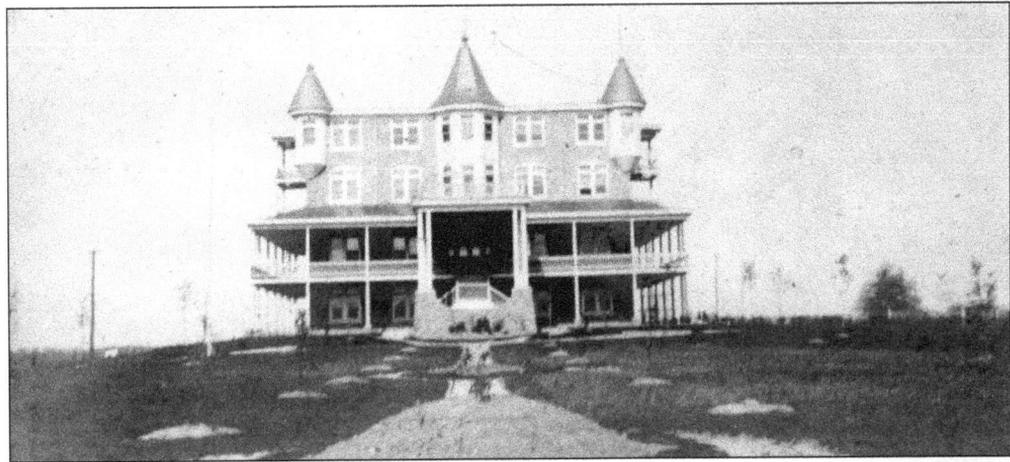

Construction on the Orange Home for Protestant Children began in September 1901, and the building was dedicated May 30, 1903. It was designed and operated as a school and home for children and aged and infirm members of the Loyal Order of Orangemen, a fraternal organization limited to Protestants of Irish, English, or German descent. The original building was a four-story, granite structure with 42 rooms; the second floor had a large wooden porch. Children as young as three were given Bible training as well as English and other subjects by accredited public school teachers. There were also industrial classes. By 1936, the occupants were mainly retired, with only a few children. The building later became a nursing home. In 1995, the property was sold to Maple Village, which made substantial improvements and renovated the original building.

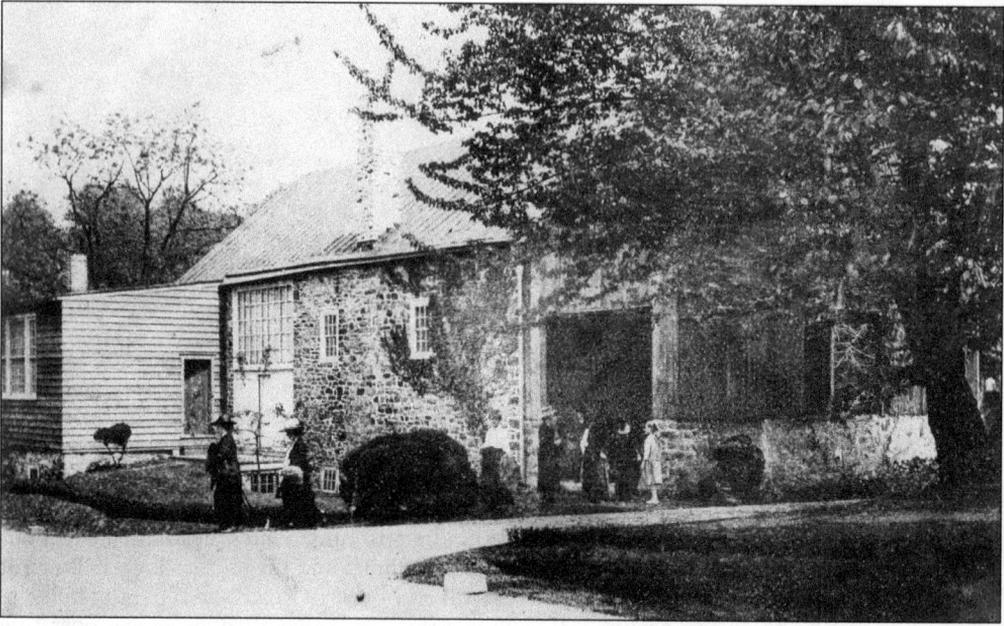

Artist Joseph T. Pearson Jr. (1876–1951) bought the old Shelmire Mills property on the southeast corner of Huntingdon and Creek Roads in 1918 and had the 1797 barn on the site remodeled into a studio. He later purchased the Edwards farm across Huntingdon Road, and the area was known as Pearson's Corner. Pearson was an instructor at the Pennsylvania Academy of the Fine Arts and was known for his landscapes and portraits. He was married to Emily Ruoff Fetter, and one of his finest portraits, *Study in Gray* (Woodmere Art Museum), is of his wife.

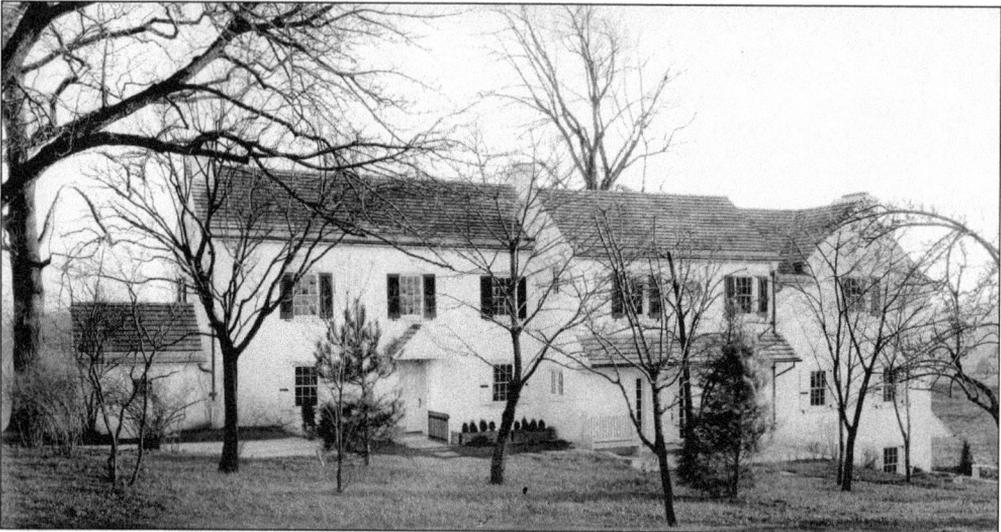

Leslie J. Hall purchased the old Wynkoop family farm and had extensive work done to the original house during the 1920s. After World War II, a Mr. and Mrs. Ruck bought the property and turned the house and grounds into a showplace. After Ruck's death, the house again fell into disrepair until the National Lands Trust bought it *c.* 1974 and turned the 35 acres over to the Pennypack Watershed Association to administer under a caretaker arrangement. In the 1990s, the Watershed Association became the Pennypack Ecological Restoration Trust. The house is currently the home of the trust's director.

56

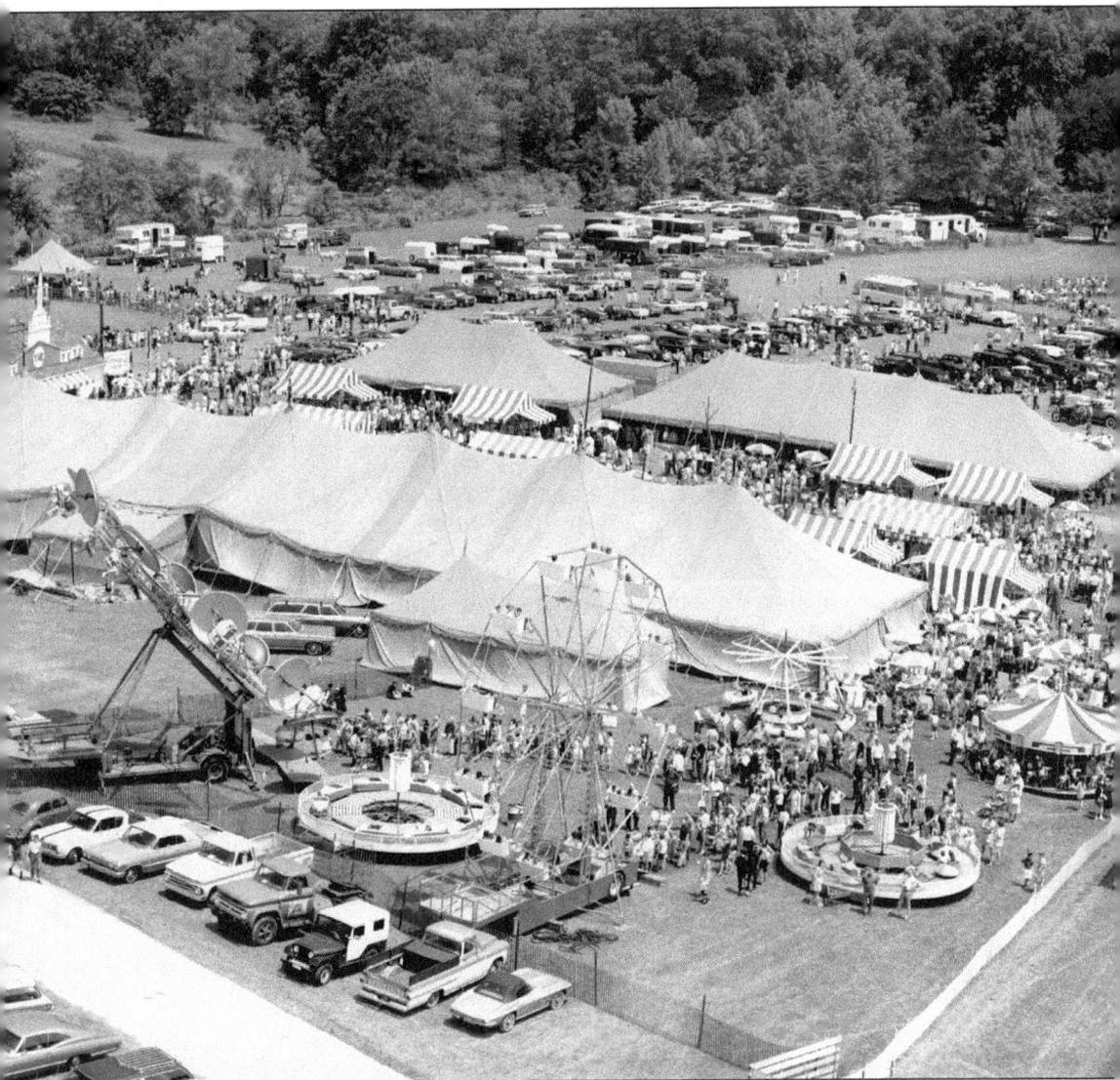

The first Abington Hospital fund-raiser fair and bazaar, then called a Garden Party, was organized by the Women's Auxiliary and held at the home of George W. Elkins in Elkins Park in 1912. Over the years, the event was held at various locations on the first Saturday in June and quickly became known as the June Fete. It was held at George Elkins's Justa Farm estate in Lower Moreland for 10 years until 1957, when Rev. Theodore Pitcairn donated 41 acres on Edge Hill Road in Upper Moreland as a permanent home for the annual event. The fete was for many years an elegant occasion and a highlight of the social season, with worldwide coverage by Pathé News of its fashion shows. It later grew to include all types of family entertainment, and remains the Women's Board's largest fund-raiser for the hospital. This 1968 June Fete photograph captures the horse show, the antique car show, the amusement rides, and the Midway.

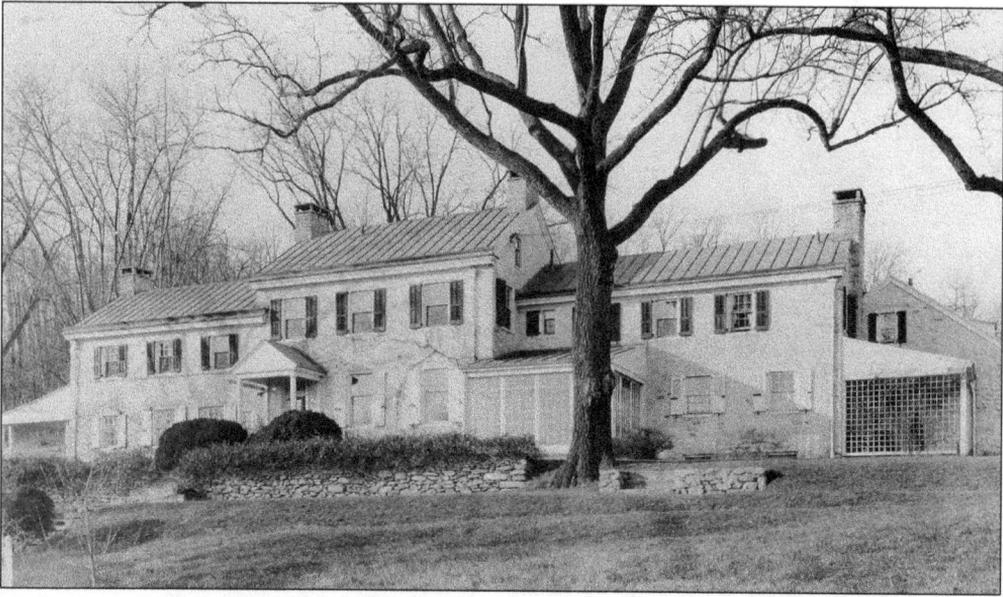

Netherfield, located at the southeast corner of Edge Hill and Terwood Roads, was the home of William M. Justice Jr. The original section of the farmhouse dates to the 18th century. The property had been owned by C. and J. Boyer and later by their estate for many years and was part of an 80-acre farm, the majority of which was located on the north side of Terwood Road. Justice purchased the house and eight surrounding acres c. 1930 and expanded the existing house and outbuildings. The property was recently purchased and is currently undergoing an extensive restoration.

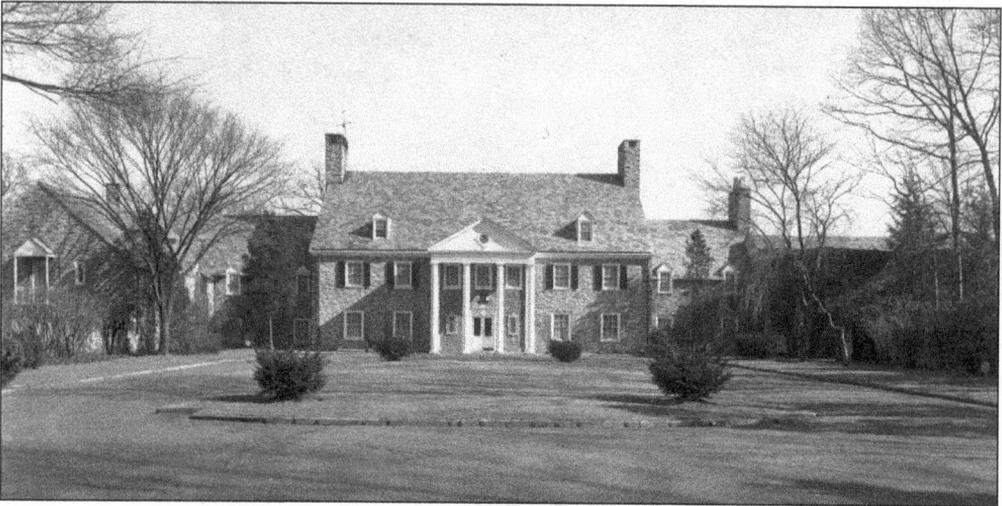

Huntingdon Valley Country Club moved from its original location in Abington on Old York Road to a new location off of Edge Hill Road in 1928. The club's property extended east to Paper Mill Road, north to Terwood Road, and south across Welsh Road into Abington Township. The land had previously been W.W. Frazier's dairy farm. Originally founded in 1896, the club had become one of the premier clubs devoted solely to golf by the time of its move. The new course was designed by nationally known designers Toomey and Flynn, and the clubhouse by architects Tilden, Register & Pepper. The club was officially opened Easter Sunday of 1928. Tennis courts and trapshooting were added and, later, a swimming pool.

Three

LOWER MORELAND TOWNSHIP

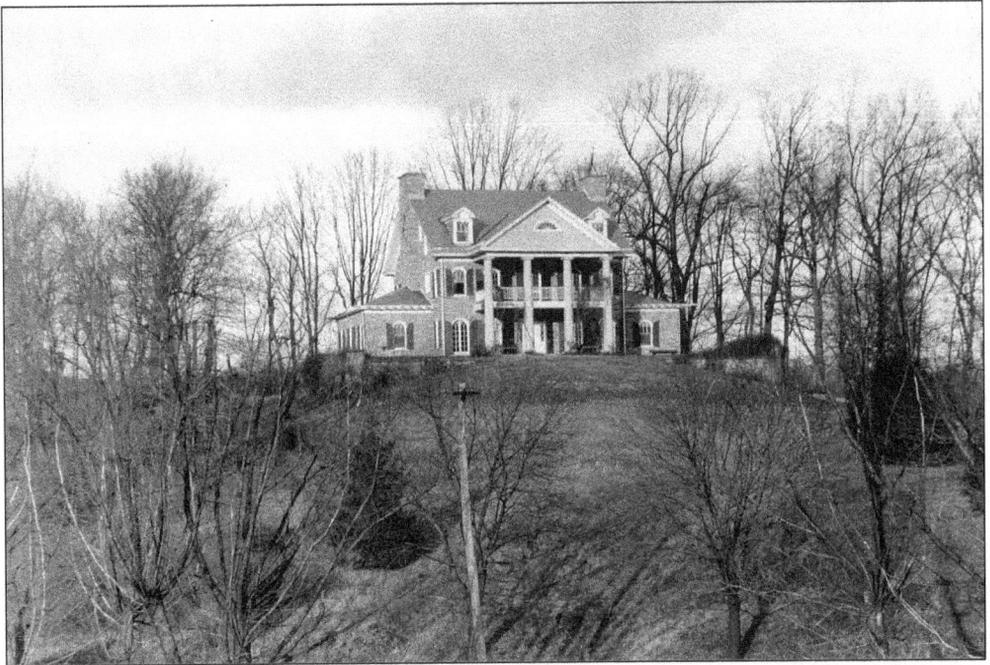

The Jarrett House was built sometime between 1900 and 1907 on 37 acres of high ground at the northeast corner of Valley and Terwood Roads, formerly owned by the Addis family. The owner, Frank H. Jarrett, also owned a small parcel of land at the southeast corner of the two roads. By 1934, the Jarretts had a large formal garden installed near the house by their young gardener Frank Tinari, who later became well-known for his development of African violets. The house is still standing, although it has been converted into a two-family residence.

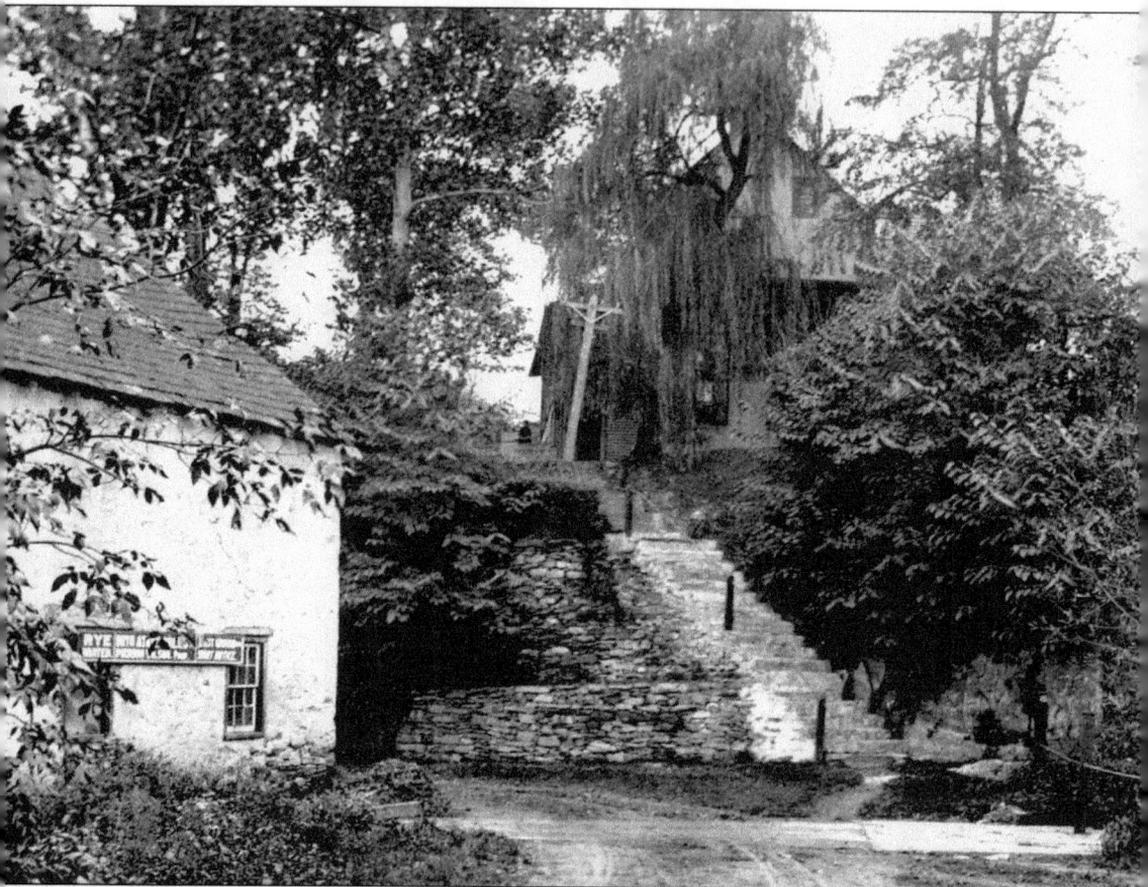

The Caprice House was built c. 1790 by German immigrant Harmon Yerkes who farmed the property. This house was one of several Yerkes homes in the area and was called "Cinquefoil," from the name of the flower that grew on the steep bank by the house. A later owner named the house Caprice. Looking west on Fetter's Mill Road where it curves around the mill and proceeds south to Terwood Road, the mill is on the left and the steps lead up to Caprice. The photograph dates from September 25, 1904, when the mill was called the Bryn Athyn Mills and Pierson Wilson was the proprietor.

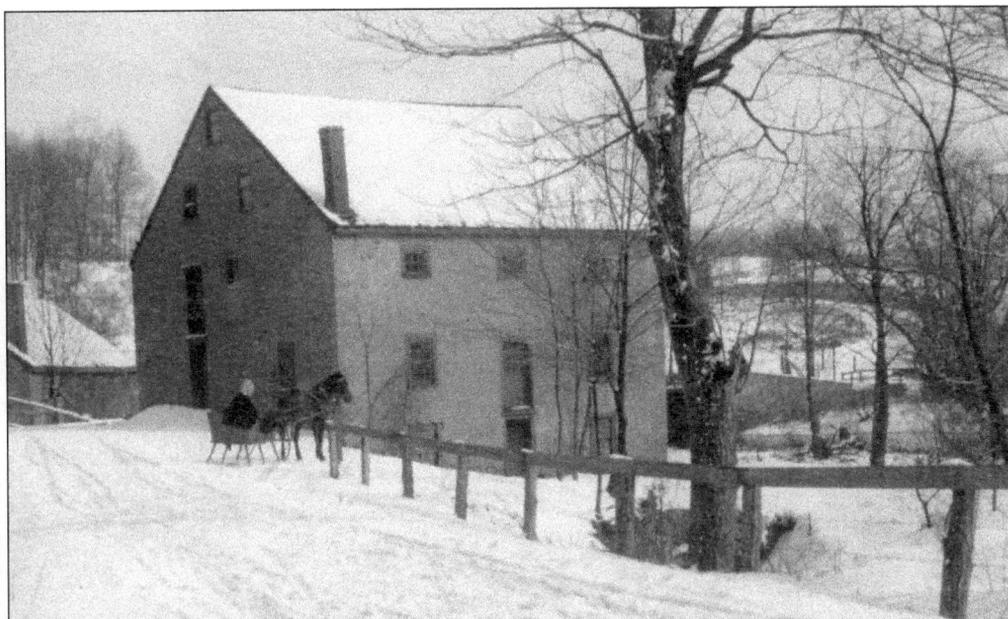

In 1835, Amos Addis bought the Yerkes property and built a mill. In 1851, a Mr. Morrison owned the property. Caspar Fetters bought the mill in 1860, but he also farmed and taught school and ran the mill only from 1867 to 1871. He then returned to farming and moved out of the immediate area. James Carr and John Eckstein Beatty were later owners of the 34 acres surrounding the mill, which is still located on Fetter's Mill Road just west of where the bridge crosses the Pennypack Creek.

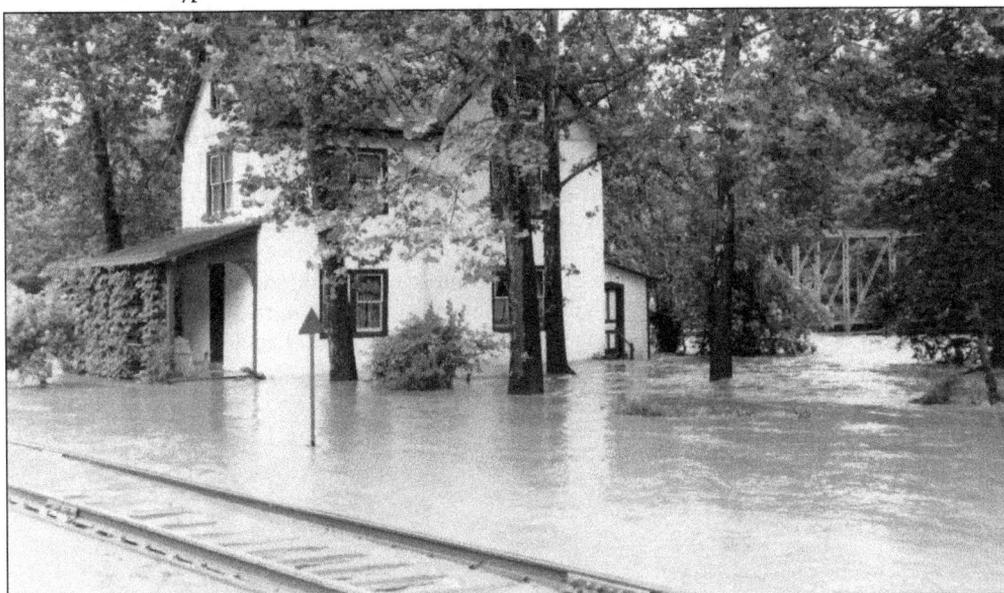

On July 23, 1938, heavy rains that had continued for seven days caused severe flooding throughout the area. The Pennypack Creek rose over its banks, flooding nearby homes with three-to-four feet of water. Cars parked at Bethayres Station were under water. This flood scene is at the old railroad station on the Newtown line that served Bryn Athyn, just north of Fetter's Mill Road. The house is still standing and is a private home.

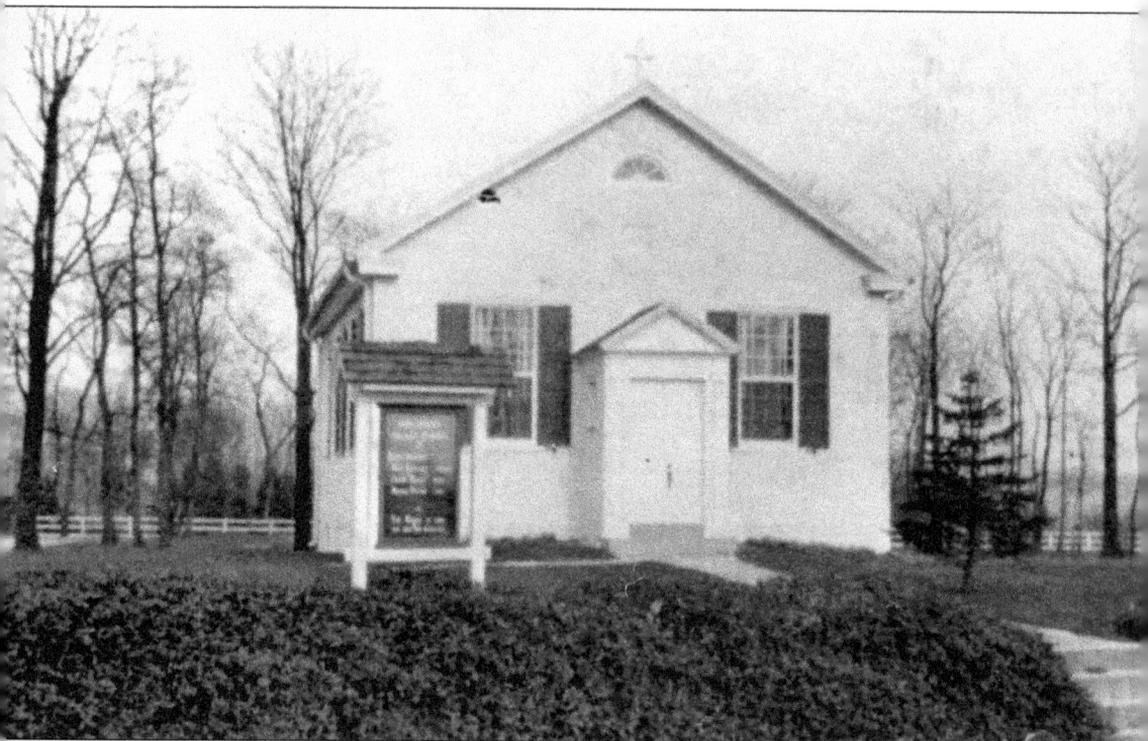

In 1847, Joseph Erwin donated an acre of his farmland on the north side of Welsh Road near the intersection with Washington Lane to establish the Fairview Methodist Episcopal Church. In 1872, services were discontinued and the building was neglected. An attempt in 1892 to open a Sunday school in the building failed. In 1919, Edward E. Marshall bought the property from the Methodist Conference and gave it to the Episcopal Diocese. Services began in November 1919, and the following year, the building was entirely refinished inside. Rev. John Walker served as first vicar of the renamed Huntingdon Valley Chapel. In 1922, Ellen Herkness donated adjoining ground for a rectory site. The chapel was improved and restored over the years, and in 1941, a new vicarage was completed. In 1956, the Huntingdon Valley Chapel was admitted to the Diocese of Pennsylvania and renamed St. John's Episcopal Church of Huntingdon Valley. In 1957, the congregation began building a new church and educational facilities on the property. In 2001, the clergy and most of the congregation left the property and withdrew from the Philadelphia diocese becoming St. John the Evangelist Anglican Church. The diocese reconstituted the congregation, and the chapel is still used for the early-morning service.

The original part of this large house dates from the late 18th century. By 1871, the Newlin family owned the property, which lies south of Terwood Road between Paper Mill Road and Washington Lane. By 1909, it was part of the very large landholdings of C.T. Wernwag, the owner of Cold Spring Farm. By 1916, George L. Satterthwaite was the owner, and during the 1920s, he made major changes in the appearance of the house. In 1934, the house was known as Terwood Run. The present owner is in the process of installing a formal garden.

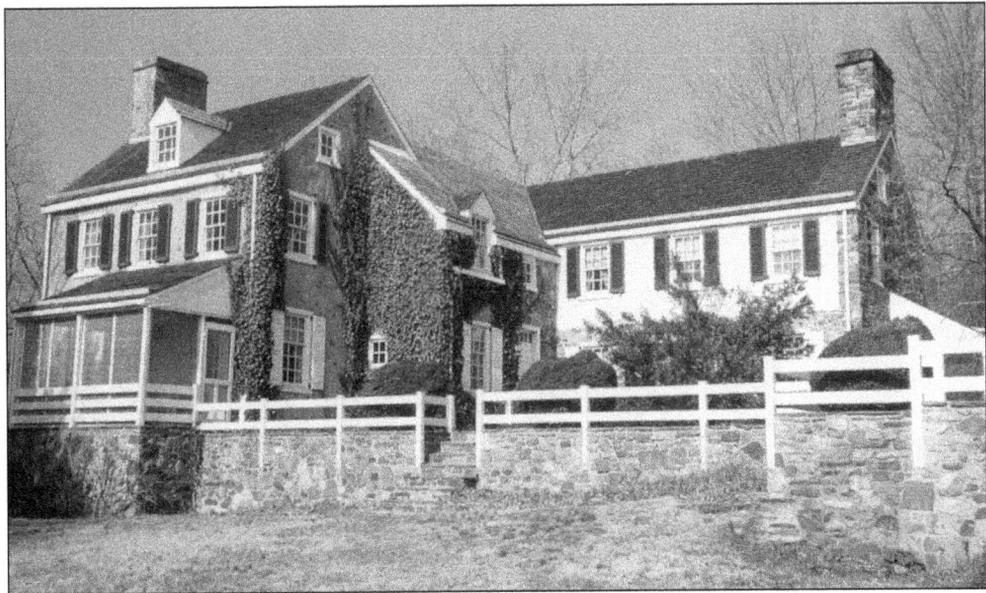

A small late-1700s three-story, stone farmhouse located at the northwest corner of Welsh and Valley Roads belonged to Charles Saunders from the 1890s to 1926. The next owner, Lincoln Roden Jr. had the house restored and expanded by Richardon Brognard Okie over a two-year period, from 1929 to 1931. Okie was one of the region's foremost Colonial-style architects, who also specialized in the restoration and reconstruction of Pennsylvania Colonial and vernacular types. The house remained in the Roden family until 1992.

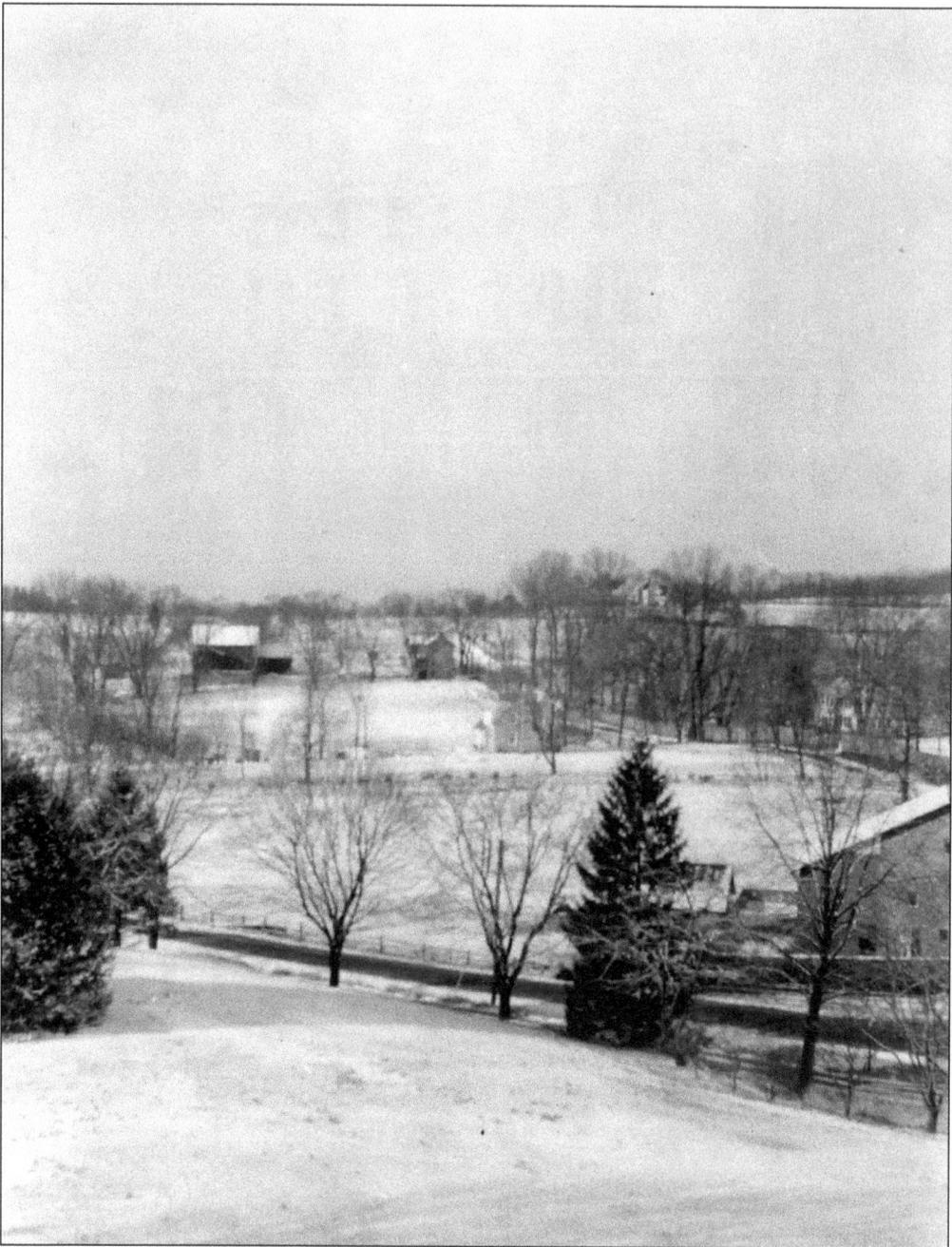

This photograph dates from April 1940 when a late snow covered the area, and was taken from the Jarrett House grounds. Terwood Road is in the foreground, and the building at the lower right is a carriage house at the corner of Valley Road, which can be seen running diagonally from the right. The building is still standing and is a private home. The white house on the right of the road in the trees is Cold Spring Farm. Across the road is the present Tinari family property. Frank Tinari was encouraged to establish his African violet nursery by Frank H. Jarrett, from whom he bought this piece of land. The two buildings beyond are still standing. The house on the horizon is at the corner of Welsh Road and Saunders Avenue.

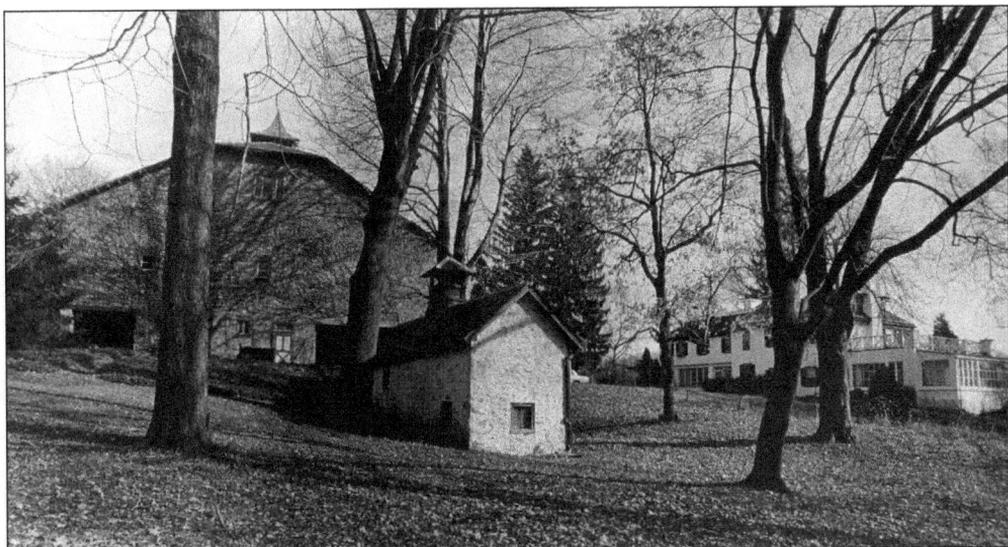

The main house on Cold Spring Farm (right) is seen here from the rear. The earliest part of the house dates from c. 1770, and there were additions in 1810 and 1928. The name Cold Spring Farm first appears when C.T. Wernwag bought the property some time before 1909. Composer Richard Yardumian bought the property in 1954, and internationally known musicians and other prominent persons were frequent visitors for many years until his death in 1985. The barn was the biggest Victorian barn in Montgomery County and was noted for its gingerbread and scrollwork. Yardumian demolished the building when it became unsafe.

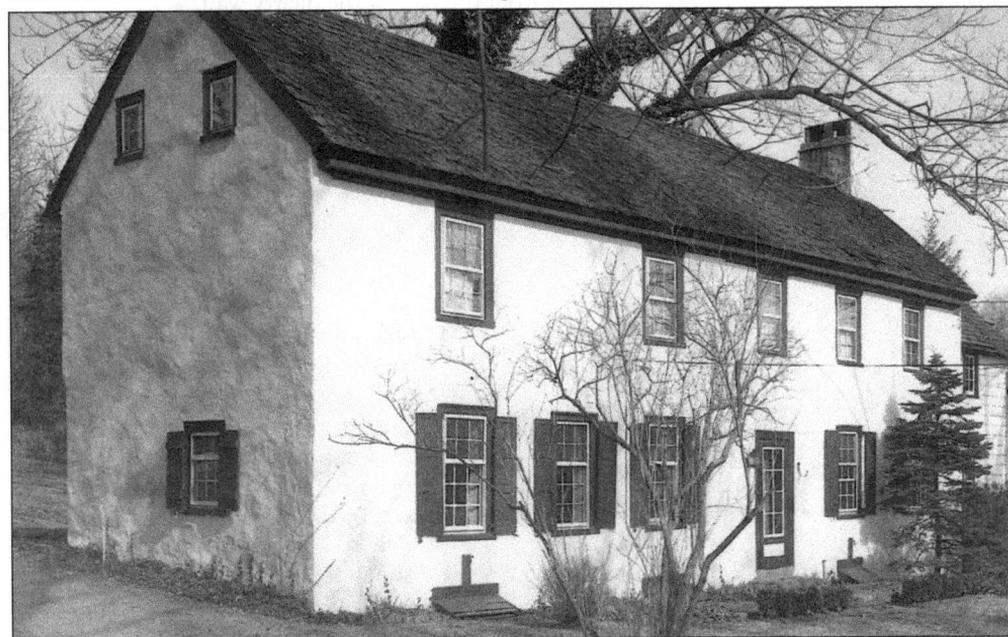

The earliest section of the Buick House was built c. 1770 on property that later became Cold Spring Farm, and it served as a tenant house on the farm. It is a typical two-and-a-half-story stucco-over-stone Pennsylvania farmhouse that has had two additions in the mid-20th century: a wood-framed kitchen and a breakfast room. The present owner has carefully restored the house, which is located just south of Terwood Road.

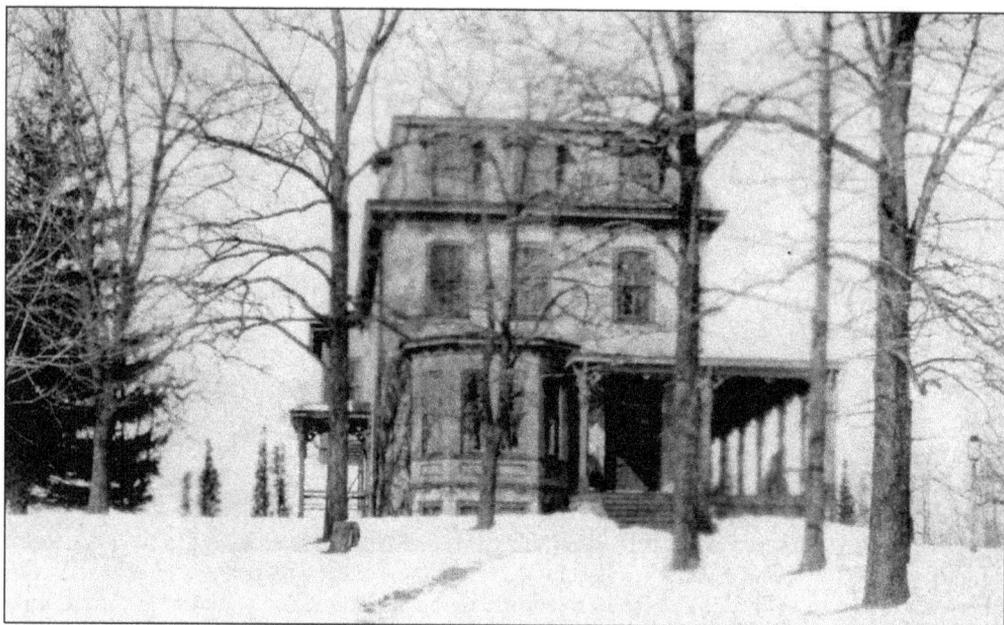

Charles Saunders, a successful Philadelphia businessman and one of the founders of Jeanes Hospital, had built his large house on the heights above the quarry by 1891. The property extended along Welsh Road between Valley and Terwood Roads. It was called Grandview and had a view in every direction. The house eventually was consumed by the quarry, and a section of the basement can still be seen protruding from the face of the quarry wall.

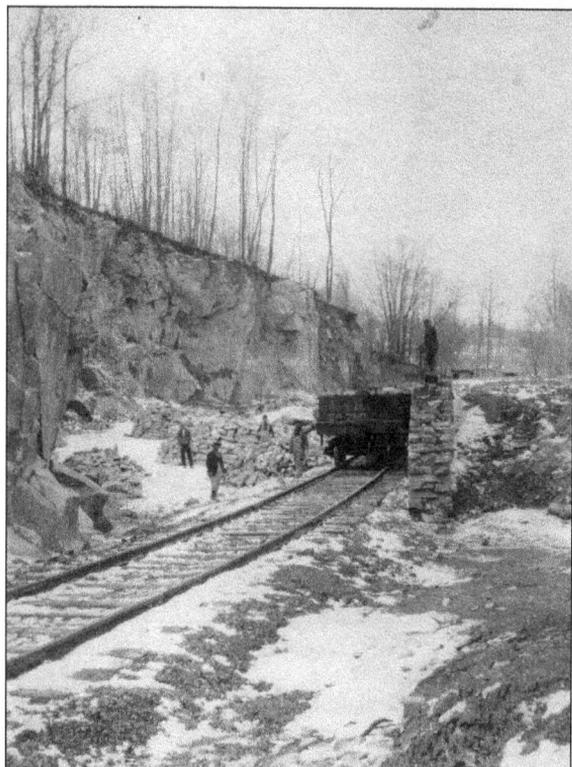

A stone quarry was located in the Pennypack Valley on the west side of the railroad tracks just north of the old Huntingdon Valley station at Welsh Road. A lead mine opened at the site in 1850, but the vein ran out after several years and the mine closed. In 1901, Charles Saunders opened a granite quarry, which later was operated by his son-in-law, Frank H. Jarrett. This photograph shows the first car on the new railroad spur that was built sometime between 1909 and 1916. When the Mignatti Construction Company owned the site in 1963, it was called the Bethayres Quarry. In 1979, the Bethayres Reclamation Corporation took over the site for a landfill.

This small house is sometimes known as the "General's house", after General George Sickle, who lived there for many years. It was one of five similar small houses built for workers at the Walton Mill and is the only one still standing. The house sits within one foot of the right-of-way and at one point was condemned by the railroad company but was later returned to the general. It is located just north of Welsh Road.

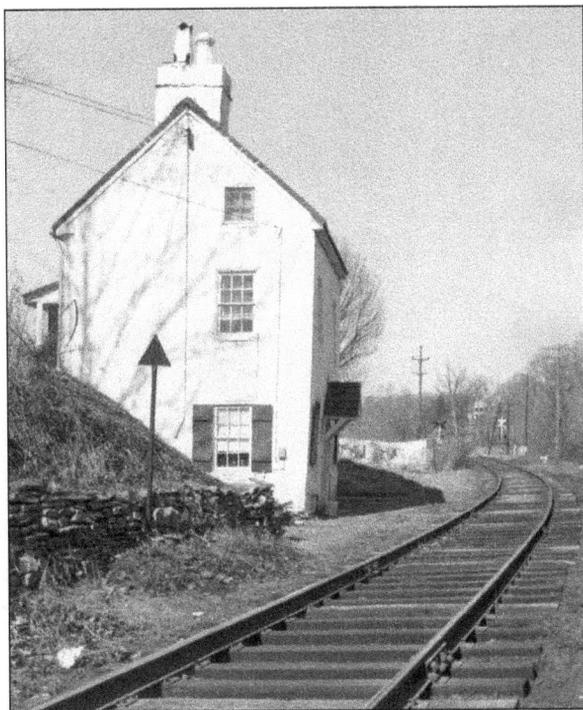

Samuel Chestnut, the flagman at the Huntingdon Valley flag stop of the Reading Company's Newtown line, stands in front of the ruins of the 1790 schoolhouse above the northwest corner of Welsh and Terwood Roads. At the right below the ruins are the flag stop and the old bridge crossing the Pennypack Creek, which was built in the early 1900s. At the left is the powerhouse of the Moreland Spring Water Company. The houses in the far right background are on Huntingdon Pike, and the steeple of the Presbyterian Church can be seen through the cross arms of the tallest telephone pole. The schoolhouse ruins were still standing in 1916. This view is from the grounds of Grandview.

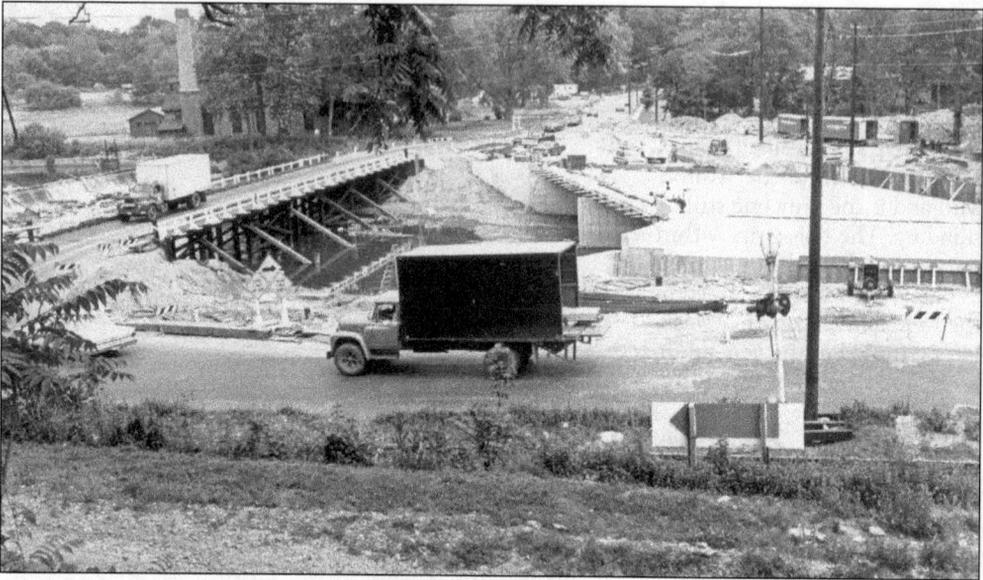

There was a ford over the Pennypack Creek on Welsh Road as early as 1711 when the road was first opened. A triple-arch stone bridge was built in 1821, and it in turn was replaced c. 1911 by a two-lane dogleg bridge. This bridge had become woefully inadequate by the early 1960s, and in 1968–1969 the state built a new wider bridge in conjunction with the widening of Welsh Road from Valley Road to Huntingdon Pike. During the construction, a temporary bridge was built upstream near the powerhouse so that the new bridge could be constructed on the site of the old. This photograph dates from May 1969.

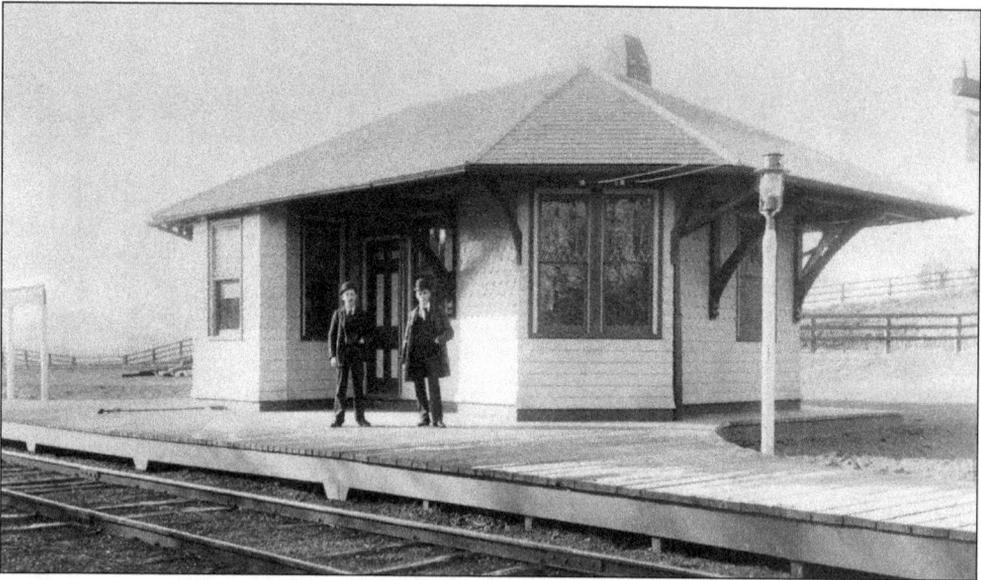

The Huntingdon Valley station on the Newtown line replaced the old flag stop at that location just south of Welsh Road. The Newtown line, originally a subsidiary of the Pennsylvania Railroad, was later traded to the Reading Railroad, which extended the line as far as Newtown in 1878. The line carried passengers directly to Philadelphia on a single track. A small shed later replaced this station. The line ceased operating c. 1975 when government subsidies were cut off after the Reading refused to pay to electrify the rail line.

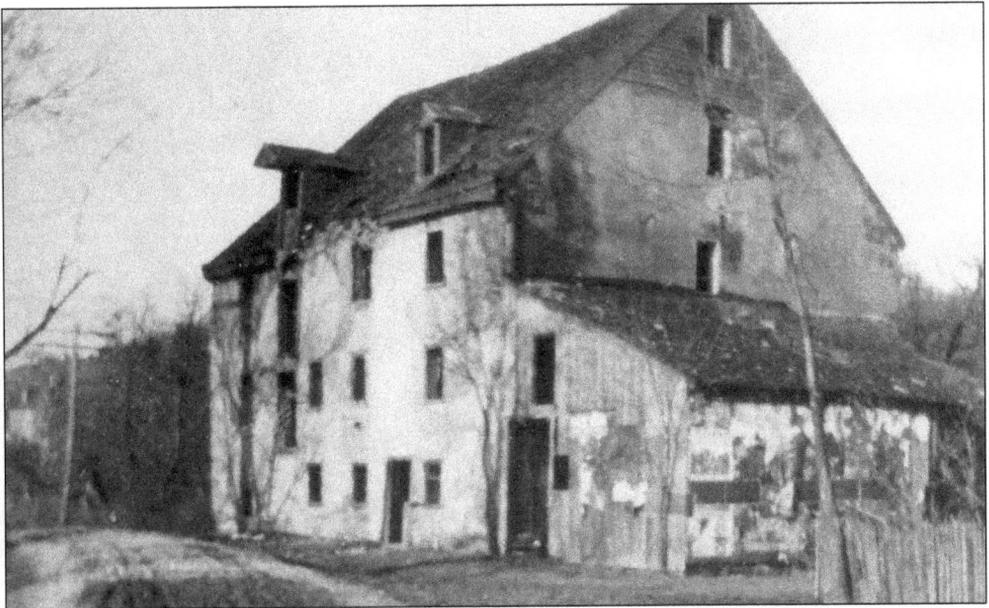

In 1831, John Walton bought James Comly's farm, Hills Highlands, and a mill, located on the Pennypack Creek north of Welsh Road. The mill had been in operation by 1747, and Walton rebuilt it in 1851. He also razed the old house and built a grand new home, Studine Farm, in 1849–1850. Even though Walton had installed a small steam donkey engine in 1881 to provide more power, the mill went out of business after Walton's death in 1884. All the mills in the area were affected by the silting up of the Pennypack Creek due to the over-logging of the land. Jenkintown Water Company later purchased the mill site.

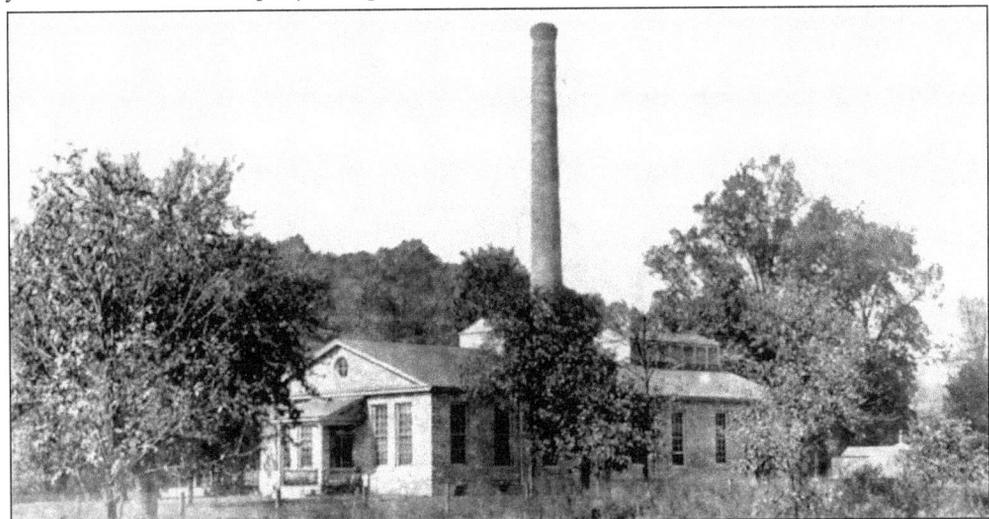

In 1909, the Jenkintown Water Company needed more wells and bought land in Moreland Township on both sides of the Pennypack Creek, near Bethayres north of Welsh Road. A new organization was incorporated the same year as the Moreland Spring Water Company, with Jenkintown officials H.K. Walt and Howard Fleck as officers. The company built a new power plant and leased the property from Jenkintown Water Company, which still retained ownership. The company operated until it was sold to and merged with Philadelphia Suburban Water Company in 1928. The powerhouse is still in operation.

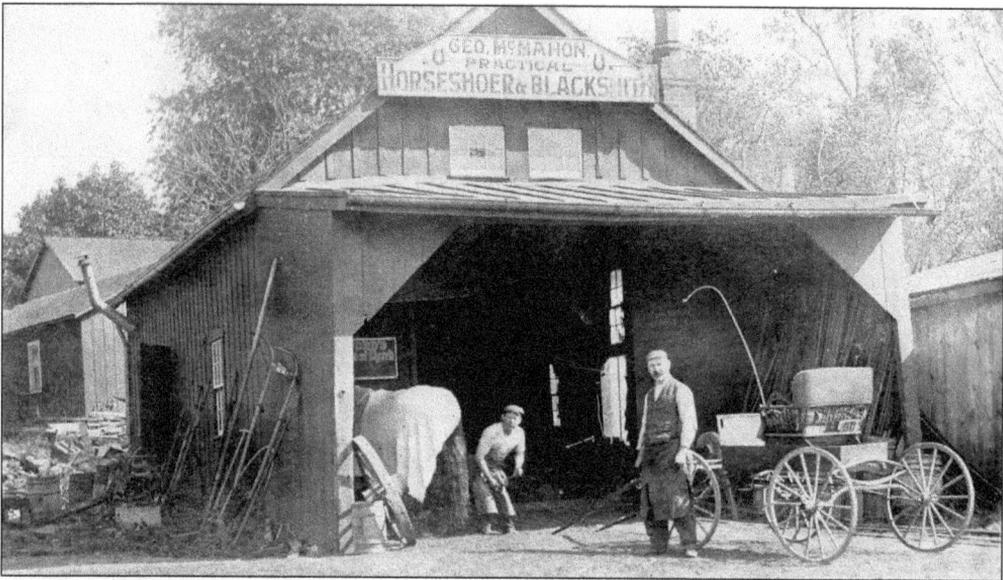

The blacksmith shop of George McMahon was located on the north side of Welsh Road and west of Huntingdon Pike, next to the McMahon General Store at the corner. McMahon and Dr. Crowe were the first two men in Huntingdon Valley to buy an automobile. After the growing use of the automobile put him out of business, he continued to do repair work in the building and did not retire until the 1940s. The building was demolished c. 1950, and McMahon died in 1957. The site is now part of the corner gas station property.

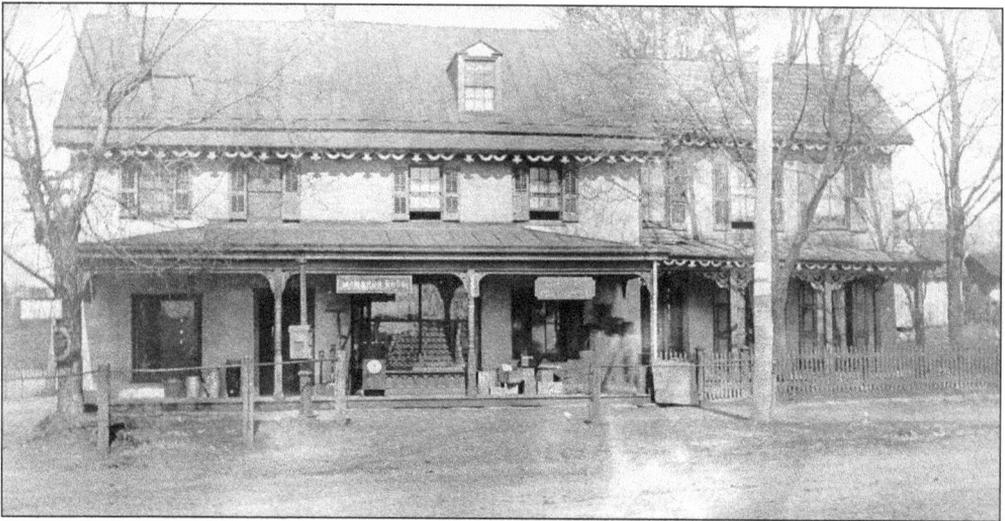

The McMahon Bros. store, later the Doering store, was at the northwest corner of Huntingdon Pike and Welsh Road. It also served as the Bethayres Post Office from its establishment in 1850 to June 1960 when it moved to 670 Welsh Road in the Bethayres Shopping Center. The first store proprietor to serve as postmaster was Charles B. Rankin. Moses E. McMahon and three members of the Doering family later held the position. The Bethayres Post Office merged in June 1958 with the Huntingdon Valley Post Office and became the Huntingdon Valley-Bethayres Post Office at this site. In 1966, the name was shortened to just Huntingdon Valley, and the distinction of having the longest postal name in the country ended. The building was razed c. 1969 when Welsh Road was widened. A gas station is now on the site.

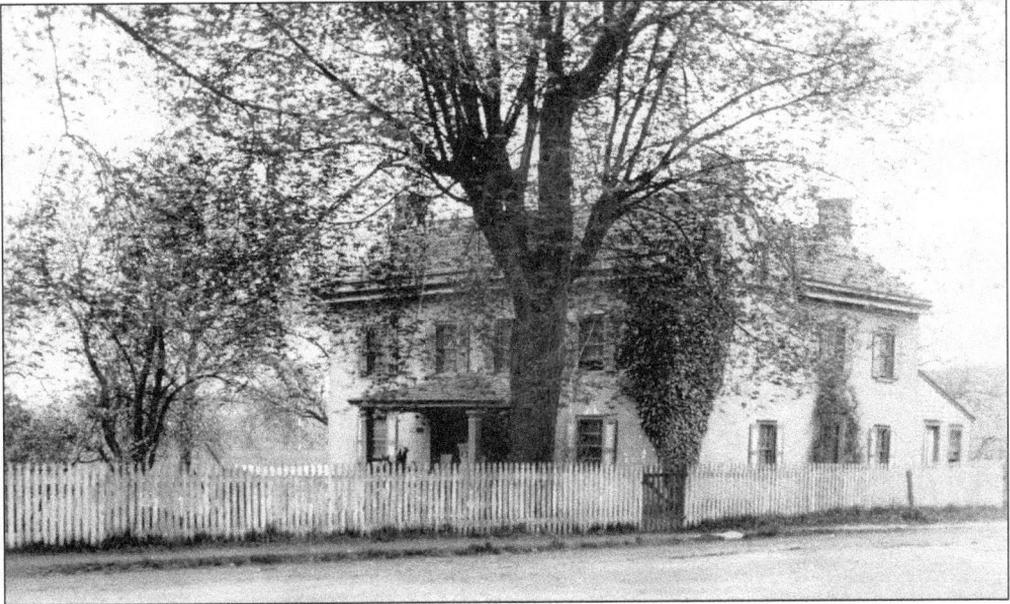

The John Barrett House was at the southwest corner of Huntingdon Pike and Welsh Road by 1871. It stood on what is now the parking lot of the Bethayres Shopping Center. Barrett was a prosperous African American who operated a wheelwright shop and smithy farther south on the west side of Huntingdon Pike near the Spread Eagle Inn. The house was demolished for the construction of the shopping center in 1960. The spring that generously supplied a pump on the Welsh Road side of the house still causes problems in the center's parking lot.

The tollhouse was located on the east side of Huntingdon Pike directly facing Welsh Road in the middle of what is now Philmont Avenue. The toll road was completed as far as the Sorrel Horse Inn in 1848 and was known as the Fox Chase-Second Street Pike. The gate was normally closed at 9:00 every evening and was only heavily used on Thursday market days when the tollkeeper often stayed on duty until 4:30 in the morning to allow farmers to return from Philadelphia markets. The toll from Welsh Road at Bethayres to the Sorrel Horse was 5¢ for one horse, and 10¢ for two horses.

This Victorian house was built by 1891 and is still standing at the northeast corner of Huntingdon Pike and Chestnut Street. It later became Hornung's Restaurant and Bar and is now the Bethayres Tavern. The houses to the right front on Chestnut Street, previously named Enterprise Road but also known as Tin Pan Alley. The Chestnut Street homes have been condemned as a result of flooding and are to be demolished.

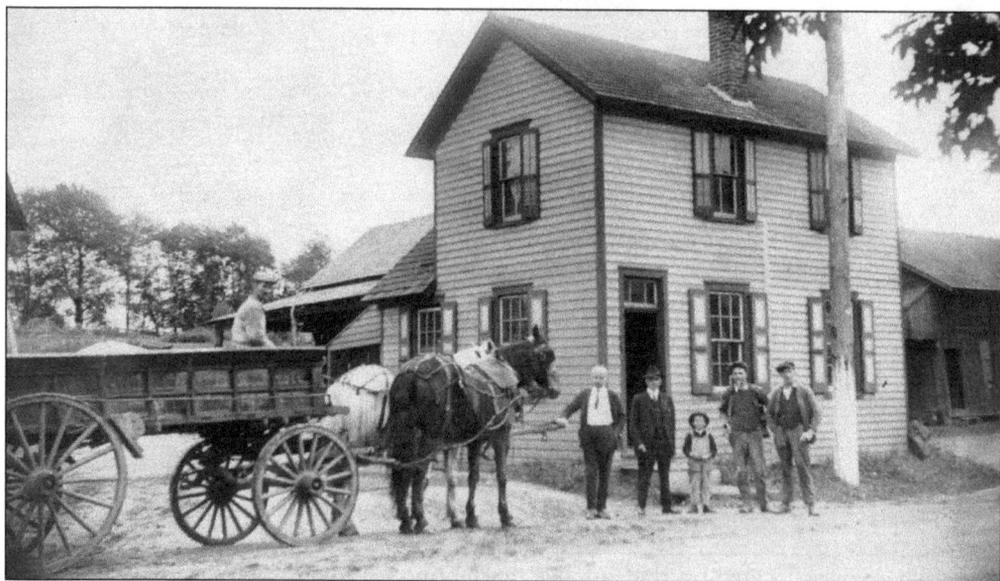

The Leedom Coal and Lumber Company was located immediately south of the Bethayres station with a spur from the main tracks. The company was established by 1909 and remained in business until the 1940s. The main building faced Huntingdon Pike. The man on the wagon is Albert Johnson, and the dark horse in the foreground is Old Ned, the lead horse. The man in the white shirt is Howard Leedom, weighmaster and office clerk, and Benton Leedom is next to him.

The Gloria Dei Lutheran Church was organized in 1917 in Philadelphia. It moved to Huntingdon Valley, and the first services with the new pastor, Ernest G. Schmidt, were held in the Huntingdon Valley firehouse in October 1956. In January 1957, it became an Evangelical Lutheran Mission Church, and in 1958, architect Vincent Kling was selected to design a new church building. Groundbreaking took place in 1959 at the new site on the southeast corner of Old Welsh Road and Huntingdon Pike. The building was completed in 1960, and at the same time, Gloria Dei became an established congregation.

Moreland Manor, the Hallowell home currently located on Cinnamon Drive, was formerly surrounded by 75 acres of farmland. The farm was located between Moreland and Welsh Roads along the southern rim of the Huntingdon Valley. The initial purchase of land was made by Israel Hallowell for his son Israel c. 1802. Israel senior owned the Hallowell mill across the township line in Abington. It is presumed a small farmhouse was on the site. Israel junior and his son Henry each added additional acreage to the farm and made extensions onto the home; the 1865 final extension included the far section of the house and the bay windows. Most of the acreage was sold for development c. 1964.

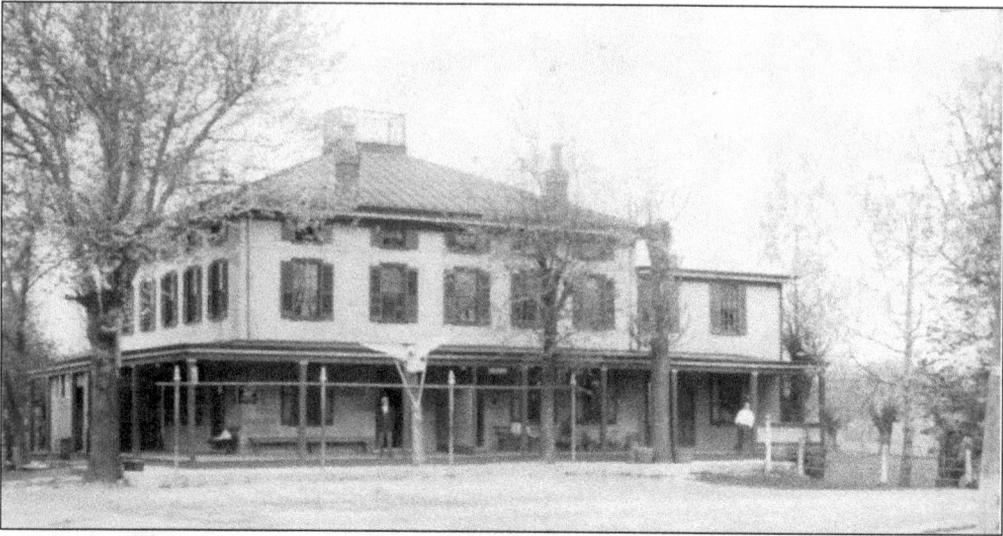

The Spread Eagle Hotel was on the west side of Huntingdon Pike opposite the old junction of the eastern portion of Welsh Road. The hotel was first licensed in 1793 and closed in November 1936. It was razed for the 1937 construction of a new overpass at the Bethayres station and the straightening of Huntingdon Pike from south of the township line to just above the station. At one stage in its history the hotel served as a temporary holding jail for horse thieves and stage robbers on their way to Norristown. It later became a well-known hostelry and served many famous visitors, including governors, senators, and other prominent or infamous men, among them Al Capone.

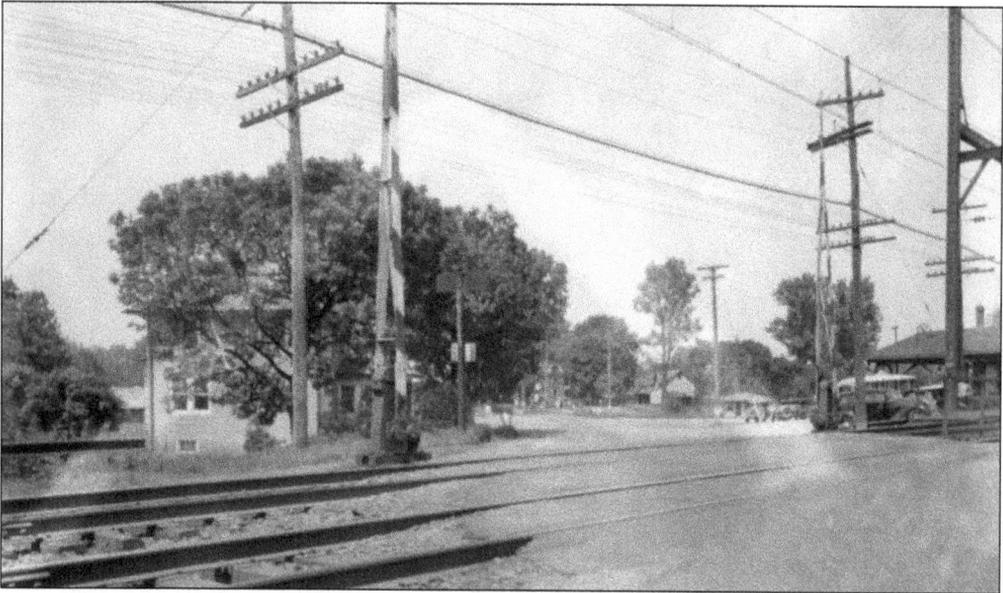

The Bethayres Station was built for the newly opened North Pennsylvania Railroad in 1876. It was named after Elizabeth Ayres, who had been born in the original house on the Ayres farm and had married neighbor James Comly. Their son Henry, who was one of the founders of the railroad and a director, chose his mother's name for the station. The view looks north over the Huntingdon Pike crossing in June 1936, before the construction of the new overpass. Three fatal accidents at the crossing were the immediate cause for the new construction.

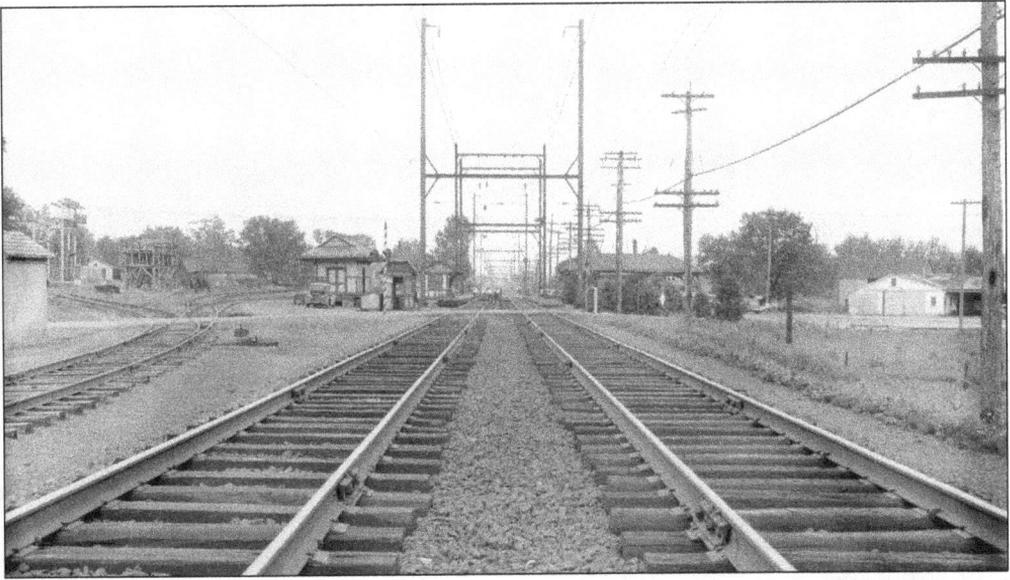

The Bethayres station was located in a triangle formed by the original route of Welsh Road east of Huntingdon Pike, the tracks, and Huntingdon Pike. The new route of the pike and the construction of the overpass in 1937 necessitated a change in the course of Welsh Road to enter the pike farther south. The photograph here dates from June 1936 and looks west along the tracks across Welsh Road with the station at the center right. The spur to the Leedom lumberyard is at the left, and the Welsh Road intersection with Huntingdon Pike is at the far right in front of the buildings. The Huntingdon Pike crossing is beyond the station. In 1981, the station was completely renovated.

A signal tower stood in the field west of the Bethayres station immediately adjacent to the intersection of the Newtown and West Trenton rail lines. Signalmen manned it on a 24-hour basis before automatic signals were installed.

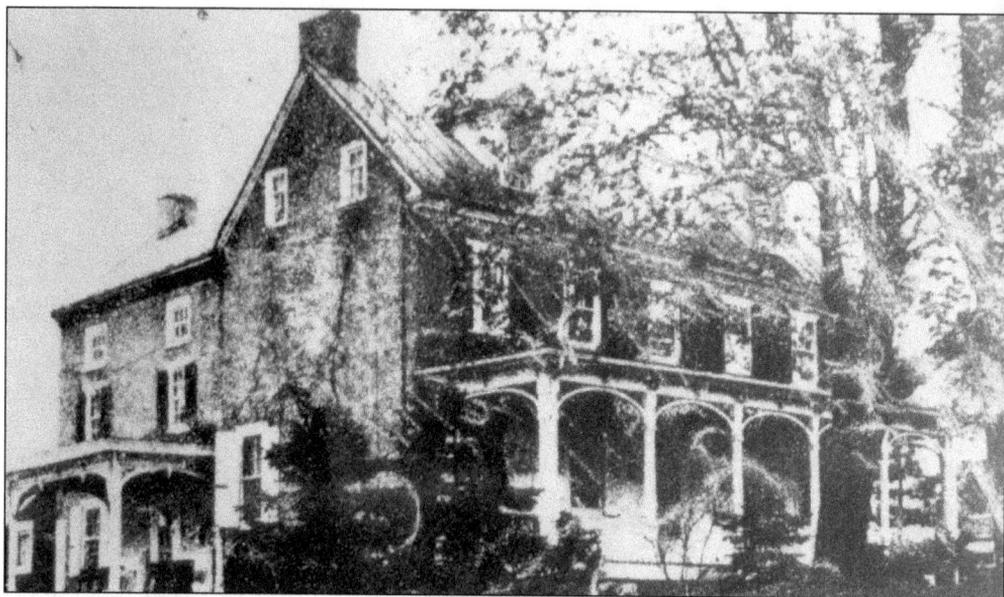

The Comly Plantation House is at 2324 Huntingdon Pike, and the original section dates from c. 1750, with an addition in 1790 and Victorian alterations much later. The Comly family was among the first group of settlers in the area. Prior to 1831, the house belonged to James Comly and his wife, Elizabeth Ayres Comly, who had been born in the Ayres House on the large farm across the Pike north of Philmont Road. John Smith owned the house by 1883, and he built a barn, carriage house, and gazebo. In the 1930s, the present owner, Joseph Traurig, used the outbuildings for a horticultural business.

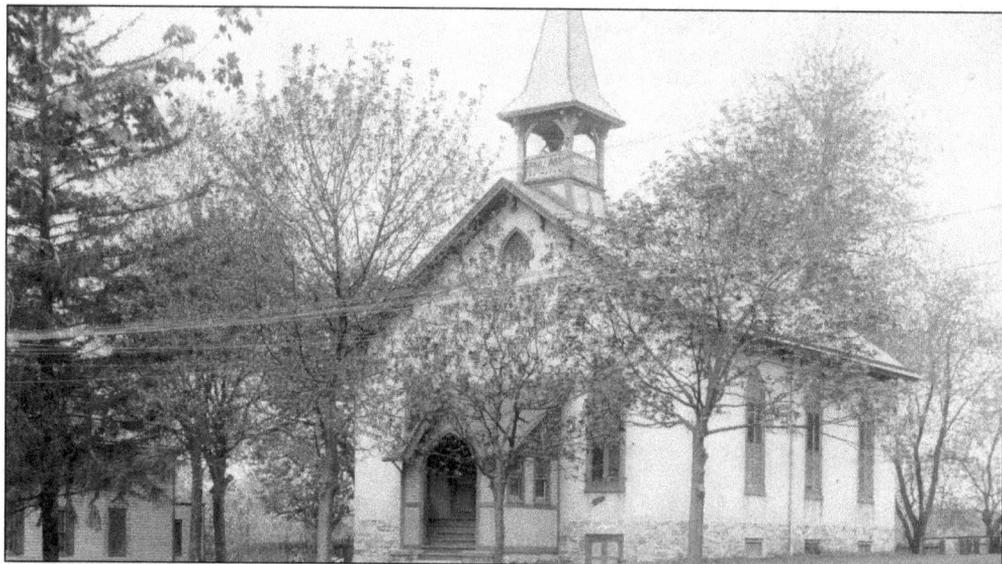

The Huntingdon Valley Presbyterian Church was organized in early 1861, with 18 members and Rev. George J. Mingus as the first pastor. Nine months later, the small congregation completed this building. After a fire c. 1899, the members repaired the damage and in 1908 added a Sunday school wing. In 1954, a new sanctuary was erected connected to the older building, and in 1958 an education building was added. The old manse was demolished in May 1960, and the old steeple was removed a month later.

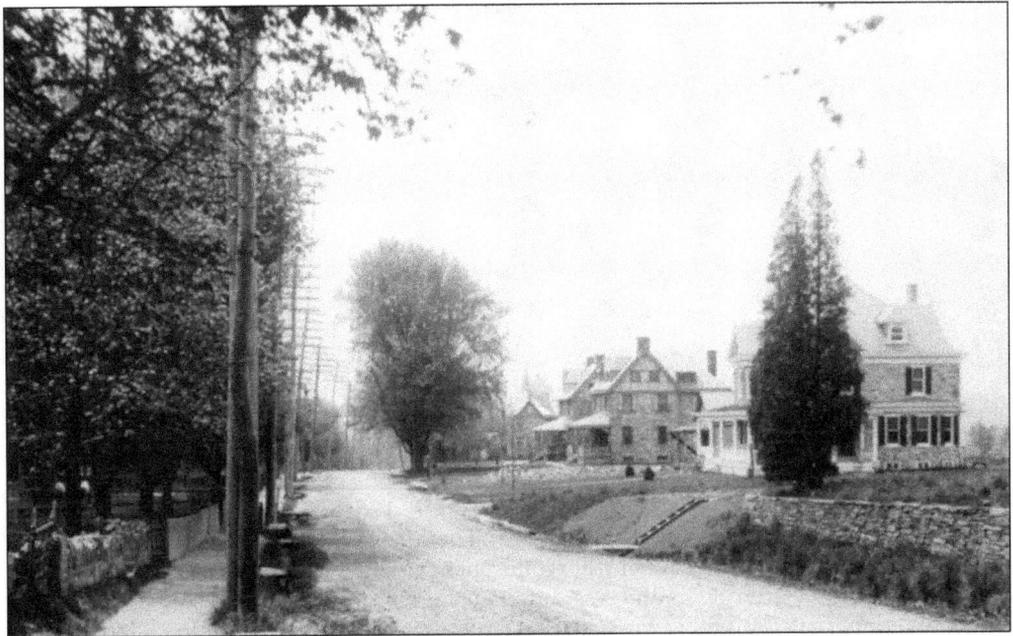

This view looks south on Huntingdon Pike from just above Wynkoop Road. The house on the near right has been the John E. Stiles Funeral Home since November 1961. The other houses still remain standing and were all built between 1890 and 1905.

Ruth and Israel Hallowell (cousin to the Hallowells of Moreland Manor) built a home in 1904 at the top of the hill where Hallowell Drive now runs. The driveway came off of Walton Road opposite the present Wynkoop Road and went up to the house, which sat in the middle of 37 acres. Following World War II, the land was slowly sold for development, the first house being built in 1948. The Hallowell house still stands.

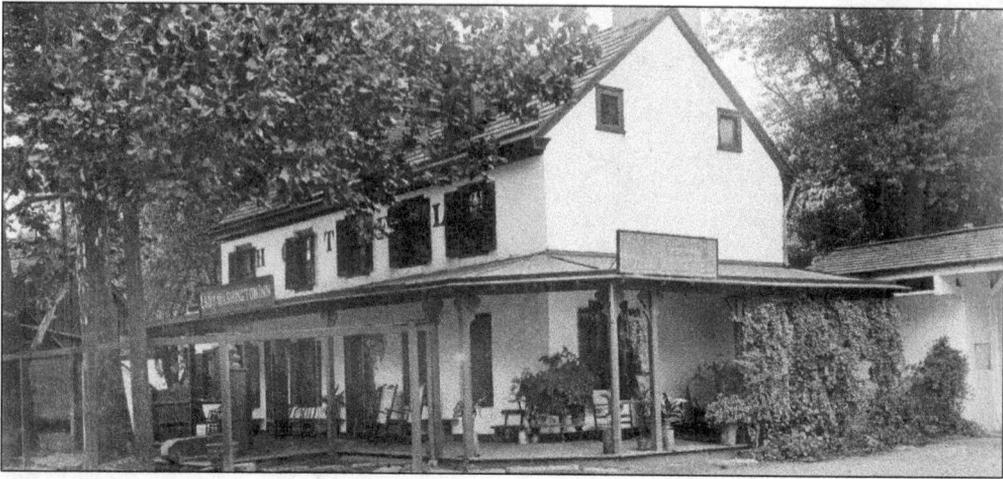

The earliest part of the Lady Washington Inn dates from 1761, the center from 1780 to 1785, and the rear frame addition from 1850 to 1875. There have been only moderate changes to the building since. The former hotel still retains many original interior features. The property extended back to Walton Road and was surrounded by a fruit tree orchard. The legend that Martha Washington stayed there while her husband conferred with General Brock in 1776 goes back to c. 1800. The inn was the largest of the three along the pike and was especially popular with the farmer's wives who patronized the Andrew Erwin store at Red Lion Road.

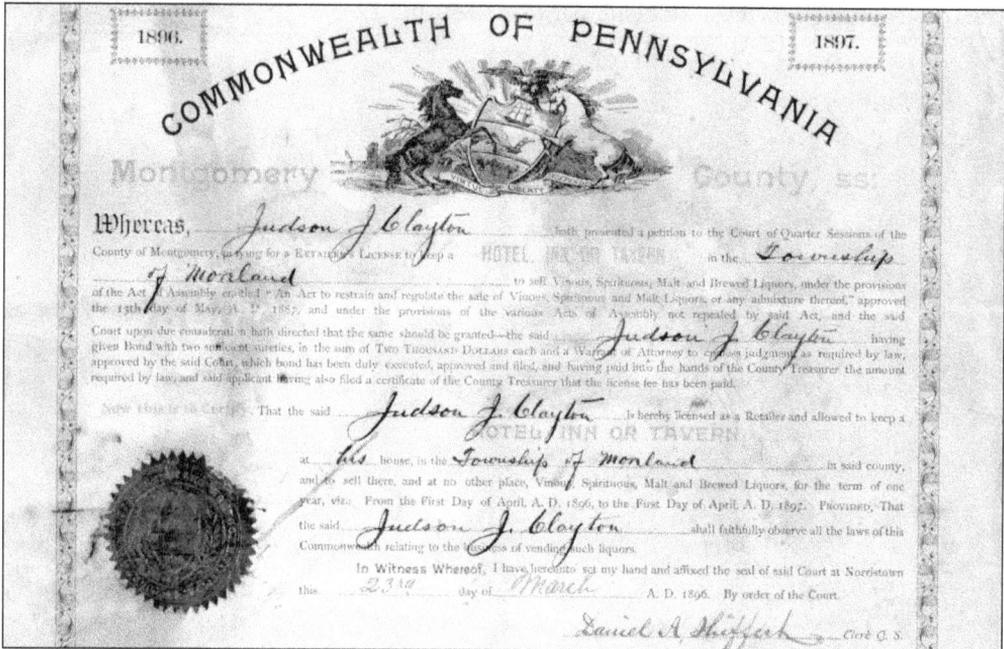

Christian Clayton bought the Lady Washington Inn in 1865, and it remained in his family for many years. The license to operate the inn for the year 1896 was granted to Clayton's son Judson. In May 1920, the Huntingdon Valley Trust Company purchased the inn and several months later sold the hotel property while retaining some land for a bank building. Restrictions in the deed prohibited the former inn from being used as a tavern, bone-boiling establishment, tannery, slaughterhouse, or fire or engine house. The building has been a private residence ever since.

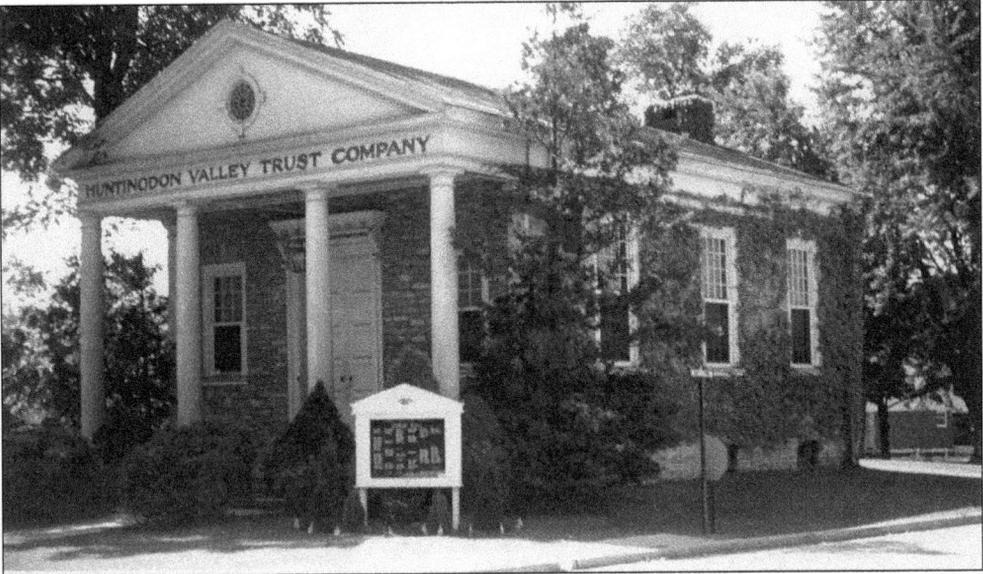

The Huntingdon Valley Trust Company was formed in 1921 and moved into this building the same year. It is located on Huntingdon Pike just south of Fetter's Mill Road on land that formerly belonged to the Lady Washington Inn. The building was designed by Gerald Glenn and built by Fesmire Brothers of Huntingdon Valley. The first president was Israel Hallowell, who was succeeded by his son George. The bank merged with the First Pennsylvania Bank on January 1, 1959. At present, the bank is a branch office of First Union.

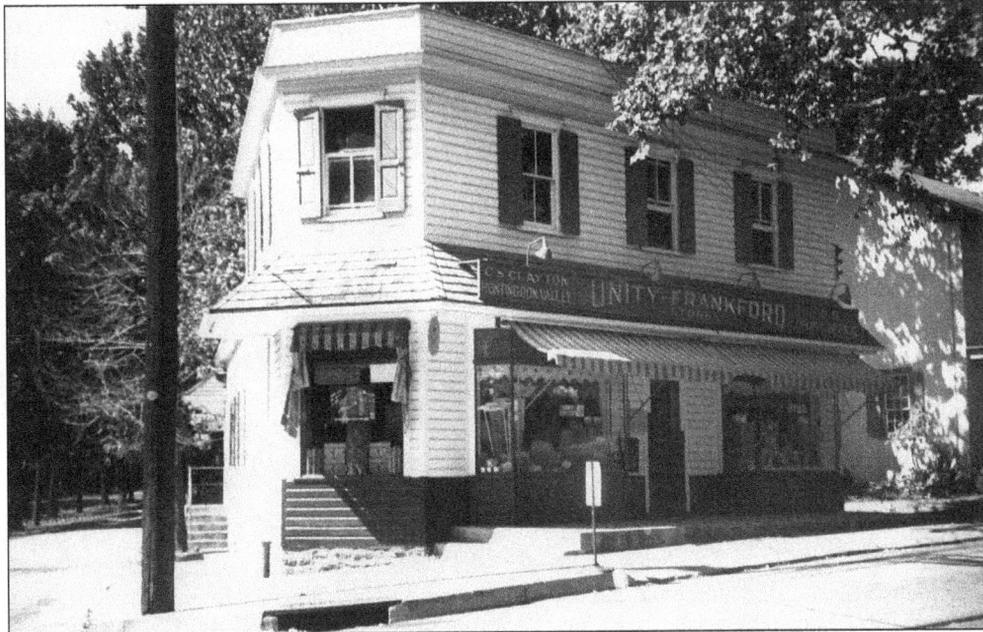

The Clayton home was set back from the northwest corner of Fetters Mill Road, and the family owned the site by 1877. The Claytons later constructed a small building on the corner and operated a store at the site. The Huntingdon Valley Post Office was in this store during the 1930s and early 1940s. Clayton's Unity Frankford store is shown here in 1944. The building is still standing and is now a men's clothing store.

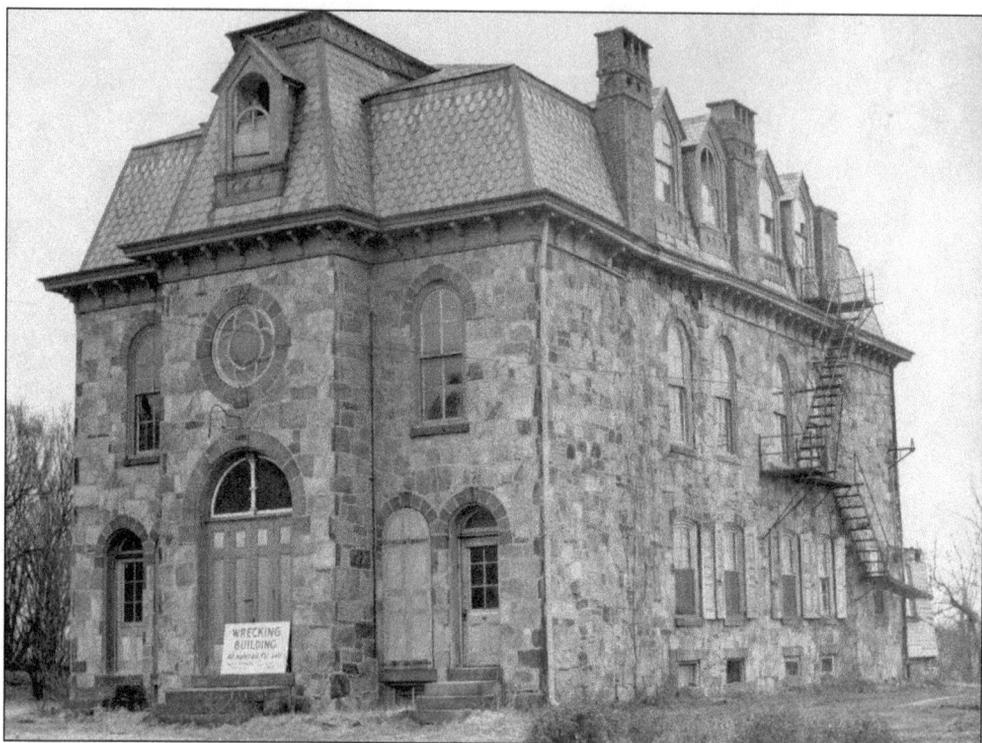

Eagle Lodge No. 222 of the International Order of Odd Fellows was established in Huntingdon Valley in 1847, and Eagle Hall was built in 1850. It was improved in 1869. The Red Men's Lodge also used the building. It was demolished for the 1955 construction of the Huntingdon Valley Savings and Loan building at 2643 Huntingdon Pike.

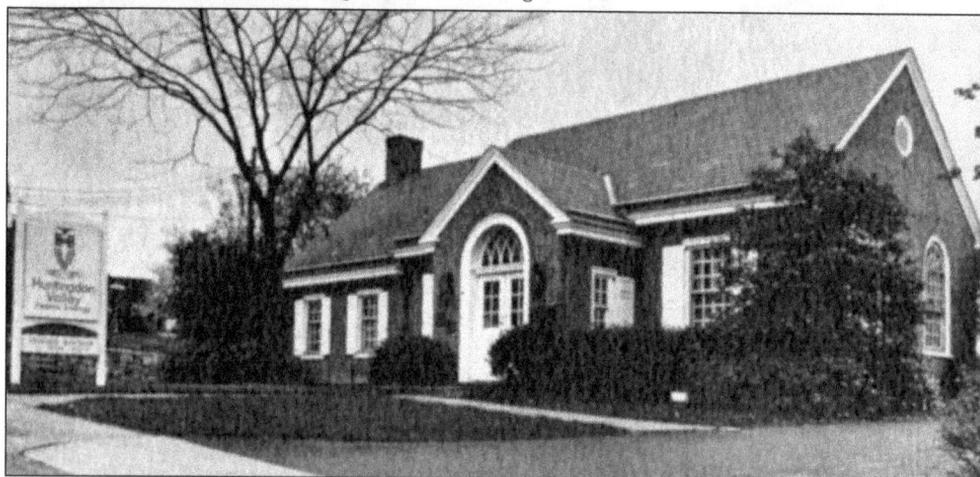

The Huntingdon Valley Perpetual Savings, Loan, and Building Association was established in 1871. In 1891, the name became the Huntingdon Valley Building Association. For many years the organization used temporary quarters, including the northern half of a small store at 2540 Huntingdon Pike from 1951 to 1955. It then moved to this permanent home on the site of the former Eagle Hall. The name was again changed when the organization received a federal charter in 1951. In the late 1980s, the organization moved again to the corner of Red Lion Road. The old building is now a professional office with four tenants.

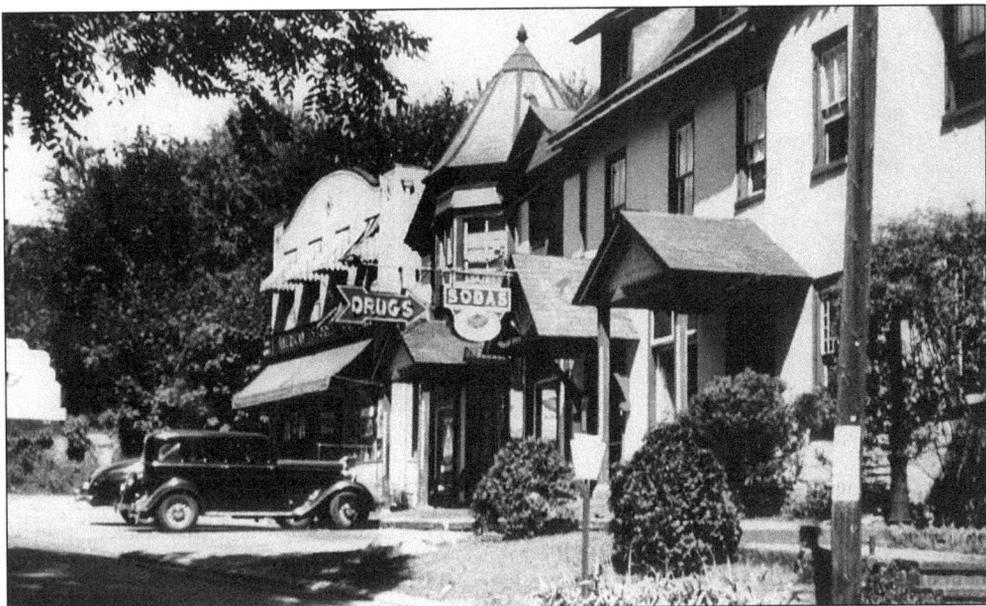

Brown's Drug Store was located on the northeast corner of Huntingdon Pike and Red Line Road, and an American Store was located at the northern end of the building, in this c. 1940 photograph. The drugstore had previously been the home of the Andrew Erwin store and Price's General Store and served both as a private home and business site. Erwin was reputed to own most of the mortgages in the area; the Hallowells held the remainder. The Huntingdon Valley Bank is currently located on this site.

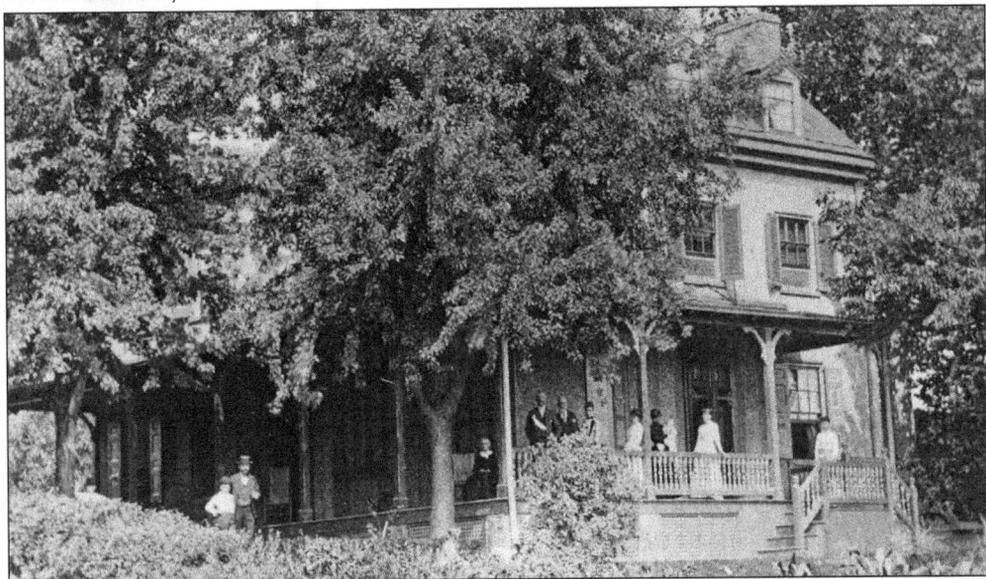

Mount Jolly originally encompassed over 72 acres, extending north to Buck Road and south to Red Lion Road. In 1871, the whole parcel belonged to John Simons, and the house was on the site. W.C. O'Neal owned the property in 1893 and into the 1930s. During this time the property was known as Hillcrest Farm. By 1934, W.C. O'Neal Jr. owned two small plots with the house along the pike, and the rest, now known as Mount Joli Farm, was part of the estate of his father. The house has been extensively renovated for professional offices.

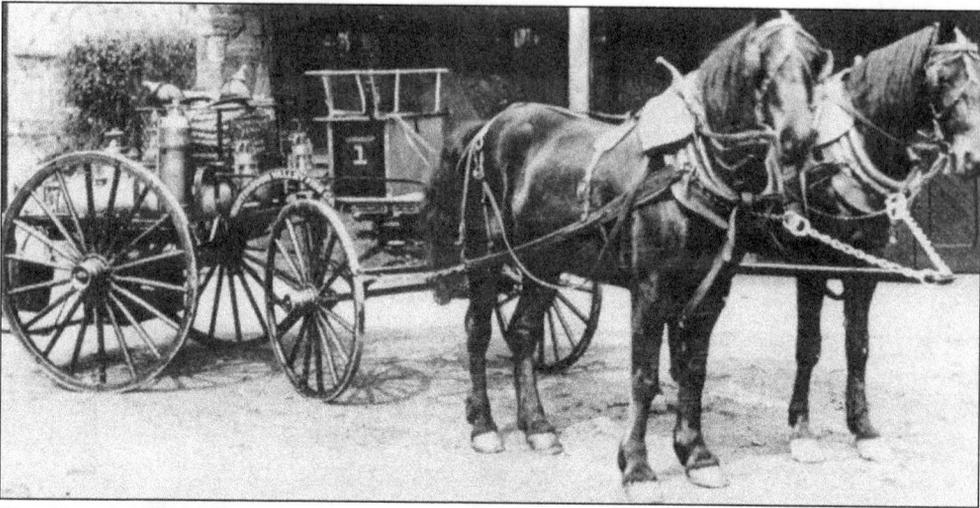

The Huntingdon Valley Fire Company was organized in June 1911, and the first equipment consisted of a hand-drawn chemical truck with 500 feet of hose. After four months of vigorous fund-raising, the company was able to purchase a two-wheeled cart with a tank and hose. Fire alarms were sounded on a donated iron wheel. The first firehouse was built on land donated by Newton Branin, a local butcher, on the south side of Red Lion Road just east of Huntingdon Pike and was completed in May 1913.

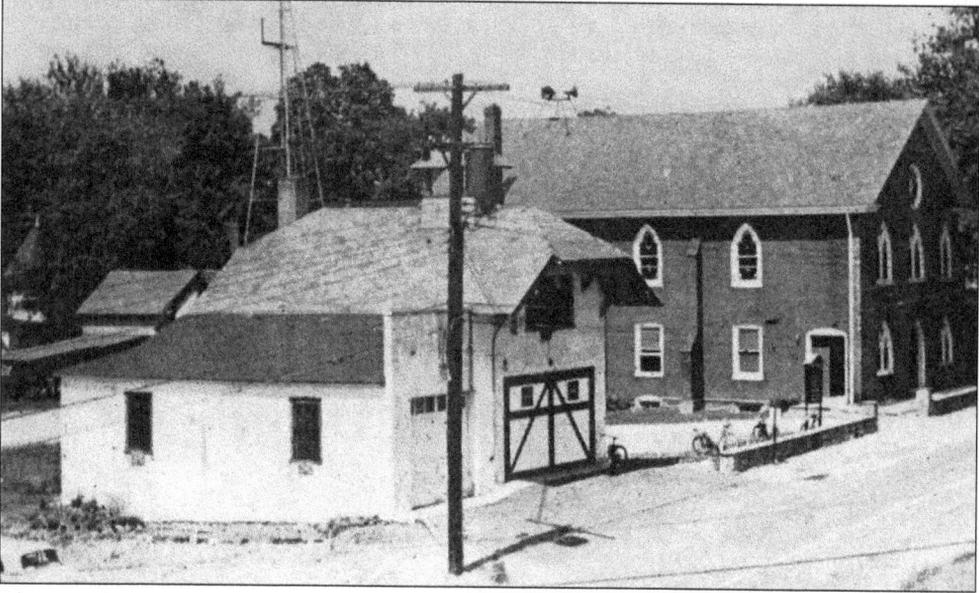

The 1913 home of the Huntingdon Valley Fire Company on Red Lion Road is shown here in 1952. The modern home is located at the same site and was dedicated on September 19, 1953. The company still has the old iron wheel in front of its quarters. The building at the right is the Memorial Baptist Church. The cornerstone for the red brick church was laid in 1900. The membership at the time numbered 23, and the first minister was S. Paul Jefferson. After the church moved to a modern new building farther north on Huntingdon Pike in 1962, the building became the Huntingdon Valley Library until 1992 when the library moved across the street to the renovated Red Lion School site. The former church building is currently used for professional offices.

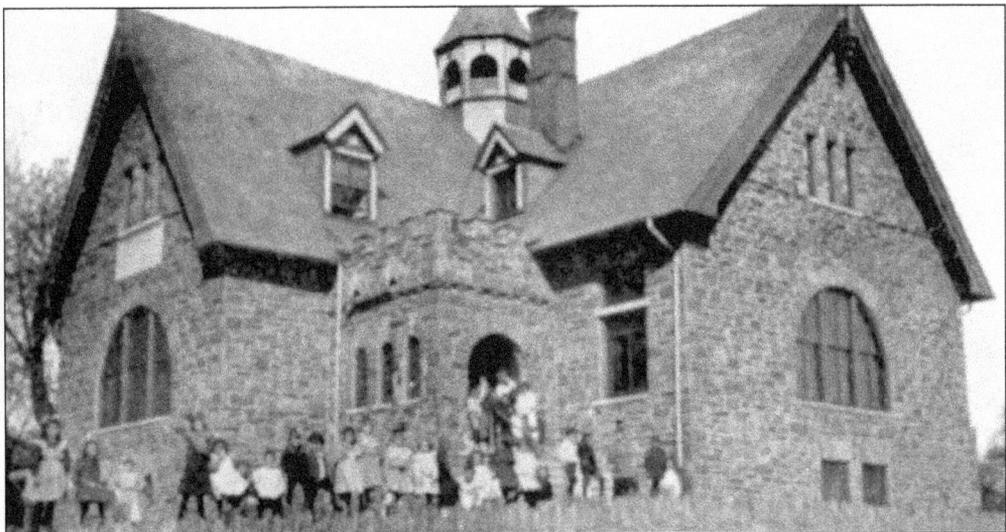

The Red Lion School opened in 1892. The building contained four classrooms for grades one through eight. In 1916, when the township split into Lower and Upper Moreland, the school added four more rooms and an upstairs auditorium. Additions were also made in 1930, 1952, 1962, and 1968. When the school closed in June 1980, it was the oldest continuously operating school in Montgomery County. The Huntingdon Valley Library acquired the site in 1992, demolished all but the 1916 addition, and added a modern building.

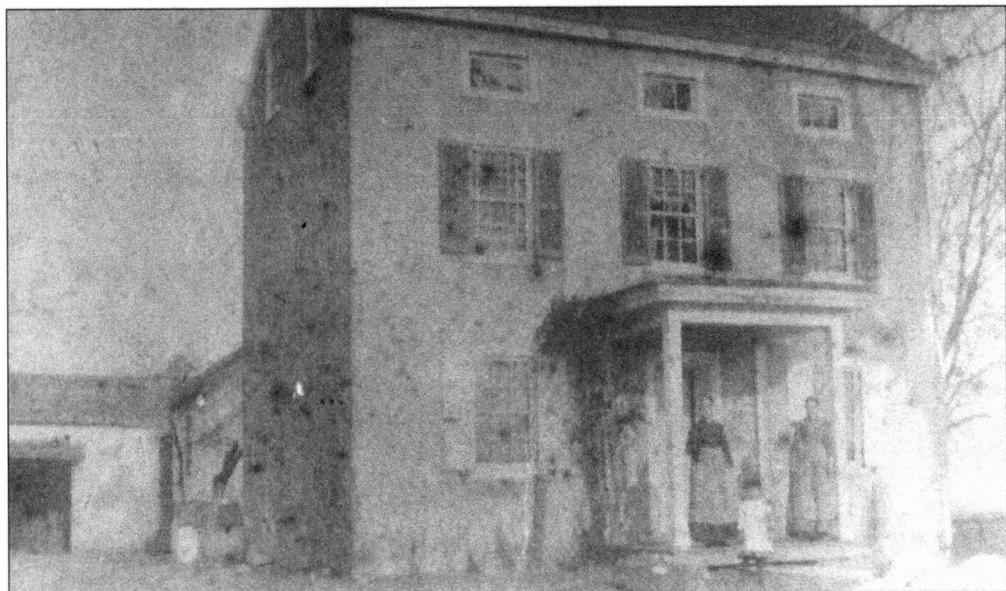

The Ely House is on Red Lion Road in front of the Huntingdon Valley Library and was built c. 1804 by a local stonemason named Ephraim Slugg. Franklin Ely and his wife, Emma Dyer Ely, came to live in the house in 1867 and by 1870 were using a shed in back of the house for the slaughtering and processing of pigs. In 1920, a two-story wooden structure was added to the rear of the original six-room house. The township used the building as the home and office of the school district superintendent in the 1930s, and in the 1970s, it was the tax collector's office. The house was vacant and in very bad condition when the township's Historic Architectural Review Board saved it from demolition in 1996.

In 1967, the new Lower Moreland High School on Red Lion Road opened for grades nine through twelve. The school's water polo team was the league champion in 1972 and went to Europe. Members pictured from left to right are manager Jim Schwartz, Bruce Pawloski, Jack Milne, Craig Schwartz, Mark Rozsa, Kirk Miller, Lee Cummins, Steve Dotzman, Tom Pecht, Bill Betz, Brian McMillan, Francis Ciabattoni, and Coach Barren.

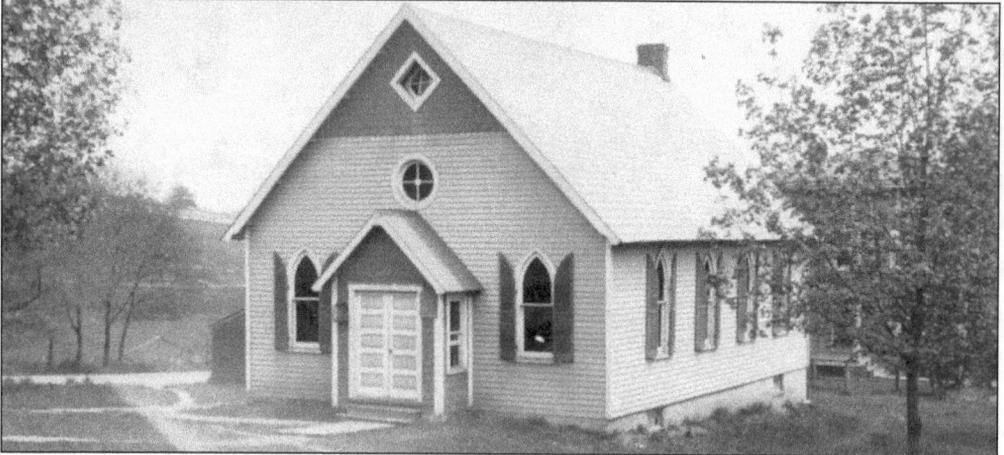

The first home of the Methodist Episcopal Church of Huntingdon Valley was at the southeast corner of Red Lion Road and Murray Avenue. It organized on February 6, 1892, with five members. The small building was dedicated on October 15, 1892. An educational wing was added in 1950. When the congregation outgrew the old building, a five-acre site was purchased at the southwest corner of Huntingdon Pike and Byberry Road, and a large new building was dedicated in 1959. The old church building served as the Huntingdon Church of the Nazarene for many years and is now the home of the Penta Corporation Insurance Agency.

84

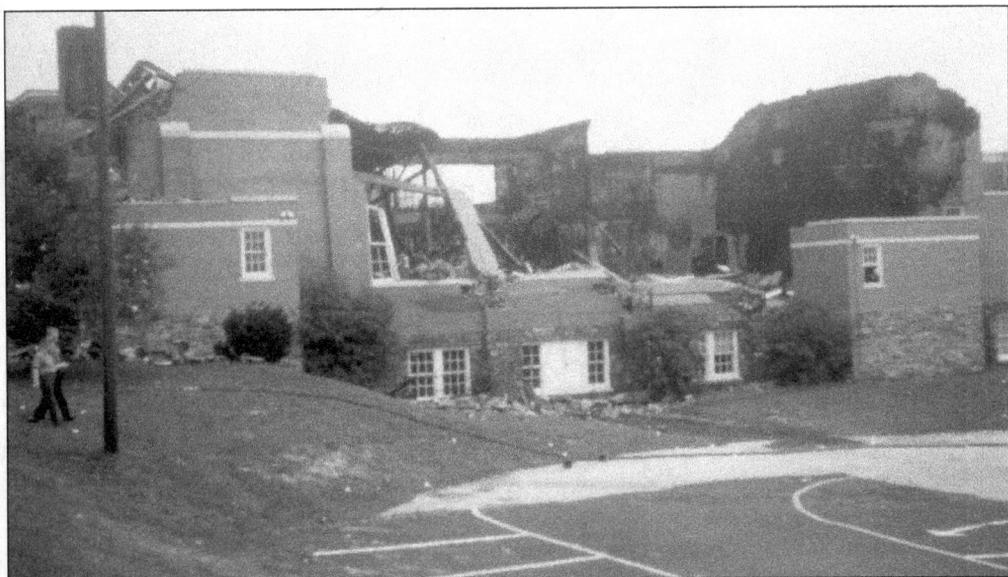

The Huntingdon Valley School on Murray Avenue was built in 1926, and the first class was graduated in 1928. In 1967, the new senior high school on Red Lion Road opened, and the older building became the intermediate school for grades six through eight. In October 1967, a fire damaged 12 classrooms and the auditorium and the district had to use temporary quarters. The building was repaired, and by 1995, after some realignment of the grades, the building became the Murray Avenue Elementary School.

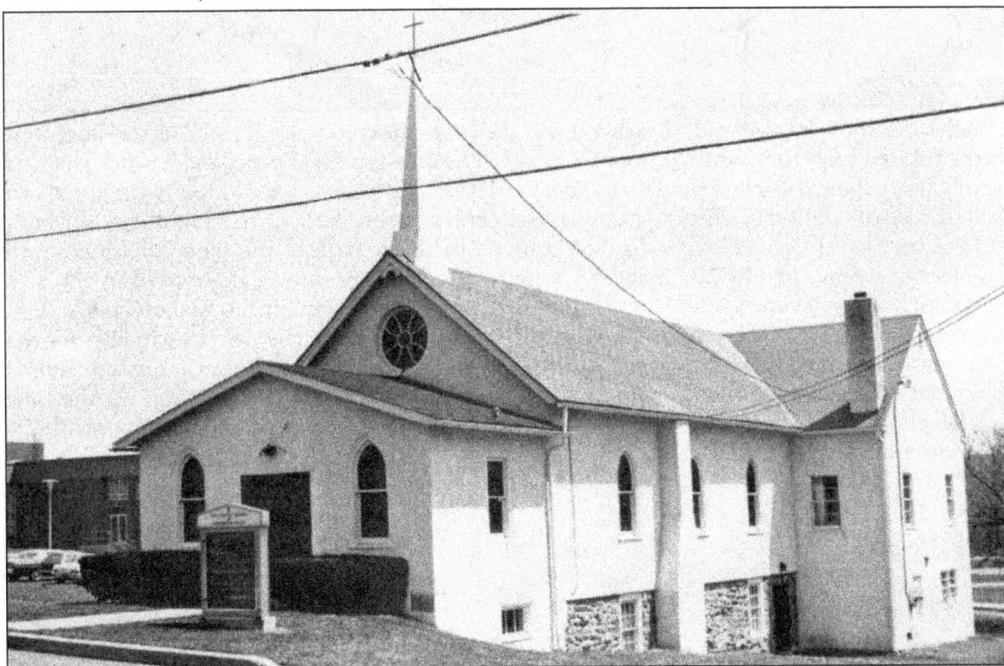

The First Baptist Church of Huntingdon Valley is located just south of the Murray Avenue School on Murray Avenue. The African-American congregation was founded in 1898, and the first meetings were held in the Odd Fellows Hall. The church was built in 1901 and has been improved several times since. The first pastor was Rev. Price D. Chandler.

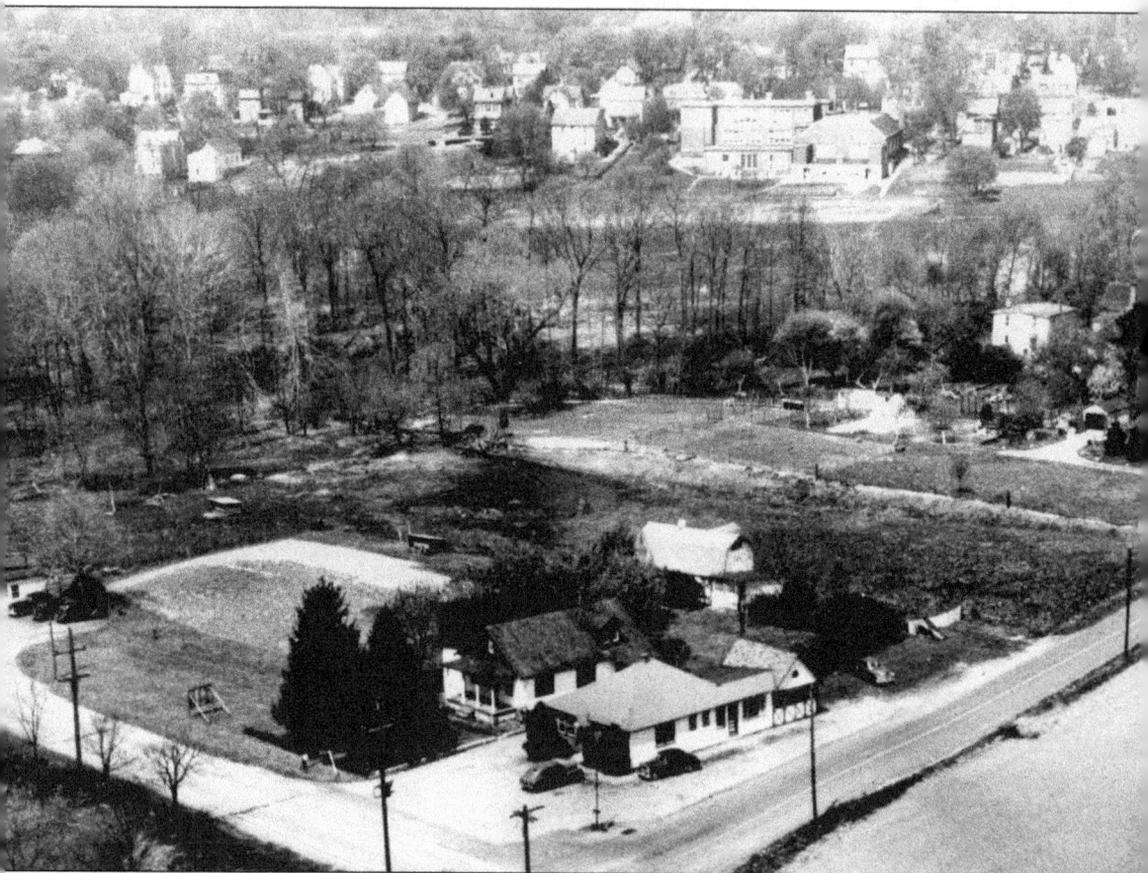

Hutch's Bar (now known as Tailfeathers) and the house next to it are located at the southwest corner of Red Lion Road and Philmont Avenue. The area is a flood plain and has not changed significantly since this photograph was taken c. 1950. The house on Red Lion Road just above Hutch's is still standing. On the ridge in the center is the back of the Huntingdon Valley School on Murray Avenue. The district's athletic fields are back of the school. Farther south on Murray Avenue is the First Baptist Church. On the other side of the school in the area between Murray Avenue and Huntingdon Pike is the small building that housed the L.B. Saint Glass factory, which made stained glass windows, including the first 13 windows for the National Cathedral in Washington, D.C. Just to the south of Hutch's on the eastern side of Philmont Avenue stood the 22-acre property of Butterworth & Sons Company. At the time of the photograph, Butterworth was the world's largest independent producer of synthetic yarn-spinning machinery.

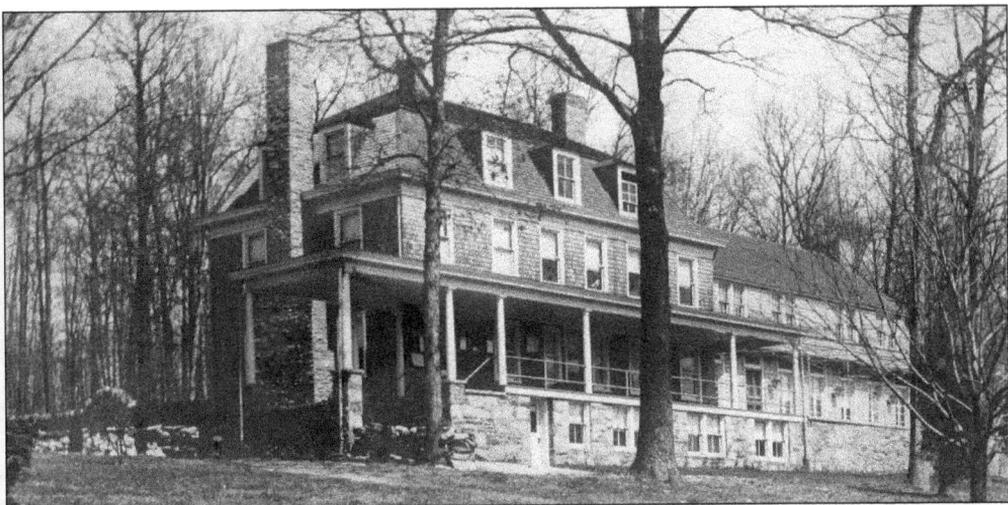

Samuel D. Lit's wife chose the site of the Philmont Country Club at the northwest corner of Tomlinson and Pine Roads. The club was formally organized on October 26, 1906, and Ellis A. Gimbel was elected president, a post he would hold for many years. Originally, the club leased the farms of James Macauley and W.H. Boucher and purchased the properties in 1911. Later property additions extended the boundaries west to Buck Road and across Tomlinson Road. The club opened on May 18, 1907, and the first clubhouse was the former Macauley farmhouse. A nearby small structure served as a locker building. A new building designed by Edwin H. Silverman and Abraham Levi was built in 1913, and the entrance was moved to Pine Road. In 1916, the Jackson farm was purchased and became the north course in 1922. The club was the first major Jewish country club in southeastern Pennsylvania, and members included Jews active in business, banking, manufacturing, and philanthropic organizations.

Greenridge Farm extended south from County Line Road along both sides of Pine Road. The house dated from c. 1854 and stood on the west side of Pine Road. Clayton A. Hoover owned the 148-acre property in 1934. He sold the property in the mid-1950s to a developer who subsequently built homes on the farm from the late 1950s to the early 1960s. This photograph dates from c. 1950.

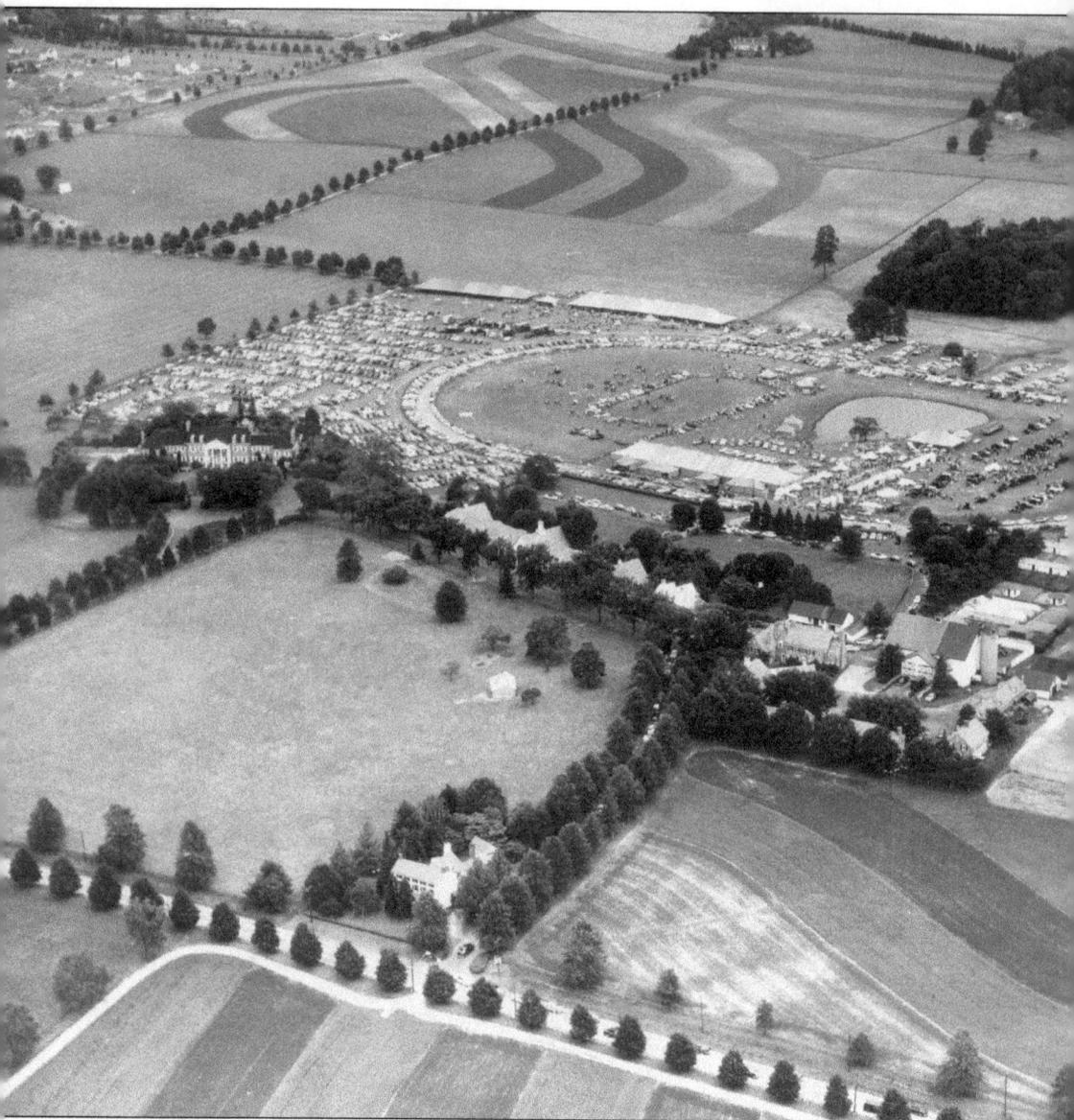

George W. Elkins purchased the farmland for his Justa Farm in the 1920s. Elkins was the grandson of William L. Elkins, the traction magnate for whom Elkins Park is named, and son of George W. Elkins, the founder of Abington Memorial Hospital who owned Folly Farm in Abington. At its height, Justa Farm totaled some 600 acres and extended from Byberry Road north to County Line and from Buck Road west across Huntingdon Pike to Heaton (now Creek) Road. The property included a dairy farm and at various times herds of Black Angus cattle and Brahma bulls. Elkins's wife, the former Natalie Crozier Fox, was vice president of the Women's Board of the hospital from the founding of the hospital until her death in 1954. From 1946 to 1956, the hospital's main benefit, the June Fete, was held on the grounds of Justa Farm. This view of the 1955 June Fete looks east across the Elkins estate, with Huntingdon Pike in the foreground. The main house is to the north. The group of houses around the barn was designed by Charles F. Rabenold in 1936 and is known today as Keller's Farm. Both the main house and the Keller's Farm buildings still stand.

88

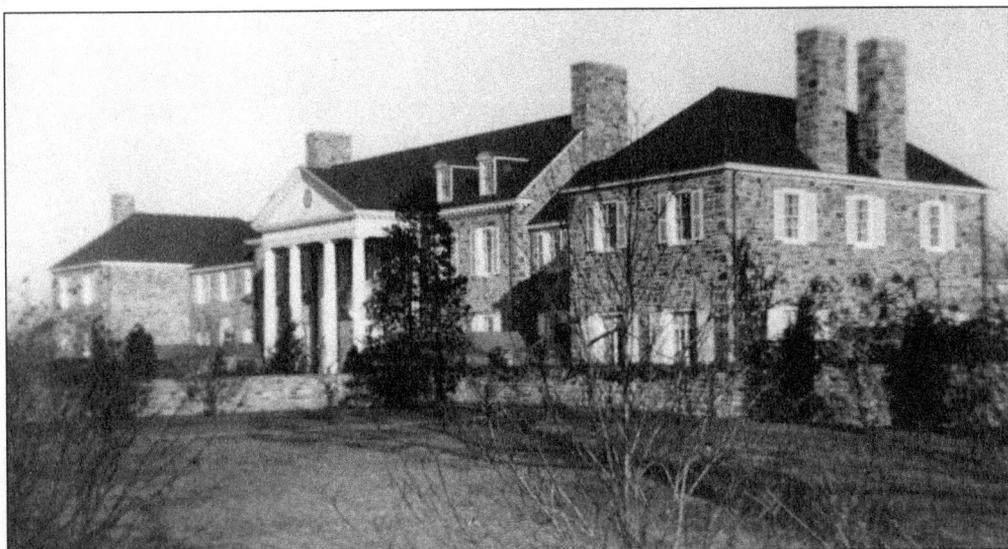

The Elkins family lived at Chelten House in Chelten Hills and maintained Justa Farm as a horse stable. However, in the mid-1930s, the family sold their land in Chelten Hills and moved out of Cheltenham Township. Elkins hired the architectural firm of Willing, Sims & Talbutt to design the main estate house in 1936. The family moved into the house *c.* 1938. In 1954, Elkins and his wife died within five days of each other. Their son George Jr. moved across Huntingdon Pike and took up residence in the main house until the property was sold in 1958 for development. While many of the buildings on the property remain, the farmland was developed throughout the 1960s. Albidale is the development on the east side of Huntingdon Pike.

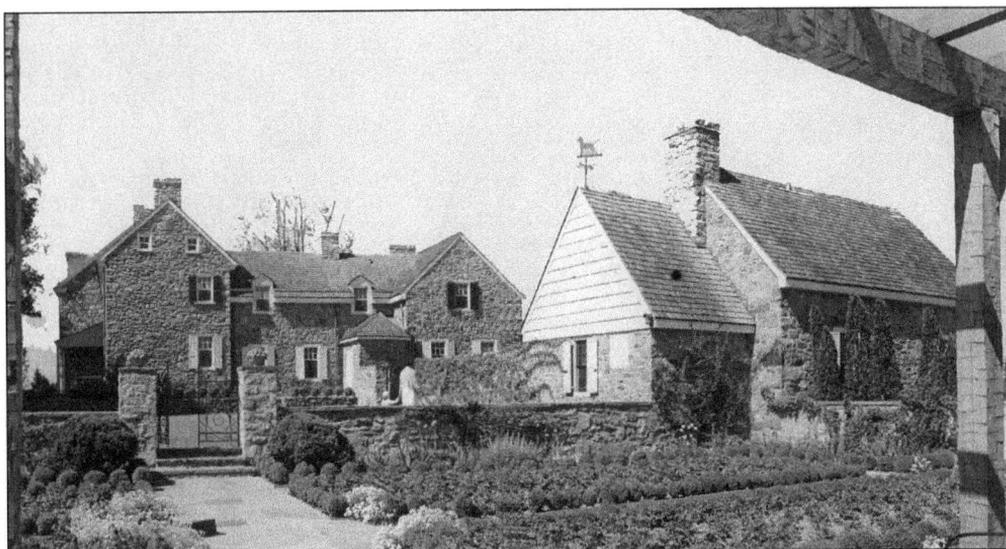

Justa Corner was the house of Elkins's son George Jr. and stood near the southwestern corner of Huntingdon Pike and County Line Road. It was the only significant complex of buildings on Justa Farm west of the Pike. The home incorporated a 1791 farmhouse and was likely designed by Willing, Sims & Talbutt in 1935. When Justa Farm was sold, the development on the west side of Huntingdon Pike was named Justa Farm. Justa Corner still stands on Mettler Lane.

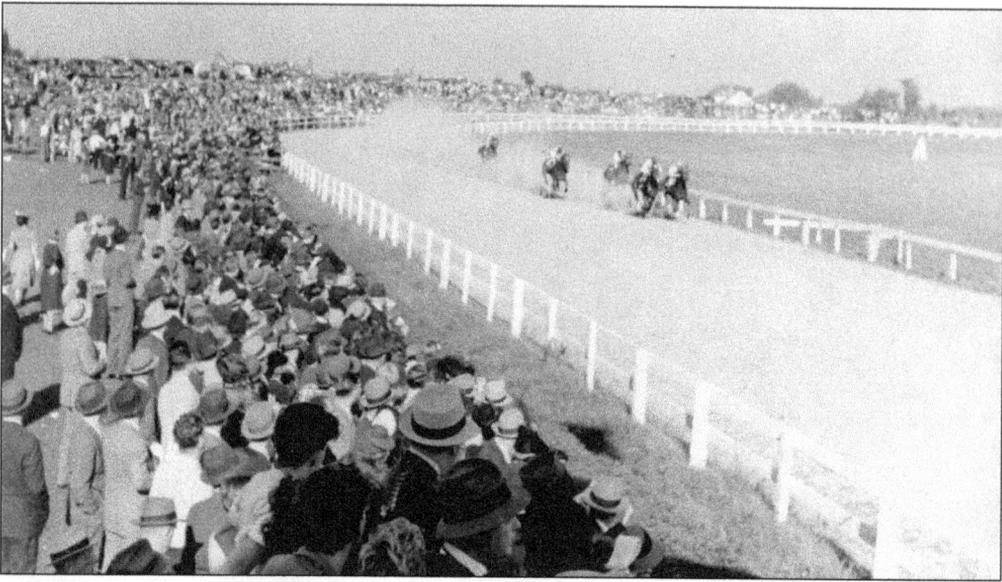

In 1928, Elkins, in partnership with his eldest daughter, Stella, then 18 years old and a fine rider, constructed a stable and racetrack on the fields of Justa Farm. The course opened in October and included a half-mile racing track, a three-mile steeplechase course, and a brush course. It cost $500,000 and was considered one of the finest privately owned racetracks in the country. The following year the steeplechase course was modified so that viewers would have an unobstructed view of the entire course. The races held at Justa Farm were among the high-society events of the year, and attracted thousands of racing enthusiasts. Pictured is one of the races held on Saturday, October 7, 1939, as part of the 29th Race Meeting of the Huntingdon Valley Hunt.

George W. Elkins was one of the preeminent sportsmen and racing enthusiasts in America. The Justa Farm Stables attained great renown, as its horses regularly won many top racing events. Elkins was also considered a top breeder, and the stables produced many winning thoroughbreds. The main stable was built according to plans by architects Tilden, Register & Pepper. It was designed so that during inclement weather horses could continue to exercise inside along the perimeter of the building. Elkins also raised many hunters and jumpers and entered them in steeplechases throughout the country.

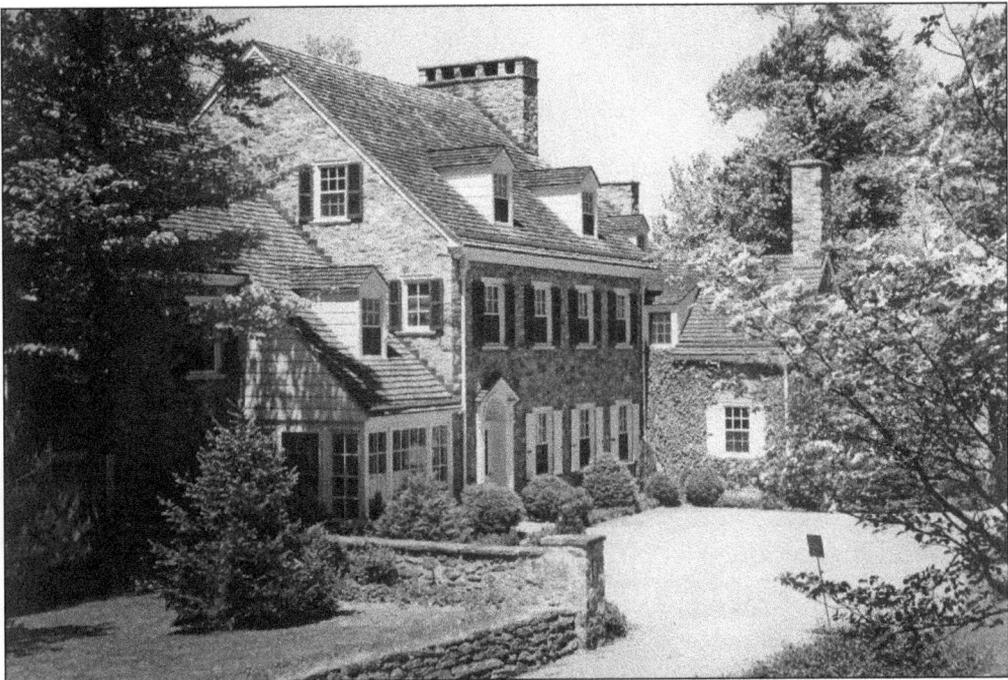

Justamere House was built in 1930 for Stella McIntire Elkins and her husband, Lloyd Reeves. Designed by the firm of Tilden, Register & Pepper, the house was later occupied by Stella's sister Natalie and her family after Stella and Lloyd Reeves moved to Street Road in Southampton in the early 1950s. Natalie renamed the house Weatherwood. The house still stands on Buck Road.

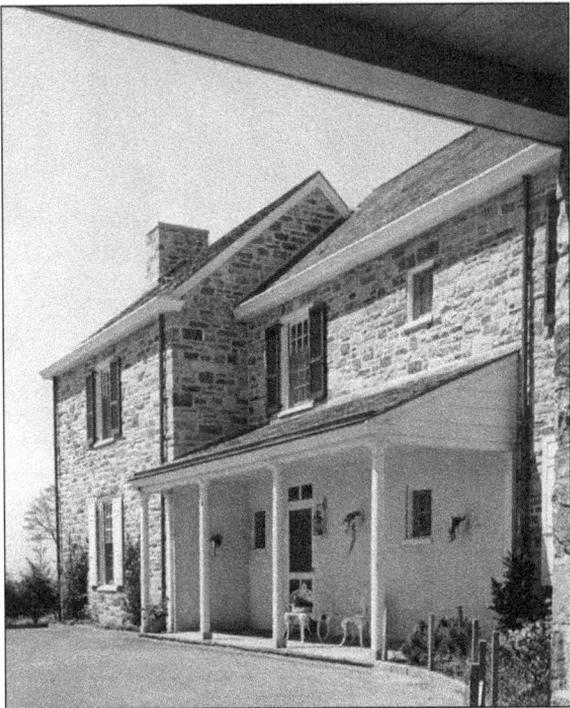

The Elkins's youngest daughter, Natalie Fox Elkins, married John Gribbel II, and they took up residence on Justa Farm near the Justamere House in 1938. The house was demolished c. 1990 to make way for a modern residence.

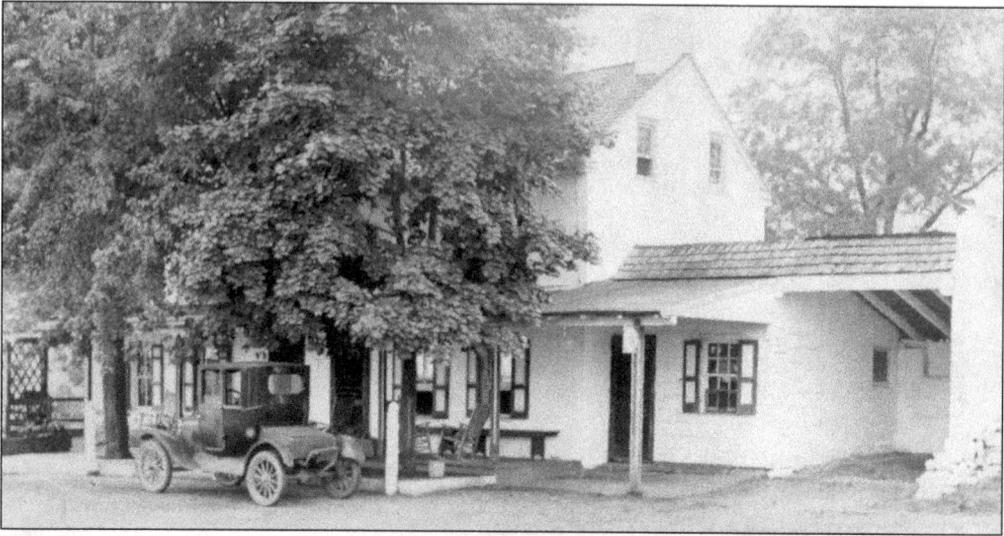

The Sorrel Horse Inn was built c. 1750 at the southwest corner of Huntingdon Pike and Spur Road. It was a two-story building with a long rear wing. There was a large stone barn in back and other barns to the south along the pike on the more than 34-acre farm. James Fulton was the landowner in 1737, and he kept the inn during the Revolution. His daughter sold to John Radcliff in 1825, and two years later, David Jones bought the property. There were several more transfers until 1881 when Elisha Engle bought the tavern and only the immediately surrounding 18 acres. Elections were held at the inn in 1779 and for more than 100 years thereafter.

The Sorrel Horse Inn stood on the southwest corner where the spur runs from Huntingdon Pike to Byberry Road. The inn was demolished in 1936. The triangular piece of ground became the home of the Huntingdon Valley Methodist Church in 1959 when it moved north from its old home on Red Lion Road. On the north side of Byberry Road is the Warner House, a 1780 farmhouse with its stable on the lower floor. The house was one of the last of its type in the state. The house was also known as the Sorrel Horse Annex and partially functioned as an inn after the Sorrel Horse Inn was demolished. Architect John Bower restored the building for George Elkins when he owned the property. The Penickpacka Historical Society was formed in 1966 to try to save the building from demolition but to no avail. The house was knocked down for a road-widening project that never occurred. The photograph dates from 1924.

Four

BRYN ATHYN

Alnwick Grove was located along the Pennypack Creek south of Fetter's Mill bridge. The area was improved in 1879 by a M.J. Campbell, an excursion agent in Philadelphia, and promoted as a "goodly land." It was a popular spot for Sunday school picnics, with tables, rowboats, canoes, pleasant places to swim, and a pavilion for dancing and shelter during storms. For those desiring to escape the heat of Philadelphia summers, the Philadelphia–Newtown line ran excursion trains to the site.

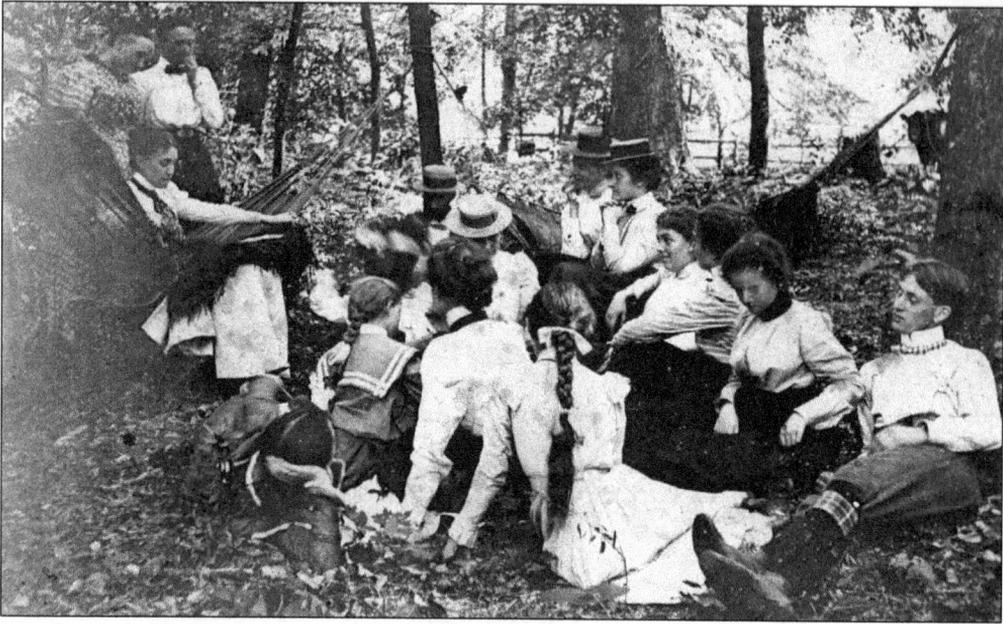

Members of the Swedenborgian community on Cherry Street in Philadelphia were among those who found the banks of the Pennypack Creek at Alnwick Grove a delightful site for picnic excursions. The Swedenborgians traveled to the grove in the 1880s. They came to the area for several summers before members of the community decided that the area would be a suitable site for locating their religious community.

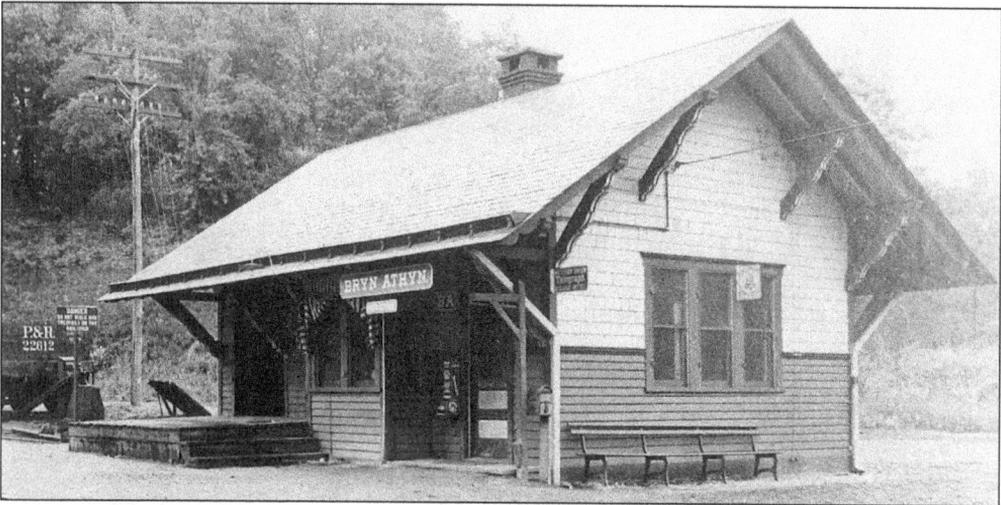

The original train station at Bryn Athyn was located at 2560 Fetter's Mill Road in Lower Moreland. The station came into being in the mid-1890s after John Pitcairn had purchased the surrounding land, including Alnwick Grove. In 1902, the original station closed after a new building had been erected on the opposite side of the tracks in what would later become the borough of Bryn Athyn. The name of the station changed from Alnwick to Bryn Athyn on November 18, 1899, prior to the move. The stationmaster at the time was Harry C. Young, who also served as the first postmaster. The station building still serves as the post office, and Bryn Athyn residents still come to the building to pick up their mail. The building that served as the first station, now in Lower Moreland Township, became Young's home.

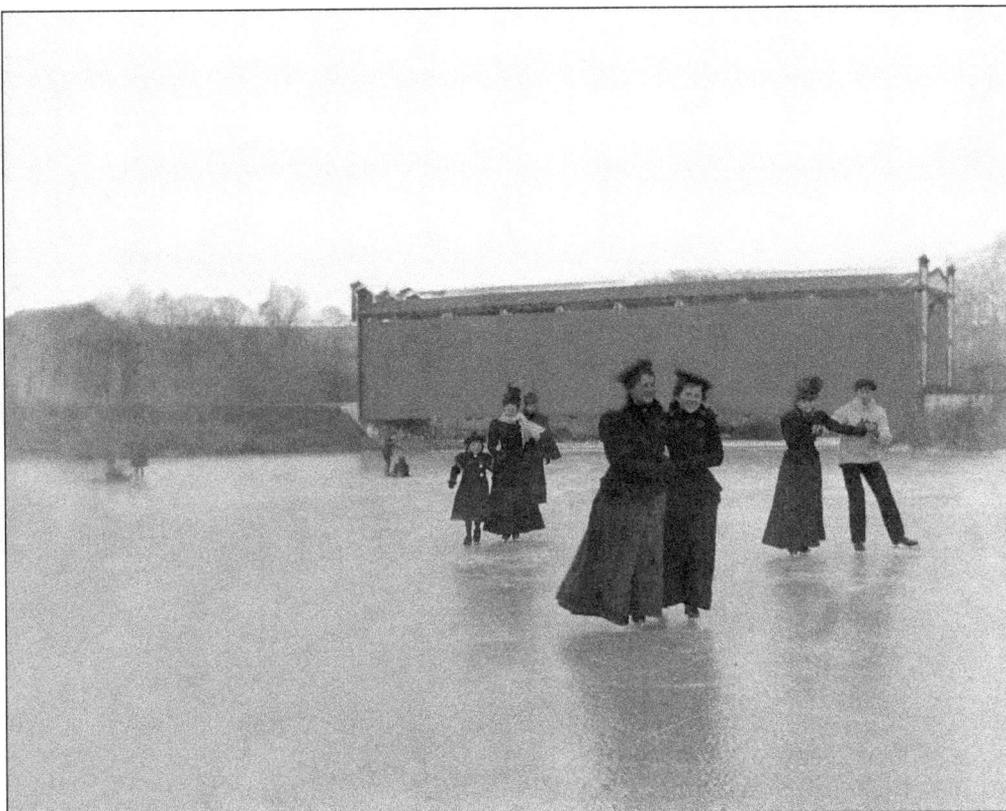

The course of the Pennypack Creek made a large loop northwest of the Bryn Athyn station, and railroad bridges crossed the creek at two points. A covered bridge was at the lower end of the loop, just above the station. Skating on the Pennypack was a popular pastime during the winter months. The photograph dates from c. 1895.

The decorative metal-trimmed covered bridge over the lower loop of the Pennypack was destroyed by fire on June 24 1916. The bridge was rebuilt by the railroad but without the cover.

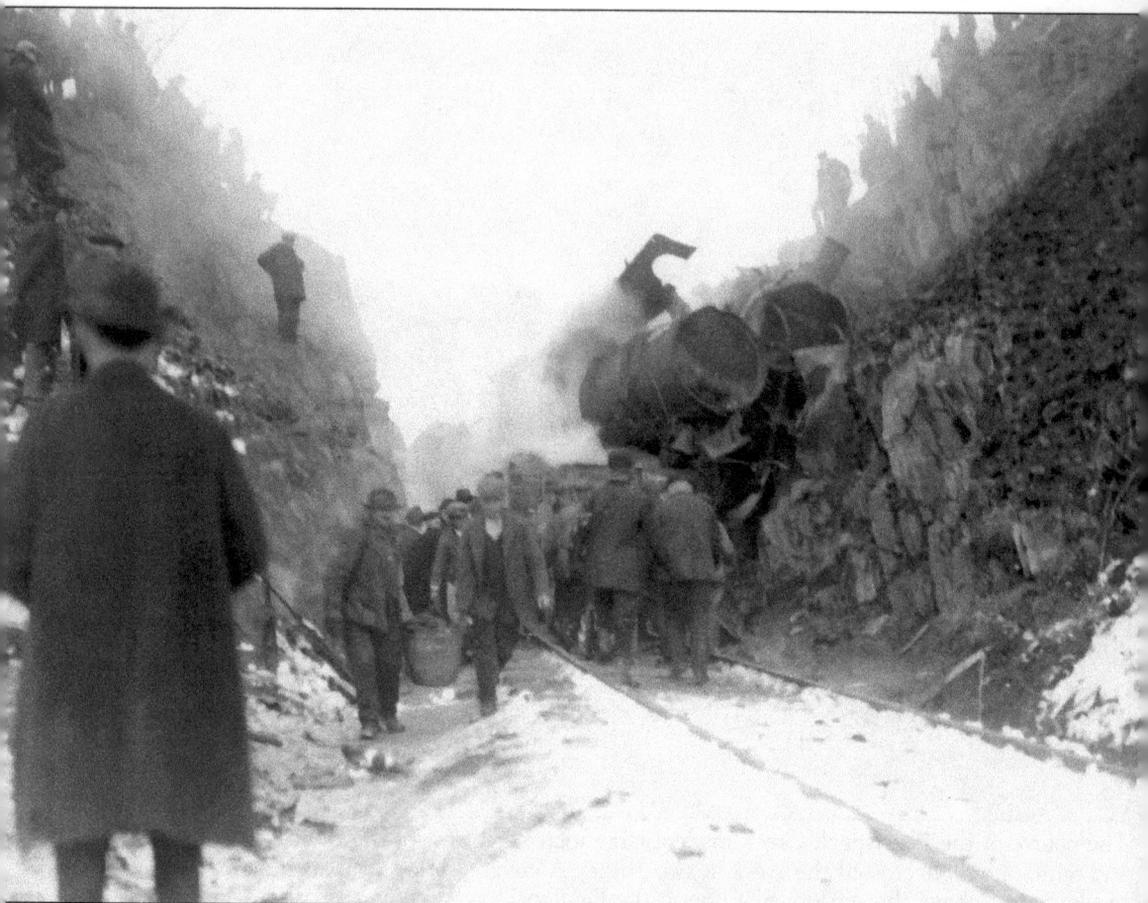

A terrible train wreck occurred on the single track Philadelphia–Newtown line north of Bryn Athyn on December 5, 1921. The engineer of the northbound train, which was carrying cathedral workmen and was due at Bryn Athyn at 7:25 a.m., had been ordered by the dispatcher at the Reading Terminal to pull onto a siding at Bryn Athyn and wait for the passage of two delayed southbound trains. The stationmaster at Bryn Athyn who received the telegraphed order wrote it out in duplicate and had the conductor of the northbound train sign one copy for his record. However, the northbound train pulled onto the track after only the first train had passed and proceeded north. The stationmaster, Russell Clayton, realizing what would happen, immediately called the fire company and the hospital, and then called his wife and instructed her to lock the telegraphed order in his safe. The two trains, both traveling at top speed, met head-on in a narrow rocky cut on a sharp curve; the results were devastating. The two locomotives reared up into the air, with the northbound one climbing over the other then falling over on its side, and both tenders fell back on the wooden passenger cars behind them. The wooden rail carriages then caught fire. Twenty-six people died in the inferno, and many more were seriously burned. Water had to be pumped from the Pennypack Creek, which was about 75 feet from the track, and the nearest road was about 150 feet beyond the creek. The only access to the catastrophe was a small footbridge over the creek, over which firemen pulled their hoses and removed the injured. The crew of the northbound train was held responsible for the accident. The account of the accident appeared in nationwide news and made the front page of the *New York Times*. The wreck was considered one of the worst in the history of the railroad. Following the inquiry, laws were passed banning the construction of wooden passenger cars and the use of gas fixtures in them.

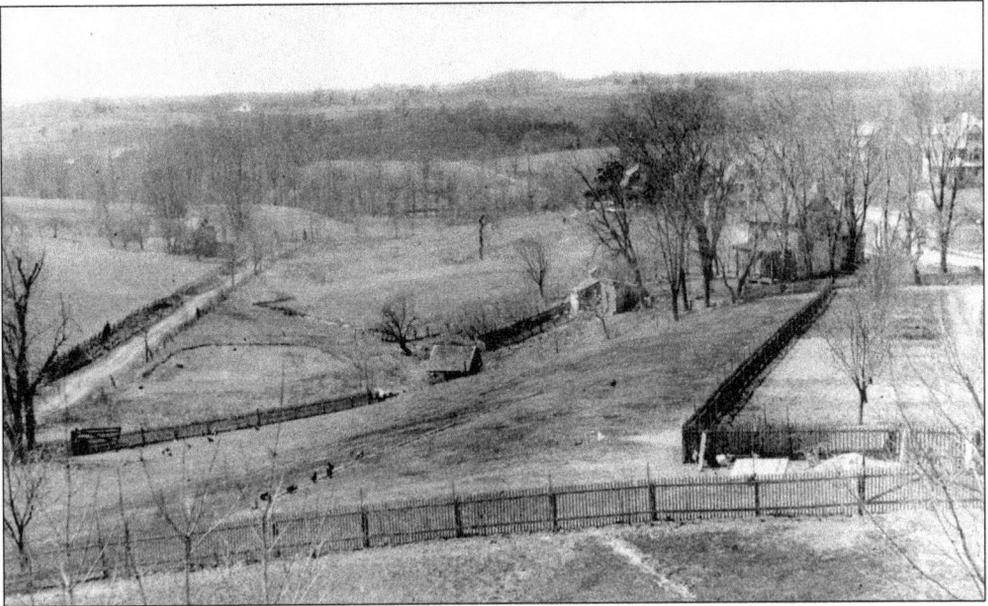

Bryn Athyn still presented a serene country vista in this c. 1895–1900 photograph. The house toward the upper left in the grove of trees is the Rose House on Alden Road. At the center right is the 1765 Marsh House, later occupied by Henry Stroh, who built many of the first houses in Bryn Athyn. He and his family lived here from 1895 until 1914. Edward Bostock Jr. bought the property and had the house torn down to build a new one. The springhouse is still standing. The houses at the right are on South Avenue. The view is from a house on Huntingdon Pike looking west.

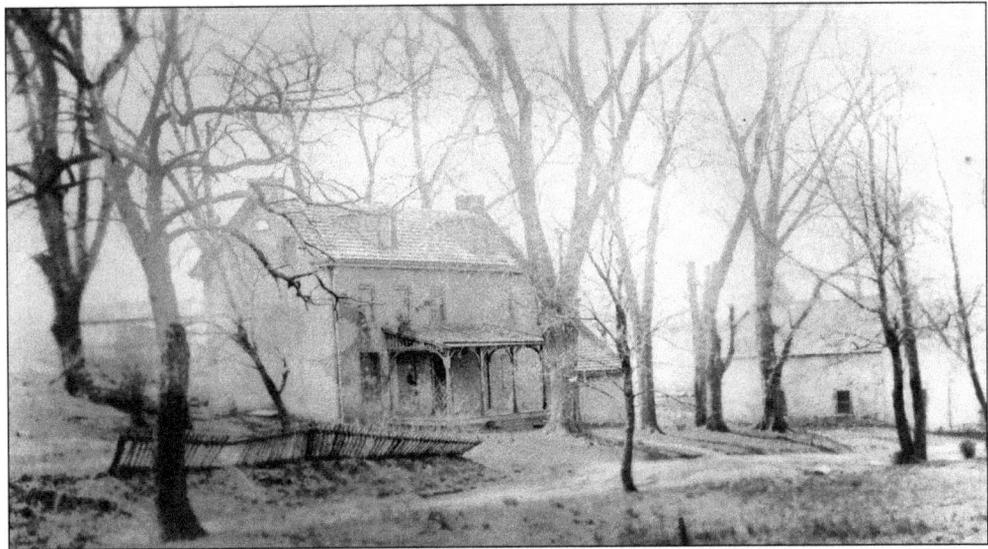

The Rose House is located at 2639 Alden Road and dates from c. 1792 when John Webster built the three-story fieldstone farmhouse. Christina Snyder owned the property in 1830, and later Benjamin Yerkes owned it and lived there until his death in 1851. His widow and son stayed in the house. From 1906 until 1910, James Worthington lived there. Transient farmworkers then occupied the house until Don Rose purchased the property in 1918. After he left in 1952, his daughter and her husband became the owners.

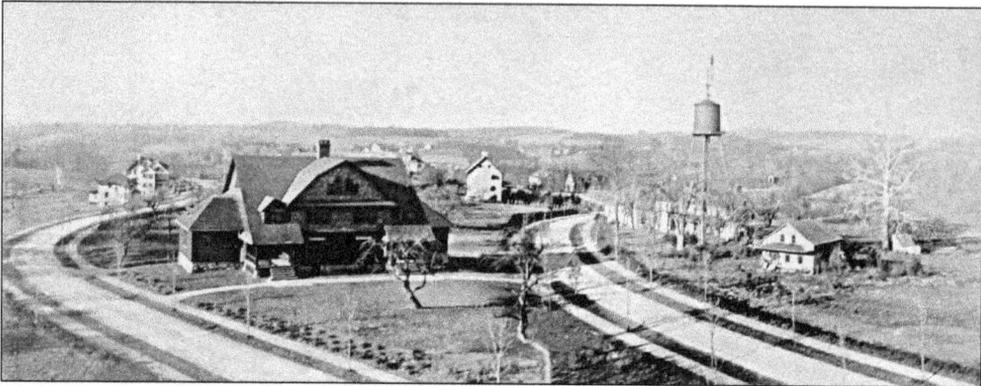

The Loop was the name given to the neighborhood bounded by Alnwick Road (right) and South Avenue (left). Laid out by the famed landscape architectural firm of Olmsted, Olmsted, & Elliot, the Loop was originally envisioned as a three-road development, with Alnwick Road named Central Avenue and a North Avenue looping into the valley. North Avenue was never laid out, and Central Avenue was renamed Alnwick Road early on. The loop became the site of many of the early and most important homes in Bryn Athyn. The Bryn Athyn Inn stood at the northeastern interior end of the loop, with access from both streets. The Potts House is just beyond on Alnwick Road. The building underneath the water tower is the Lescher Farmhouse, later called the Inn Annex, and the building at the right is the carriage house, later the home of Louis Pendleton.

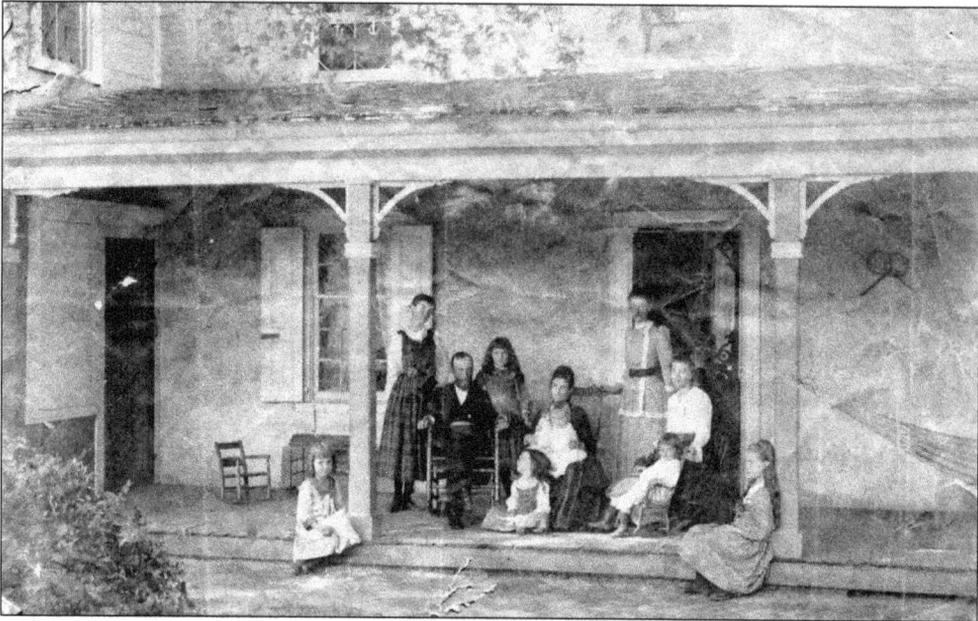

Bishop William F. Pendleton and his family rented the Lescher Farmhouse on the north side of Alnwick Road during the summer of 1895, while their new home was being built further west on the street. This group includes nine of their ten children. The house, later known as the Inn Annex, served from 1920 to 1923 as a dormitory, and from 1923 to 1939 as an apartment house with five apartments and the community nurse on the first floor. Later, the owners signed the property over to the Church, and Bishop Louis King's home is now on the site.

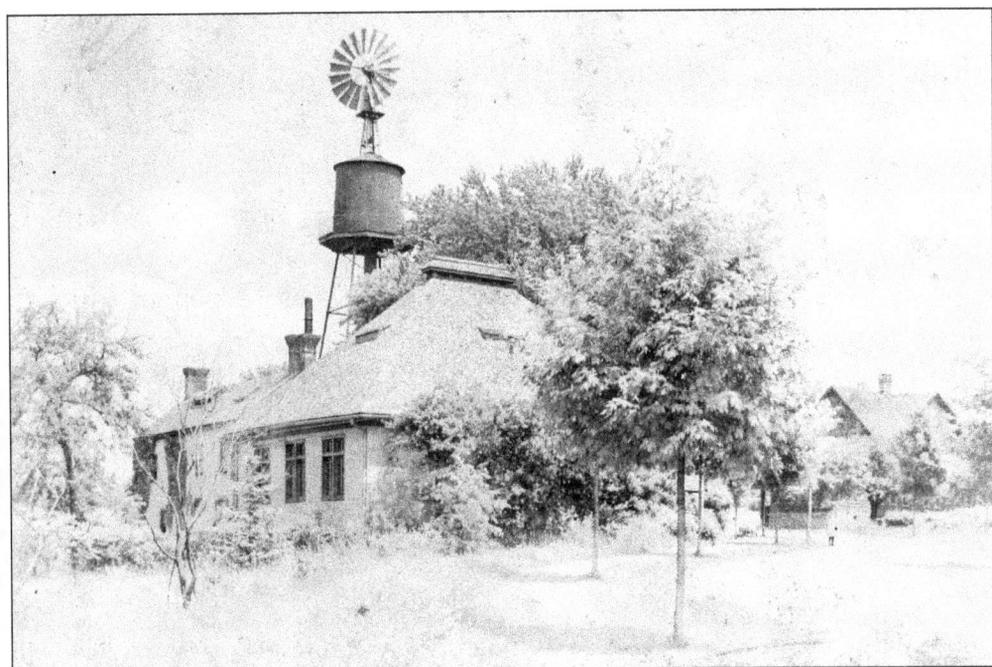

A large building was erected adjacent to the Lescher Farmhouse in 1895 to serve as the school, a clubhouse, and meeting area for the Academy of the New Church. It was known as the Clubhouse and was designed by Benjamin Smith and built by Henry Stroh. It was razed in 1903 because there was no longer any use for it, and the farmhouse was refitted again as a private home and became known as the Inn Annex. The windmill stood over the well between the house and the carriage house toward Alnwick Road. The building on the right is the Bryn Athyn Inn, located within the loop at the northeast end. The photograph dates from c. 1900.

A springhouse stood behind the windmill on the Inn Annex property. One of the two large sycamore trees in front of the building is still standing behind the Bishop Louis King House. The hill behind the springhouse later became the site of the Bryn Athyn Cathedral.

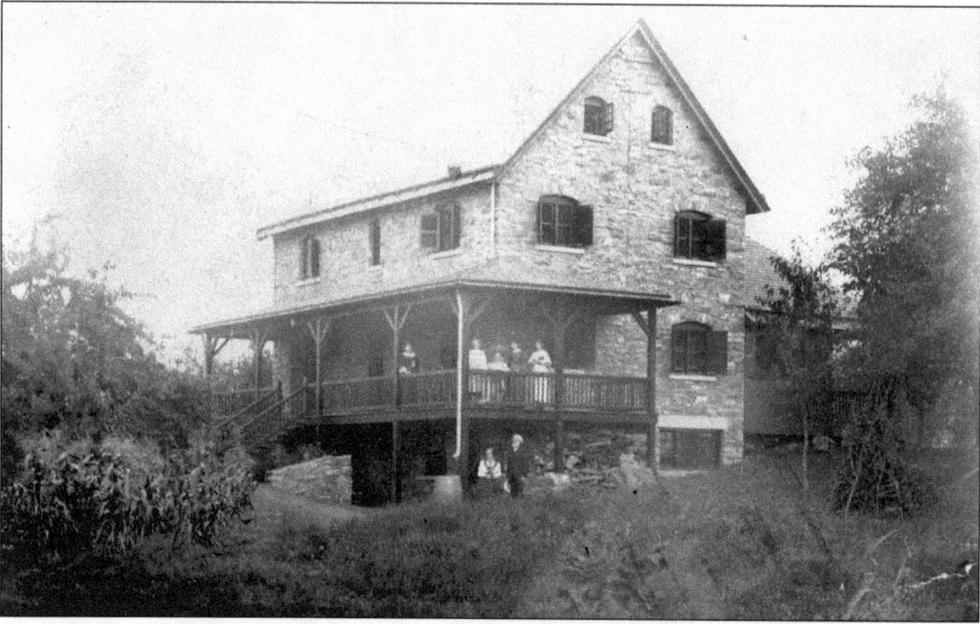

The Potts house, Stancott, meaning "stone cottage," dates from 1896 and is located on the south side of Alnwick Road. It was built for Rev. John Faulkner Potts, his wife, and nine children. Reverend Potts was not an active minister but rather spent 27 years, starting in Glasgow before his relocation to Bryn Athyn, compiling what would become a 10-volume concordance, or index, to the writings of Emanuel Swedenborg.

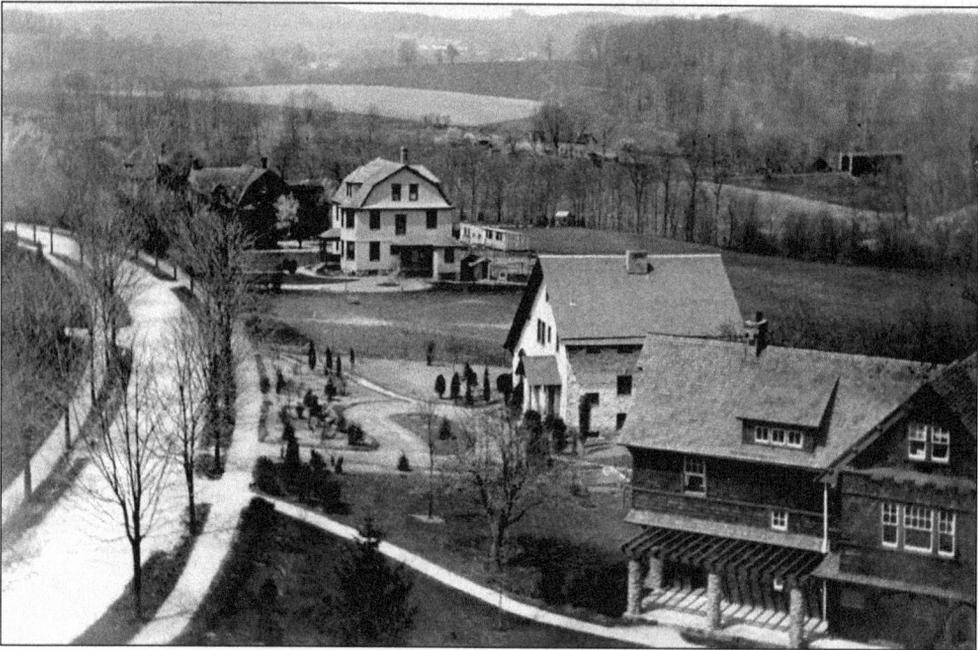

This view from the water tower looks west down Alnwick Road. In the right foreground are the Cooper-Brown and N.D. Pendleton houses. Beyond are the Alfred Acton and John Wells homes, both of which no longer stand. The covered railroad bridge over the southern crossing of the loop of the Pennypack Creek is at the upper right.

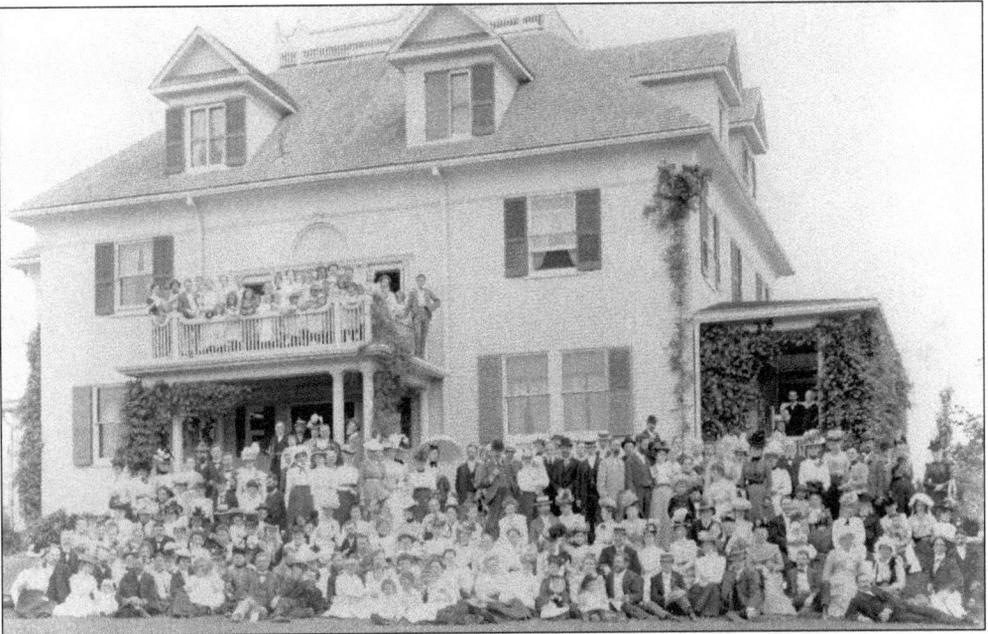

Henry Stroh built Pendle House in 1895 for the family of Bishop William F. Pendleton. The house is at 2701 Alnwick Road, on the south side within the loop and sited to look down the slope toward the valley and creek. The southern-style mansion remains a showplace in Bryn Athyn. The gathering is of the attendees at the International General Church Assembly in 1900.

The small Doering House at the right is at 2685 South Avenue and was the home of Rev. Charles Doering before he moved to the larger Starkey House. The brown-shingled house is unusual because of the four equally sized dormers. Reverend Doering was a doctor of theology and taught for 59 years at the Academy of the New Church. He also served as principal of the Boys School, dean of faculties, and treasurer of the academy. In 1929, William Cooper's family owned the house and they completely remodeled the interior and removed the front porch. A workshop, breezeway, patio, and terraces were also added. The other two houses at the left are the second and third of similar houses built by Henry Stroh. The first, located off to the right and not pictured, is the Vinet House at 2671. The Schwindt House at 2691 is immediately to the left of the Doering House, and the Hobart House at 2697 is at the far left on South Avenue.

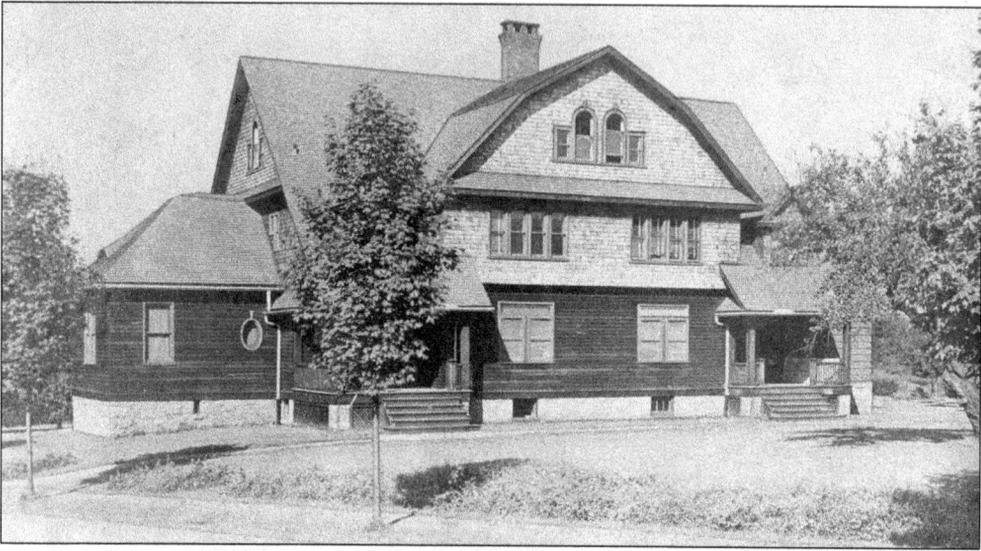

The Bryn Athyn Inn was built in 1898 at the northeastern end of the loop and was at that time one of the largest buildings in Bryn Athyn. It first served as the boys' dormitory, and later as the girls' dormitory. When new dorm buildings were constructed, the three-story building became the inn with rental apartments. At the time it was listed for sale in 1938, it had 22 rooms and 7 baths. There were no buyers; so, in September 1939, it was demolished and replaced by a new house. This photograph dates from c. 1905.

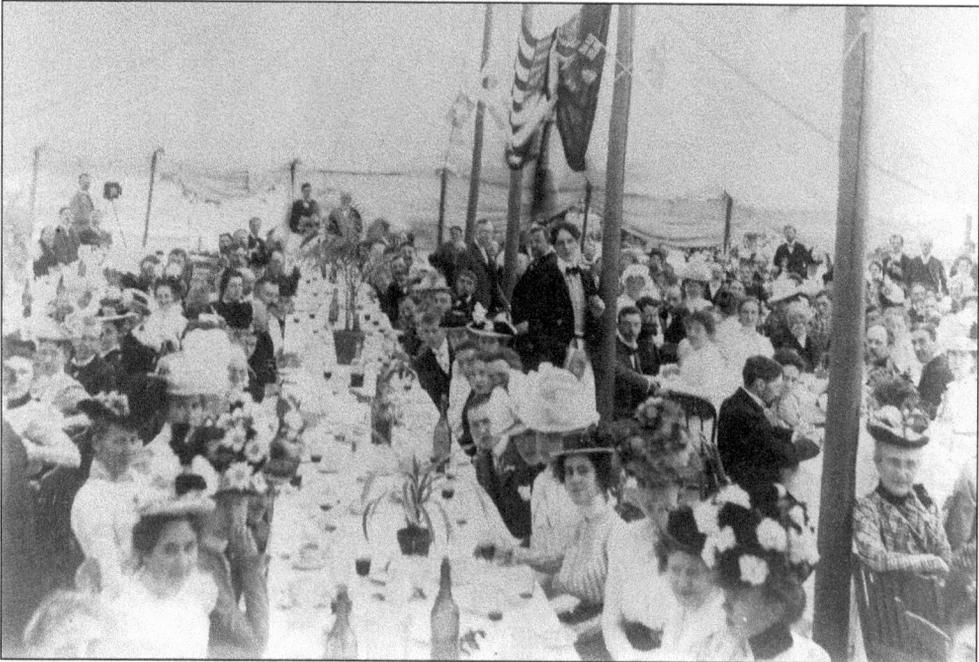

The participants in the International General Church Assembly in 1900 dined in a tent on the grounds of the Bryn Athyn Inn. These assemblies were held every few years and included delegates from all the countries where the New Church was established. The community centered in Bryn Athyn is but one of several Swedenborgian sects throughout the world, albeit the largest and most renowned. The General Church has missions around the world.

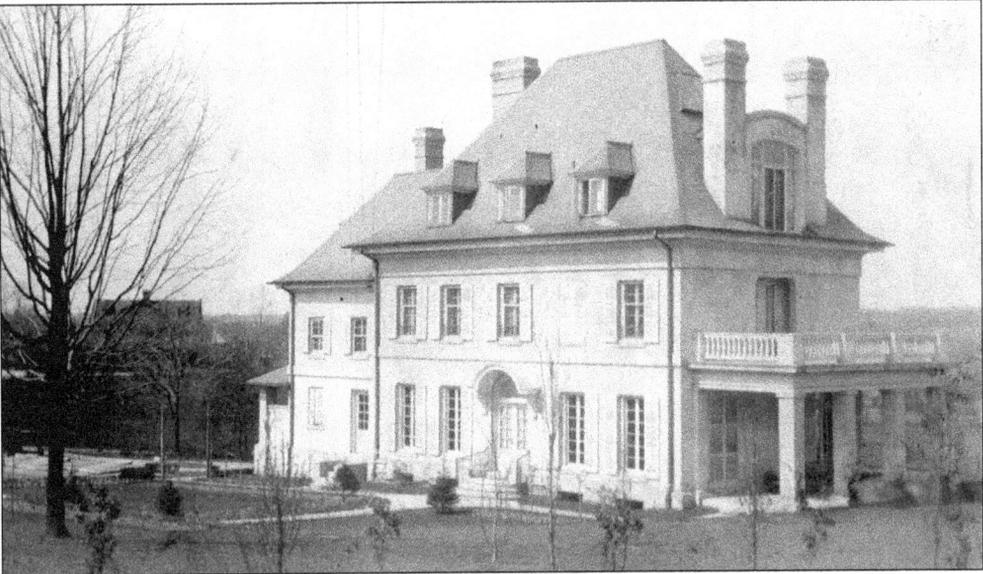

Regina Iungerich's house still stands at 2832 Alnwick Road, east of the loop near Huntingdon Pike, and was built in 1910. The Howards were later owners, as were Robert Cole and his son. The French chateau–style house was called Petit Chateau.

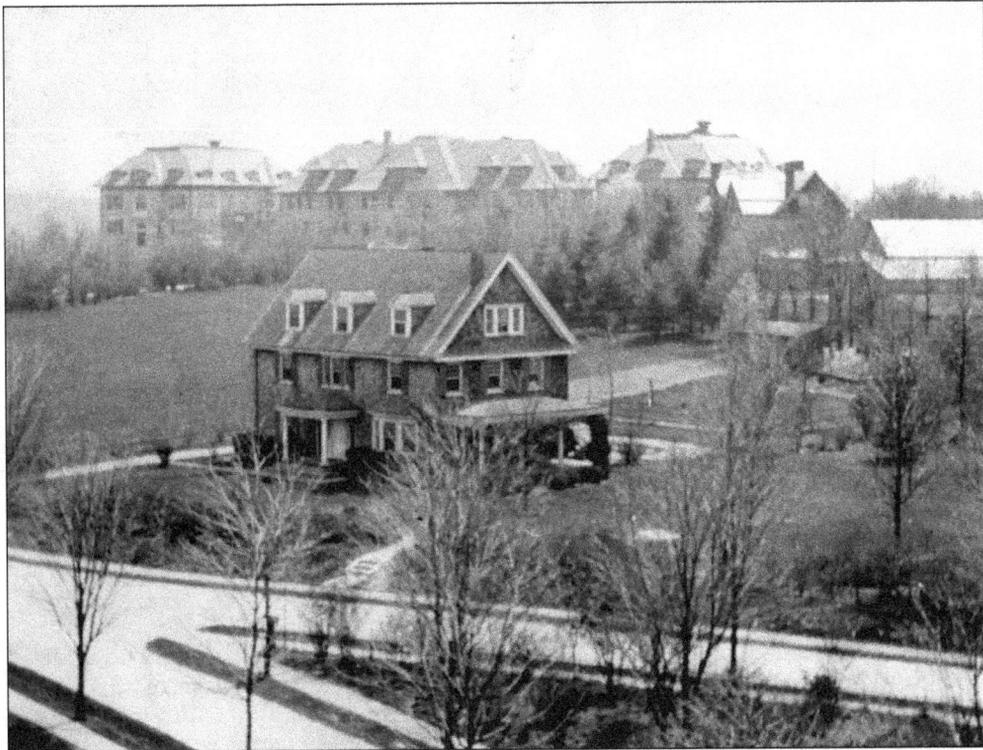

The Charles Smith House is on South Avenue at the east end of the loop. The buildings of the academy are on the east side of Huntingdon Pike. This house, as well as the Iungerich House, was not part of the group of original houses largely built between 1895 and 1900 on the Loop.

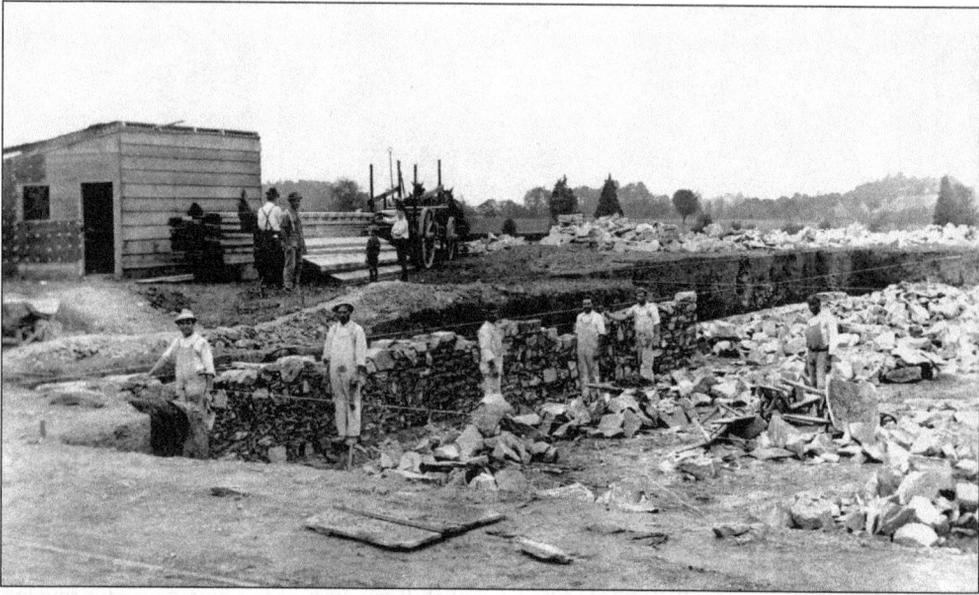

The construction of Benade Hall, the first of the new academy buildings, began in September 1900. After the school community moved to the area, the first school was in the parlor of Charles S. Smith's wife in Huntingdon Valley in October 1894, and in February 1895, moved to the Glenn House to a room fitted for the purpose. In October 1895, the school moved to the newly built clubhouse. The final move to Benade Hall came in October 1901. The building was named for Bishop William Henry Benade, one of the founders of the academy movement in the New Church, who also was instrumental in the formation of the General Church.

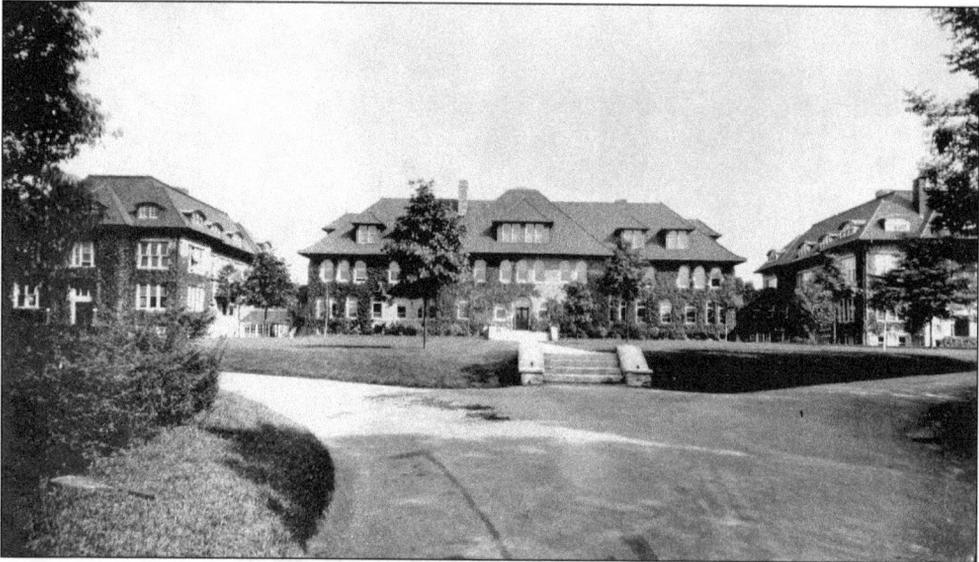

The library on the left and DeCharms Hall on the right were both completed in 1911 as matching buildings. Benade Hall is in the center. They were all of stone, with red tile roofs. Benade Hall was 160 feet long by 90 feet wide through the center portion, with three stories. It contained 50 rooms, a gym, and a chapel. DeCharms housed the elementary school. In addition to these buildings, the Academy of the New Church had built two dormitories—Stuart Hall for boys and Glenn Hall for girls—a dining hall, and power plant.

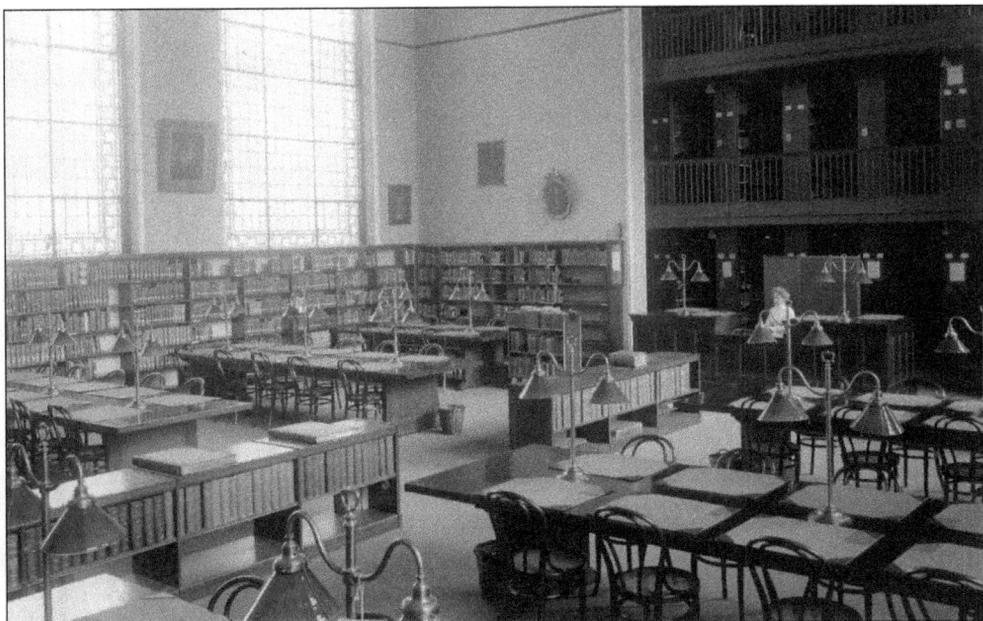

Ground was broken for the academy library in June 1909, and the building was dedicated two years later. It was three stories high, with four stories of stacks, and was a gift to the academy from John Pitcairn. The library moved from this building in 1988 to a modern facility, and the old library building was converted to an arts center. The main reading room currently functions as the main exhibition area.

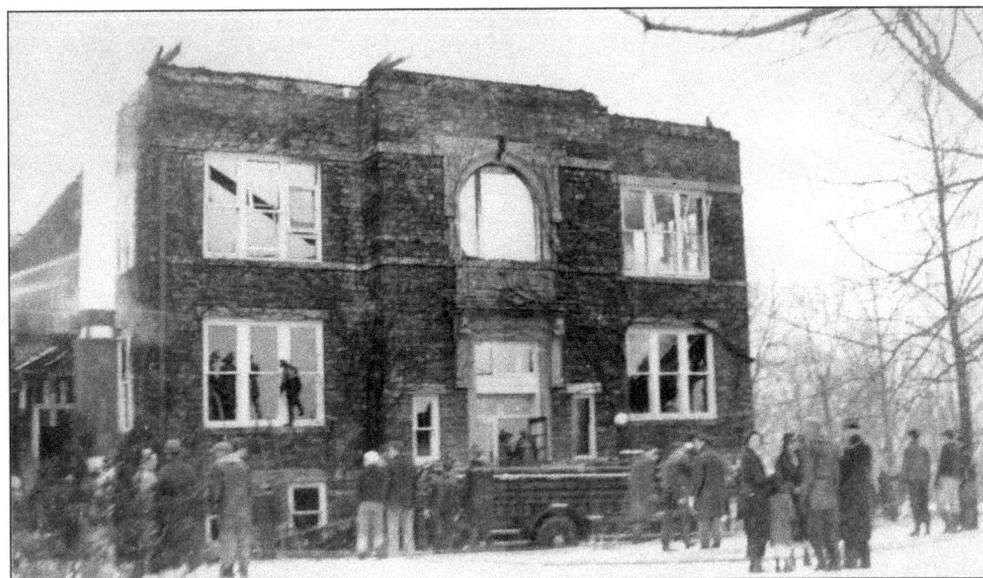

On February 3, 1935, a fire destroyed DeCharms Hall. The third floor had held the auditorium and gym where dances, banquets, and other activities were held. It was never restored, but the lower floors were rebuilt. DeCharms Hall was named for Richard DeCharms Sr., who lived from 1796 to 1864 and was responsible for distilling the writings of Emanuel Swedenborg into clear and specific guidelines for a church government reflecting the new revelation.

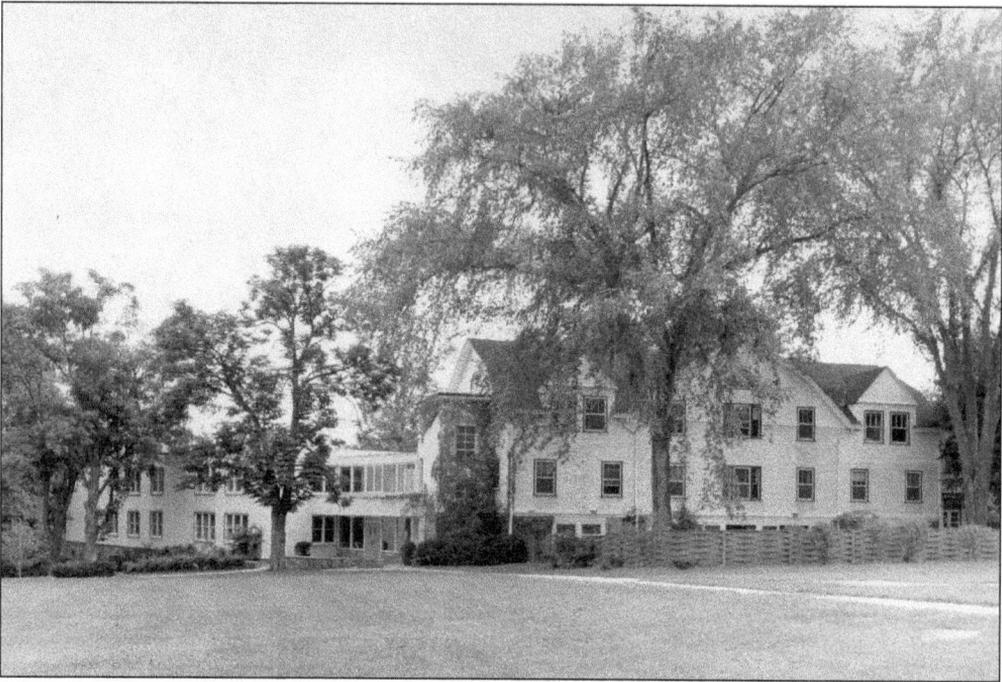

Glenn Hall, the girls dormitory, was of wooden construction and the only original building not made of stone. It was finished in 1902. This 1965 photograph shows the modern addition that was built in 1959. The original section was demolished in 1970.

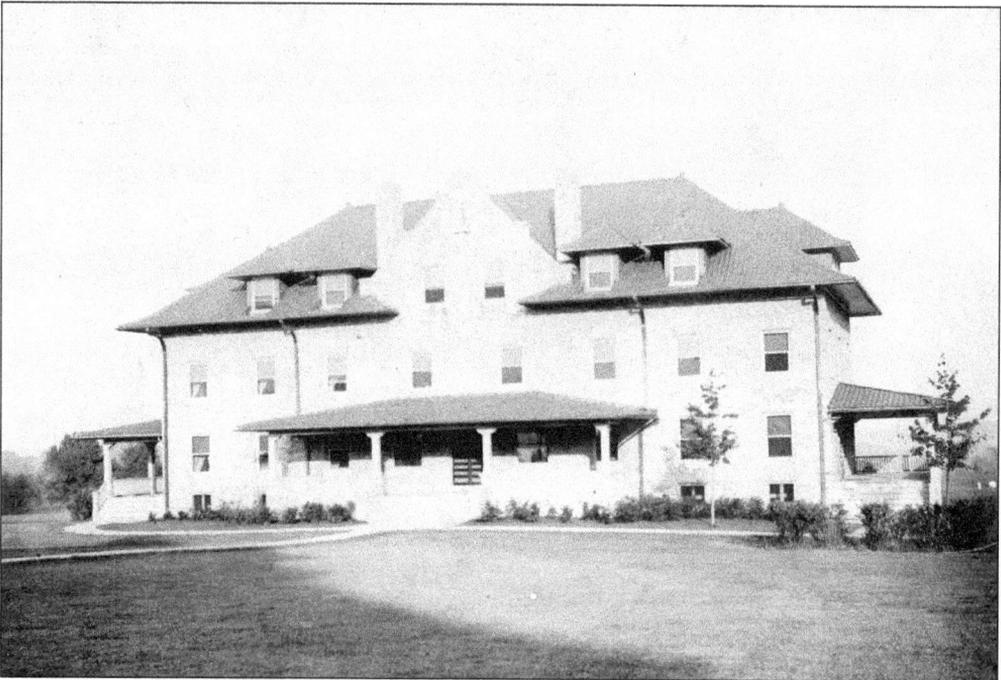

Stuart Hall, the boys dormitory, was built by 1905, again of stone with a red tile roof. It also contained the housemaster's apartment. It was razed in 1969, and a new Stuart Hall was built on the same site.

106

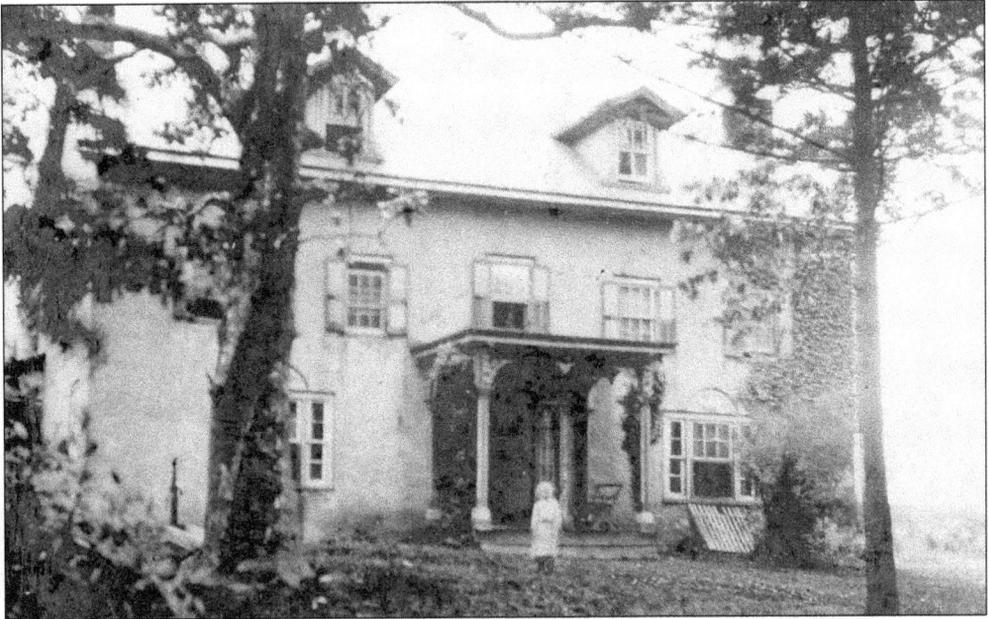

The Opdyke House stood on the farmland of Amos Opdyke. The property was purchased by John Pitcairn sometime after 1891 and was to become the site of the Academy of the New Church. The farm was located on both sides of Paper Mill Road (now Tomlinson Road) between Buck Road and Huntingdon Pike. Rev. E.J.E. Schreck occupied the house for a time, but it was later razed to make way for the academy's dining hall.

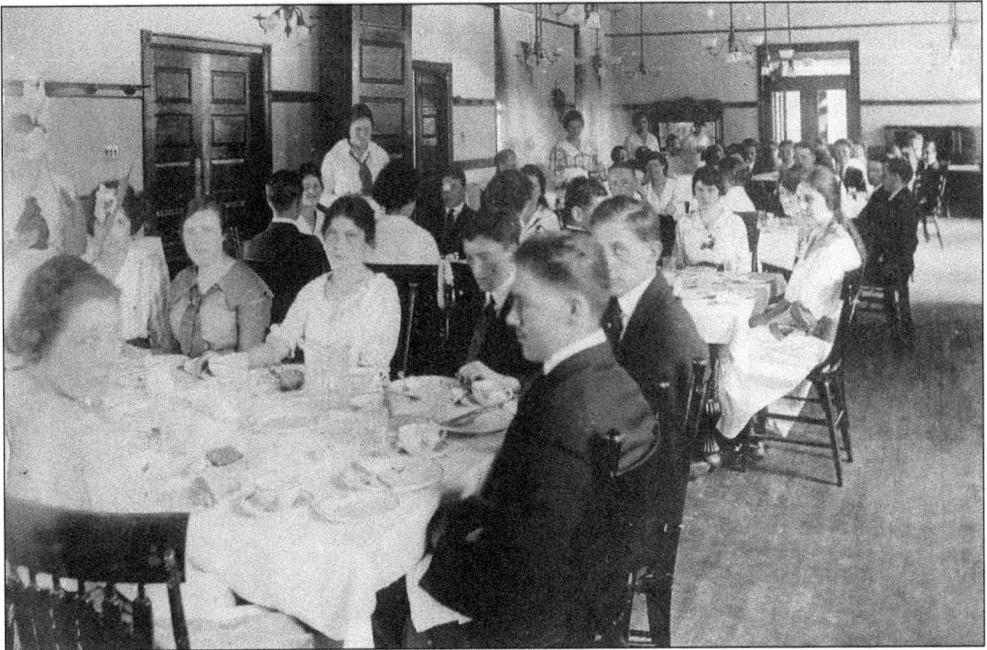

The dining hall was built in 1905 and is shown here c. 1917. This building, as well as Glenn Hall and Stuart Hall, were located behind the DeCharms-Benade-Library complex in a row near Buck Road, with the dining hall in the center, Glenn Hall to the south, and Stuart Hall to the north.

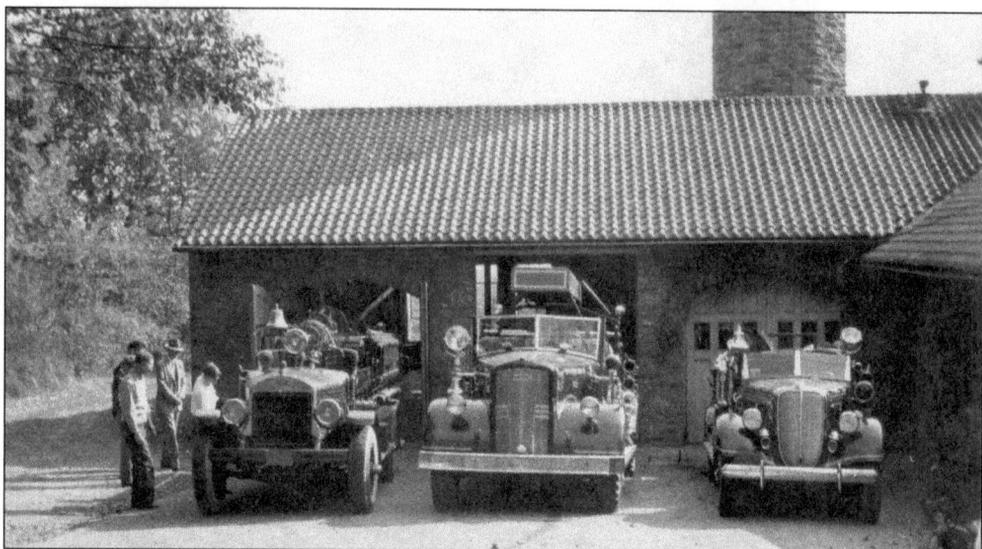

The Bryn Athyn Fire Company was formed in September 1916. The first station was a garage behind Glenhurst, the Glenn House on Huntingdon Pike. The company moved to a permanent home on Buck Road next to the powerhouse on February 13, 1917. The firehouse would continue in operation until 1992 when the left portion was modified and a larger house was constructed to the side. In 1917, the Bryn Athyn and Huntingdon Valley Companies signed a mutual aid agreement, whereby both companies would respond to all but the most minor fires in both their communities.

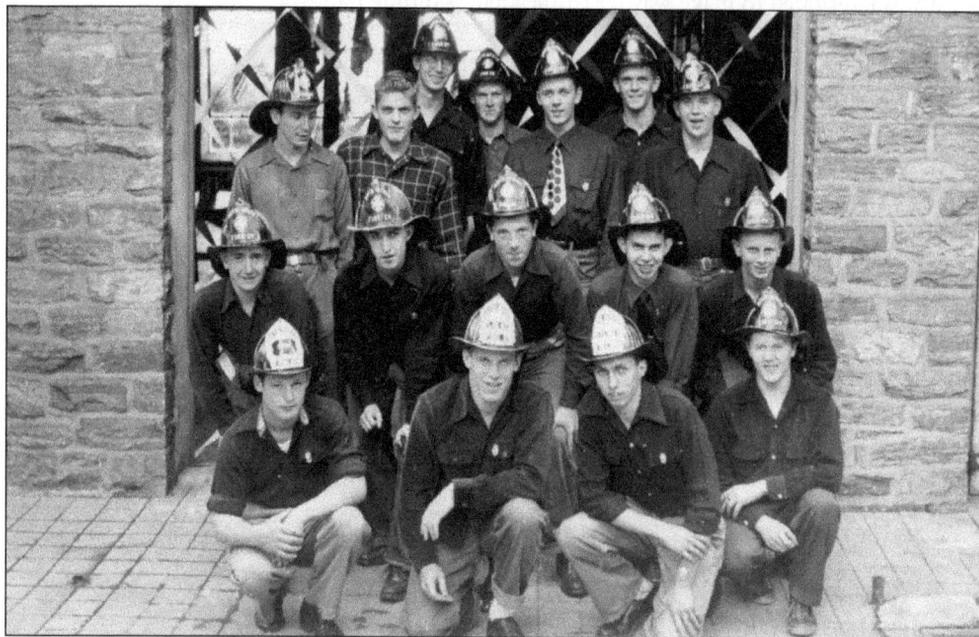

In May 1949, the Bryn Athyn Fire Company celebrated the housing of a new Ward LaFrance pumper. Pictured from left to right are the members of the company: (front row) Donal Price, Dan McQueen, Kay Synnestvedt, and J. McDonald; (middle row) Roger Kuhl, Doug Wright, Barry Smith, David Wilson, and Tom Leeper; (back row) Gaylor Smith, Norwin Synnestvedt, Les Weaver, Roger Smith, William Weaver, Bob Johns, and Mike Norman.

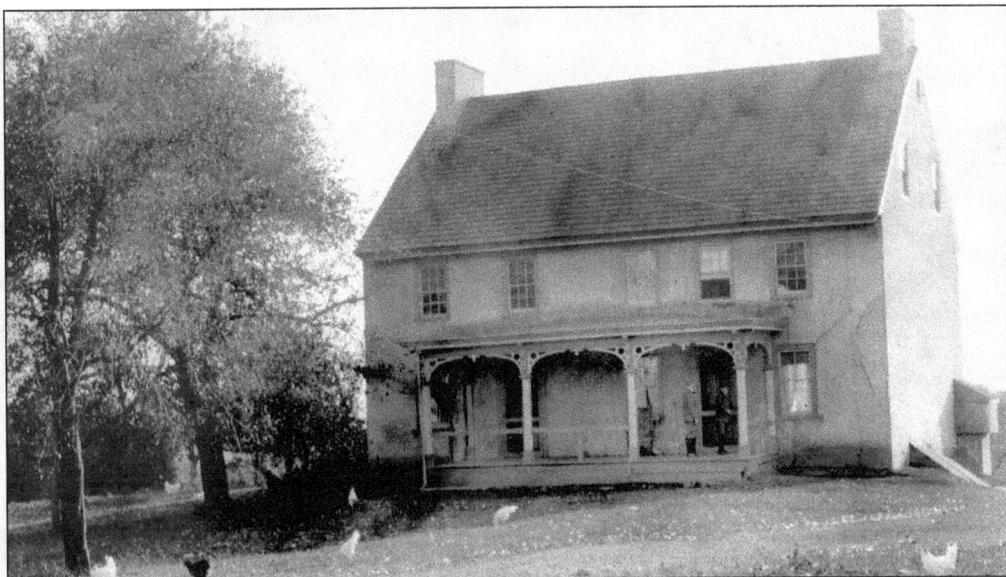

The Powell House on Tomlinson Road dates to 1806, according to a sign found in the attic, but many clues point to the first half of the house being built in the late 1700s. In 1904, the academy bought the property from William Stephen. In 1910, John Trussel rented the house and farmed the land. In 1914, the Arthur Powell family moved in and occupied the house until 1999. After the Powell family left, a group of local residents rescued the house, restoring it to a community arts center. The house is now the Orchard Art Works.

Fetter's Farm is on the north side of Waverly Road at Dale Road. The first part of the farmhouse was built in 1849 and may have been a wedding present from W.F. Fetters to his son. In 1859, a wing was added, and the house was made into a side-to-side duplex, for two families. It was later converted to a single home and remains in private hands.

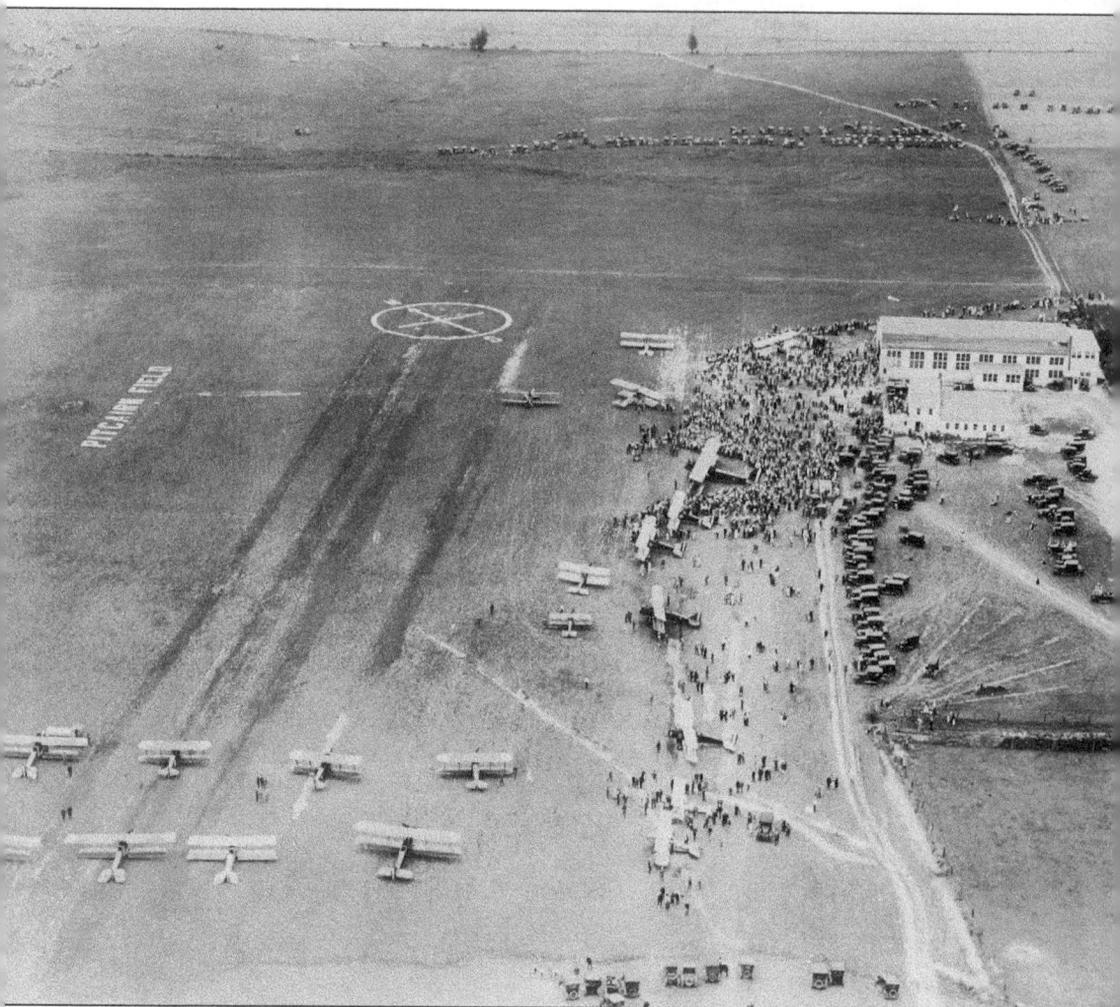

As early as age 13, Harold Pitcairn, John Pitcairn's youngest son, showed an interest in aviation. With a supportive father, Harold served as an apprentice at the Curtis Aircraft factory, where he learned to fly, at the age of 16. After serving in the Army Air Corp in World War I, he was active in the family business. In October 1923, he bought a small Farman biplane and built a small hangar at the corner of Paper Mill and Buck Roads. A year later, Harold purchased the Stackhouse Farm along Byberry Road, the farm being a combination of the former Mitchell and Shelmire Farms. Pitcairn established his own flying service and school at the Pitcairn Flying Field. Within a few months, an addition was added to the rear of the hangar for offices and a woodworking shop and to the southwest a machine shop and clubhouse. The picture is of opening day, November 2, 1924, when the field was officially opened under the auspices of the Aero Club of Pennsylvania.

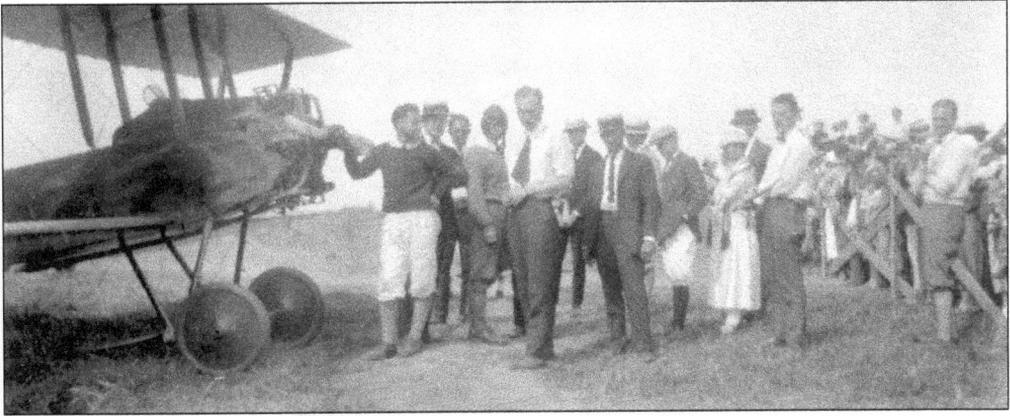

The opening day ceremonies at the Pitcairn Flying Field included a high-class exhibition flying by World War I French flying ace Captain Charles Nungesser. It was estimated that 20,000 attended the air show.

In February 1926, Harold Pitcairn purchased farmland in Horsham Township, and the site became Pitcairn Field No. 2. Later that year Pitcairn Aircraft was incorporated. The company would grow to not only operate one of the largest lines in the country but also to build and design conventional airplanes. When the U.S. airmail service was established, Pitcairn applied for and won a contract. His route started in New York, went through Philadelphia, Baltimore, Washington, D.C., Atlanta, and ended in Miami. He designed two very excellent planes, the Fleetwing and the Mailwing; the latter plane was used as a standard plane by 12 American and 2 Canadian airmail lines. On July 10, 1929, Pitcairn sold his airmail route to a syndicate of Curtiss Wright and General Motors executives for $2.5 million, and this line eventually became Eastern Airlines. Until 1943, Pitcairn focused his efforts on designing and producing both rotary and fixed-wing aircraft. Most of the Horsham site was transferred to the U.S. Navy during World War II and is now the Willow Grove Naval Air Station. Pitcairn left the Bryn Athyn field in 1927.

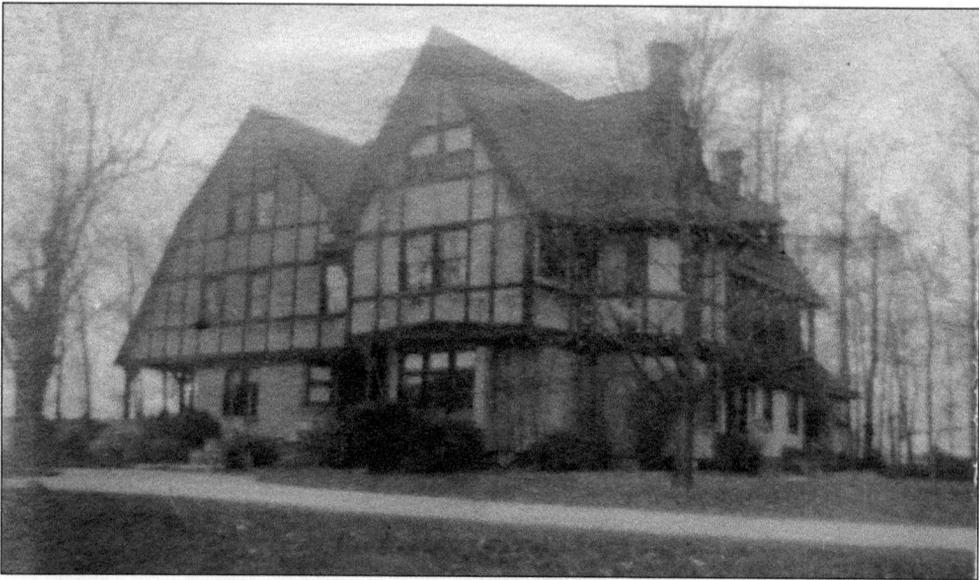

Built for the family of Robert Glenn, Glenhurst, at 3095 Huntingdon Pike, was dedicated in January 1895 by Bishop Benade. It was of Elizabethan Tudor design and surrounded by walnut trees. After the death of Glenn in December 1901, his wife remained in the house until her death in 1938, and then a daughter lived there. Dr. Hugo L. Odhner and his wife bought the house in 1940, and an Odhner grandson lives there now with his wife, a Glenn great-granddaughter.

When the Fox Chase and Huntingdon Turnpike Company owned Huntingdon Pike, a tollhouse stood at the corner of the Pike and Paper Mill Road (now Tomlinson Road). It was a brown-shingled, three-story house with a shed on the south side. Harry Worthington was the tollkeeper in 1899. Since the tollhouse was only really busy on market days, he also helped out at Cairnwood Farm, carried mail down to the Bethayres post office and back by bike, and delivered newspapers. In 1906, he moved to a house on Alden Road, and a Mrs. Sorenson moved into the tollhouse. The house burned in 1908 and was not replaced. Huntingdon Pike was freed by the state as a toll road in the early 1920s.

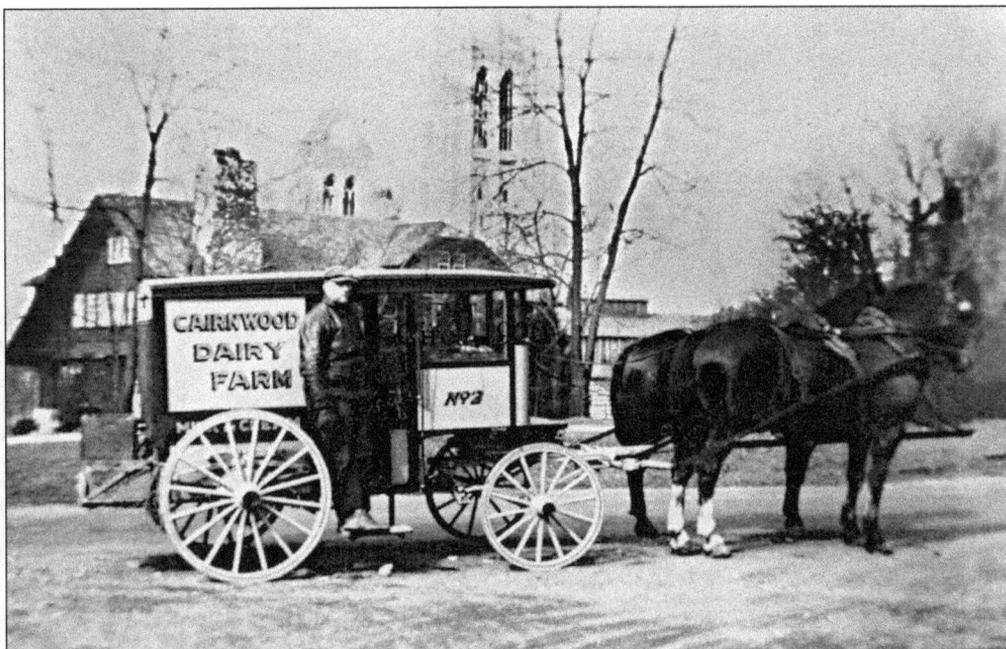

Cairnwood Farm was located on the east side of Huntingdon Pike across from Cairnwood, the home of John Pitcairn. The dairies provided milk to many in the community. Pitcairn purchased the Samuel J. Trank and George Blake farms for Cairnwood Farm. The main dairy buildings were those on the former Trank farm.

The Pond was a popular swimming hole during the first half of the 20th century. It was located just below the dairy near Buck Road. The pond is on private property and is no longer used for swimming.

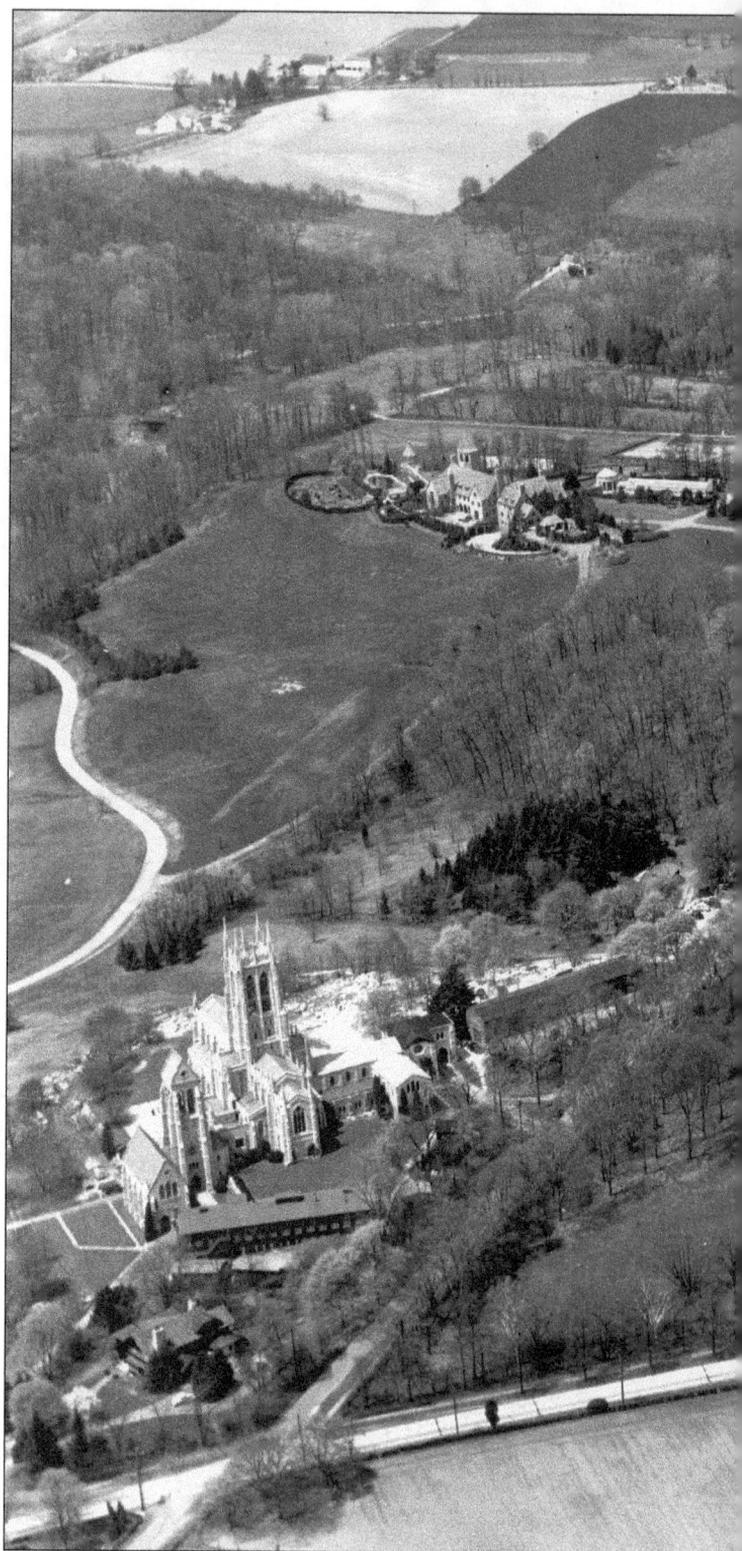

This c. 1939 aerial photograph shows the original setting for the Bryn Athyn Cathedral and the homes of several Pitcairn family members. The gentle curving driveway and the arrangement of the trees reflect the original landscaping as devised by Olmsted, Olmsted & Elliot for Cairnwood. Much of the original approach to the cathedral and Cairnwood was lost in the early 1990s when the roads and drives were reoriented and parking areas were added. In the distance is what is now known as Raytharn Farm, a property that extends out to Terwood Road, which had been previously owned by W.W. Frazier in the early 1900s and by the Heaton and Yerkes families in the early 1890s. Recently, part of Raytharn Farm was purchased by the Pennypack Ecological Preservation Trust from the Pitcairns to be preserved as open space.

114

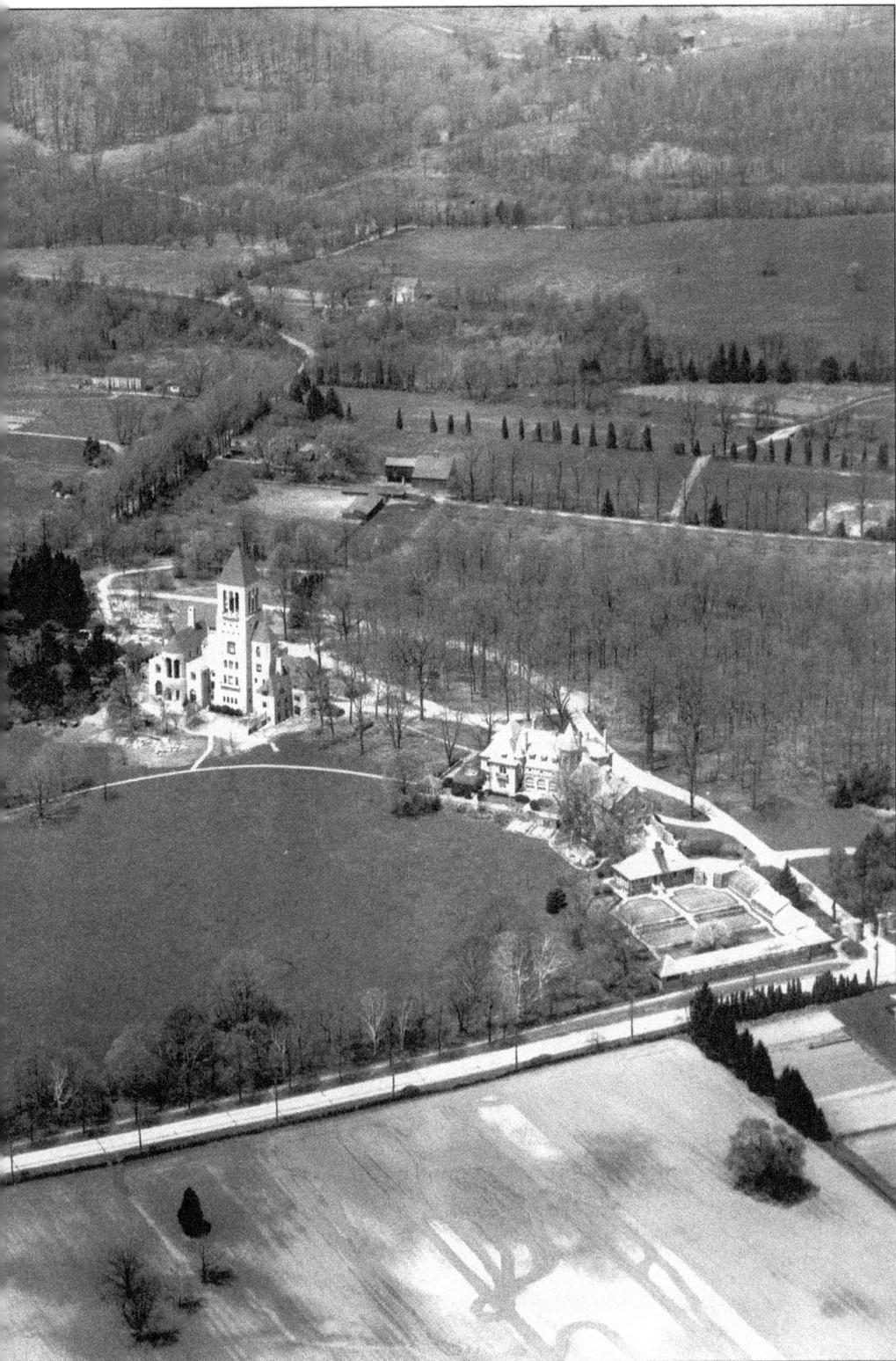

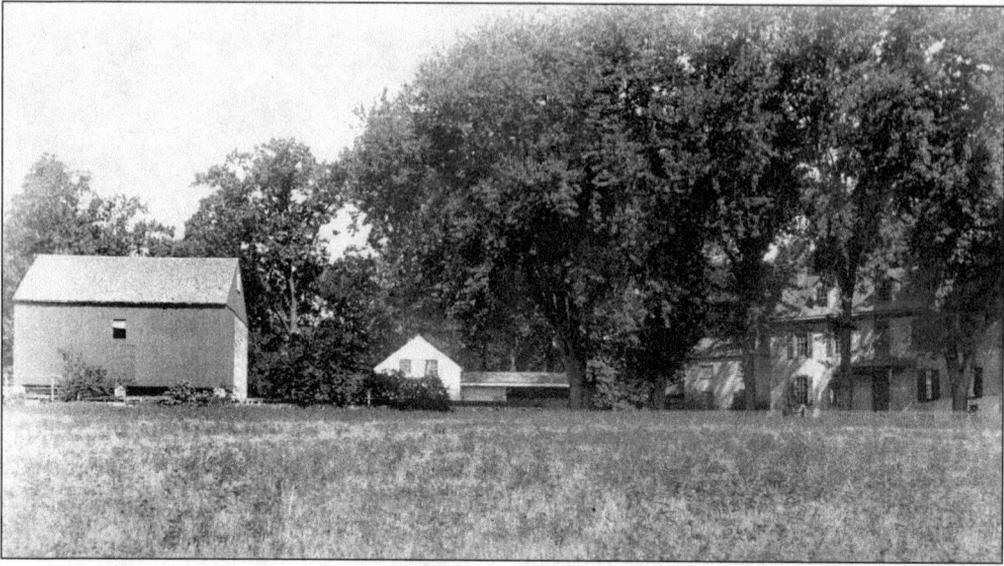

John Pitcairn, a self-educated Scottish immigrant, came to this country in 1846. When he was 14 years old, Pitcairn dropped out of school and went to work for the railroad. He was very successful in railroading and later in oil and with the founding of Pittsburgh Plate Glass Company. He moved to Philadelphia in 1884 upon his marriage to Gertrude Starkey. Shortly after groups from the New Church began visiting Alnwick Grove, John Pitcairn began purchasing farmland along Huntingdon Pike near Alnwick Grove. The first parcels he purchased c. 1890 would later be the sites of Cairnwood and the cathedral. The site chosen by Pitcairn for his home was known as Knight's Hill and had previously been the Knight farmstead.

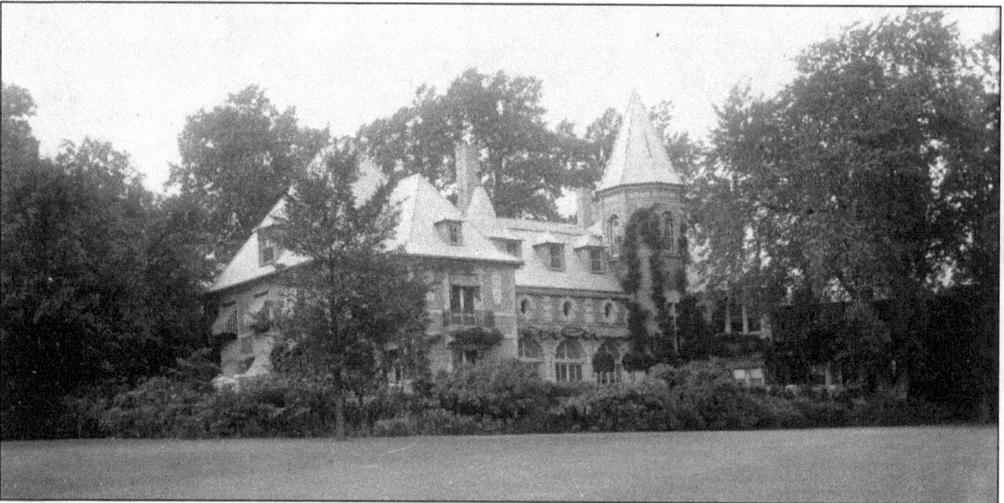

Located on the highest rise of land in the area, Cairnwood was designed by the New York architectural firm of Carrere and Hastings in the Beaux Arts style. Ground was broken in 1892, and the house was completed three years later. The total cost was $161,638.82. John Pitcairn and his family lived in the house, and following the marriage of eldest son, Raymond, in 1910, his family also took up residence in the house. When John Pitcairn died in 1916, the Cairnwood estate passed on to Raymond and his family, who continued to live in the mansion until Glencairn was completed in 1939.

116

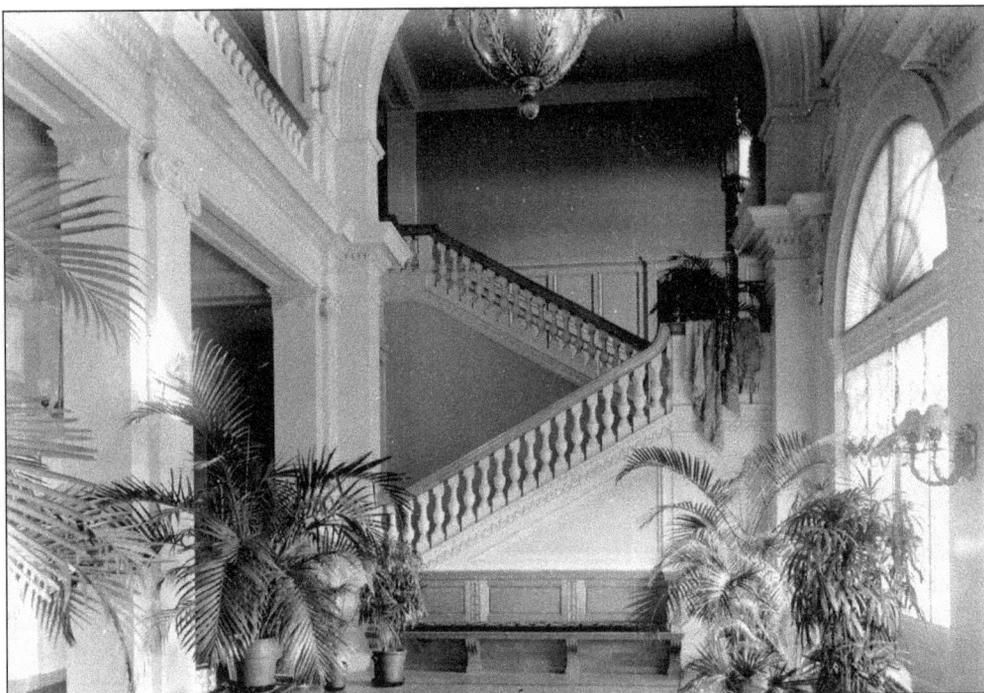

After Raymond Pitcairn and his family moved into Glencairn, Cairnwood was inhabited over the next 42 years by several Pitcairn family members. The house was given to the Academy of the New Church c. 1980. The property sat vacant from 1981 until 1995 when an effort was made to restore the property. A very successful designer's showcase was held in September 1995, and restoration began shortly thereafter. The academy currently rents the mansion for events and as a conference center.

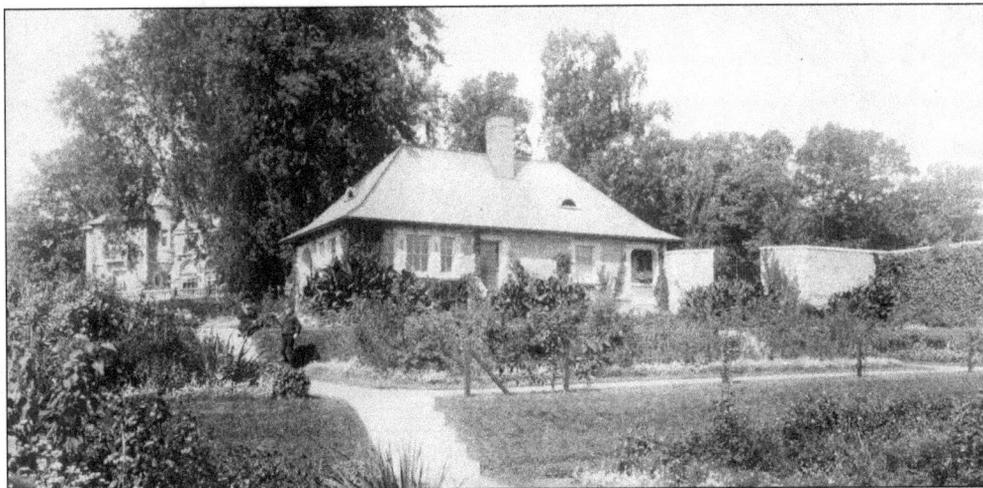

The grounds of Cairnwood were laid out by the New York firm of Olmstead, Olmstead & Eliot. The firm also laid out the plan for the Bryn Athyn community. The design for the Cairnwood grounds linked the formal architecture of the mansion with the surrounding informal wooded landscape through the use of graceful roadways and open vistas. The Garden House and kitchen garden were photographed in 1897. In 1986, the Garden House was converted to house the John Pitcairn Archives.

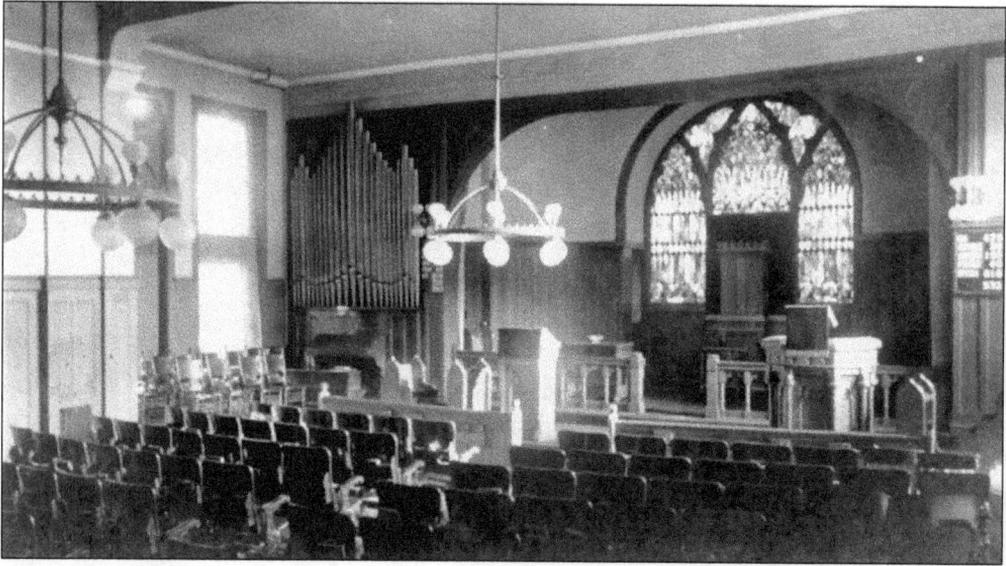

When the Swedenborgian community first came to Bryn Athyn, church services were held in various homes and the clubhouse. After the completion of Benade Hall in 1901, worship services were held in the building's chapel. Despite the large capacity of the chapel, by 1907, the community was outgrowing the space. John Pitcairn and Bishop W.F. Pendleton were instrumental in envisioning a house of worship dedicated to the Lord in His Second Coming. The enterprise of constructing a great cathedral that would serve as the ecclesiastical and administrative center of the New Church would take many years and would result in an extremely fine example of Gothic architecture.

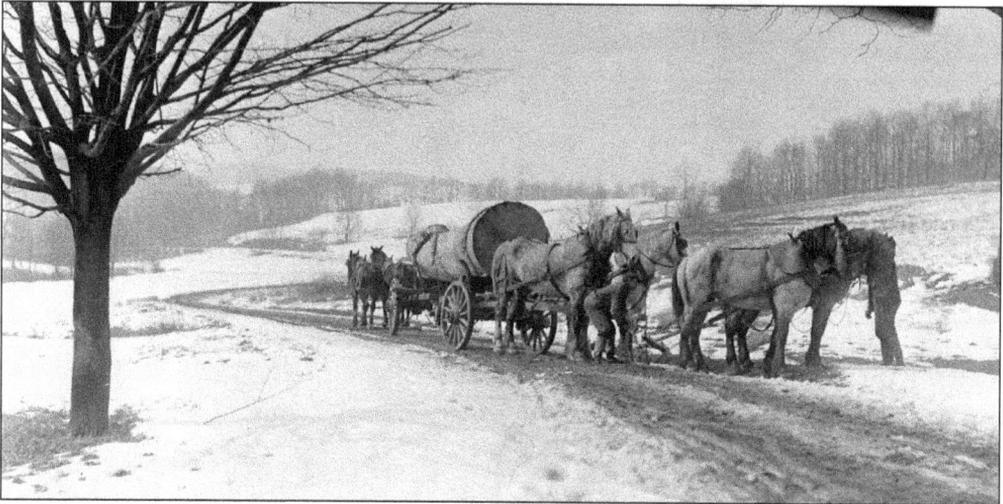

John Pitcairn was the primary benefactor of the cathedral's construction and endowment but soon turned over the handling of the design and construction to his eldest son, Raymond. In 1912, Philadelphia architect Lawrence Visscher Boyd was selected and later submitted plans for the church. Boyd's plans ran counter to the rising interest in and preference for Gothic architecture, so Raymond Pitcairn sought the advice of Ralph Adams Cram, America's foremost Gothic church architect. Cram provided plans and work began on the cathedral in 1913, with the cornerstone being laid on June 19, 1914. Logs were brought up Quarry Road to the building site from the rail siding near the stone quarry by teams of horses.

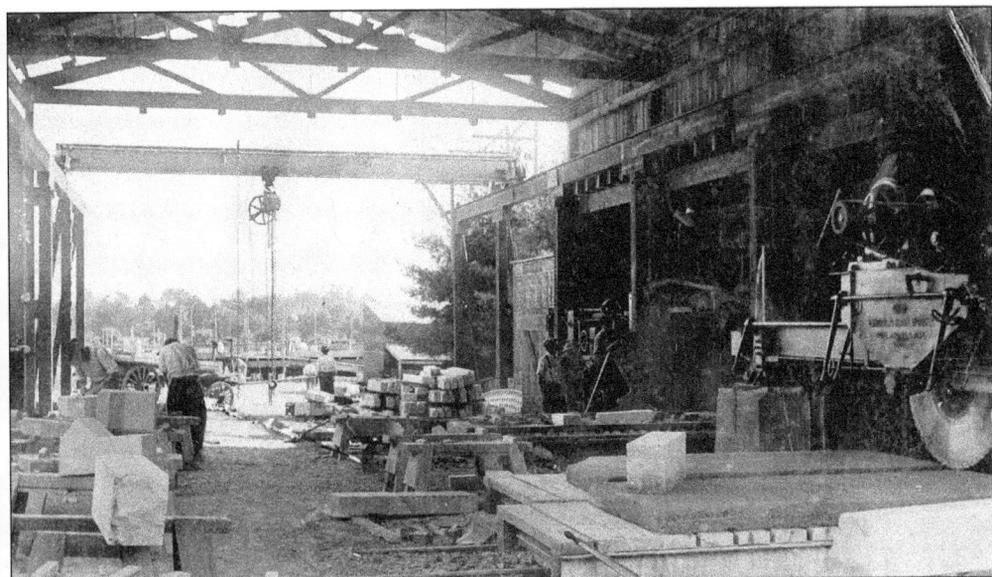

Most of the stone for the cathedral came from local sources. Gneiss granite was quarried from a stone quarry located along the Pennypack Creek at the end of Quarry Road. Bowling Green limestone was used in the construction of the pinnacles and tracery (later restorations used Indiana limestone). The stonecutting shop was located north of the cathedral near the porte cochere.

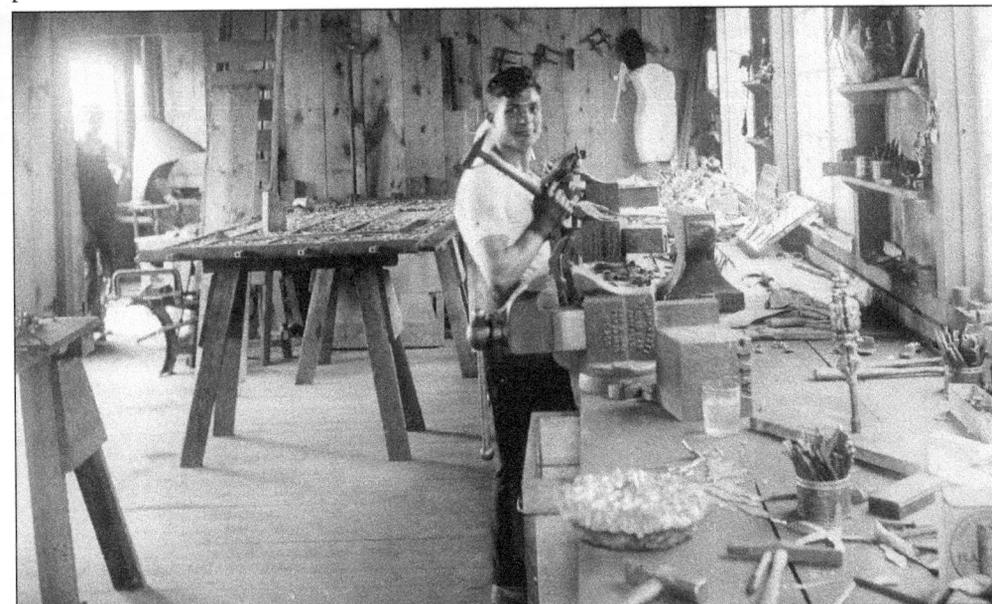

Through his study with Ralph Adams Cram, who was influenced by both the Gothic Revival and arts-and-crafts movements, Raymond Pitcairn became greatly interested in the medieval craft guilds. The craftsmen at the cathedral were organized into guilds and had considerable input during the design and construction processes. A glass shop was set up and, in time, rediscovered the long lost method for producing brilliant and deep-hued colored glass for the windows. The metalwork shop provided most of the ornamental fixtures found throughout the cathedral.

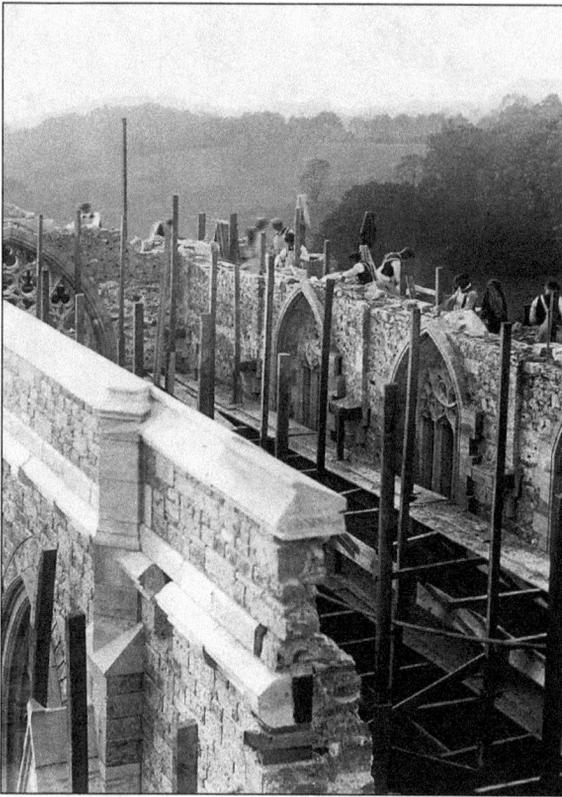

By 1917, Raymond Pitcairn had taken over total control of the design and construction of the cathedral, having dismissed Ralph Adams Cram from the project. Pitcairn pursued an organic approach to the creation of the cathedral and insisted on having those who were working on the cathedral be on-site. Photographed *c.* 1915, the walls of the nave are rising above the valley below.

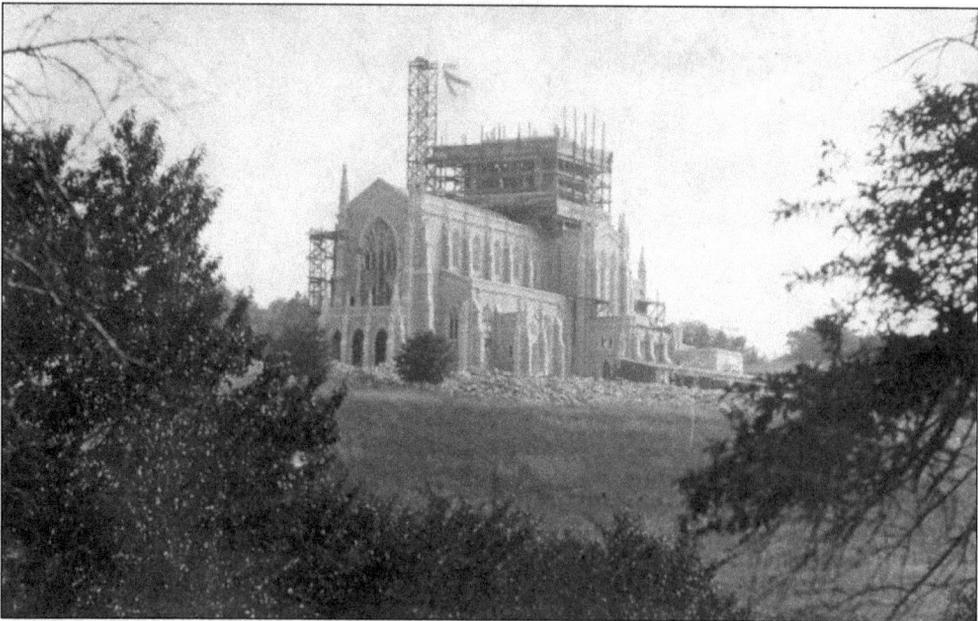

By June 1917, the roof over the nave was complete. Construction on the tower would take until 1919.

Under Raymond Pitcairn's direction, the design of the cathedral evolved over time and was based primarily upon the use of scale and full-sized models rather than architectural plans and drawings. A model for the chancel, with a full-sized plaster figure, was used in situ to evaluate the proposed design (ultimately not implemented) of the chancel space. The interior of the church was faced in Amherst buff sandstone, and the stained glass windows were modeled after medieval examples. The difficulty in discovering the correct method for producing the glass Pitcairn desired would delay for several years the instillation of the stained glass windows.

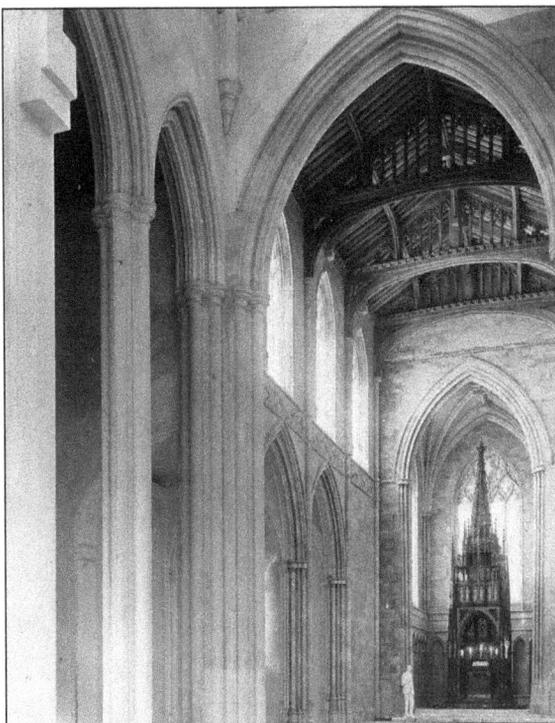

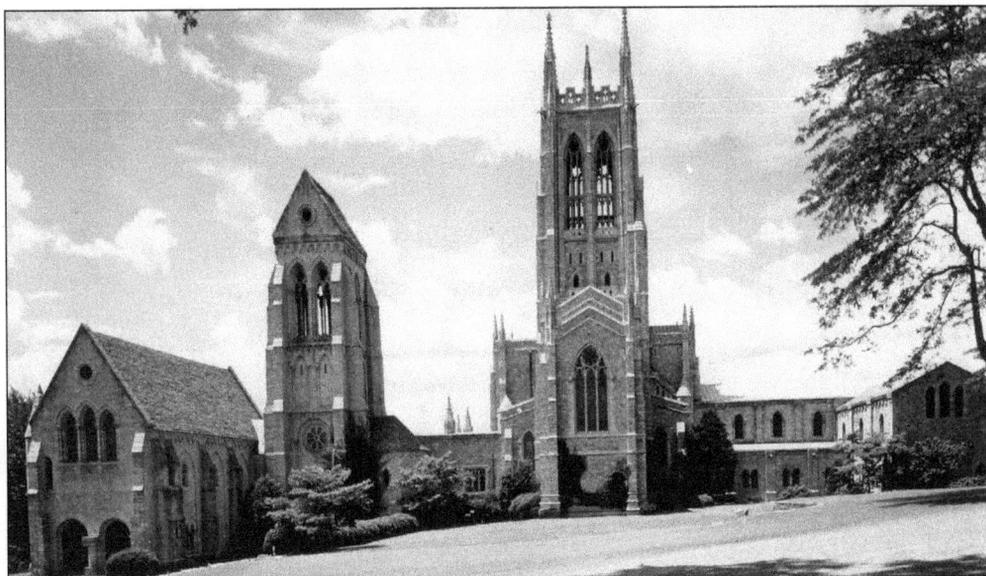

The cathedral was dedicated on October 5, 1919, and afterwards regular worship services commenced in the sanctuary. Following completion of the main part of the cathedral, several adjoining buildings were added, providing for meeting spaces needed in the running of a church. Raymond Pitcairn's work on the Gothic cathedral kindled an interest in earlier church architecture, and the later additions were in the Romanesque style. The Council Hall and Ezekiel Tower were built to the south (left) of the center spire. Work began in 1920 and was completed in 1926. Work then began on the Choir Hall, to the north, which was dedicated in 1929. The Michael Tower adjoining the Choir Hall was fully finished in the 1950s.

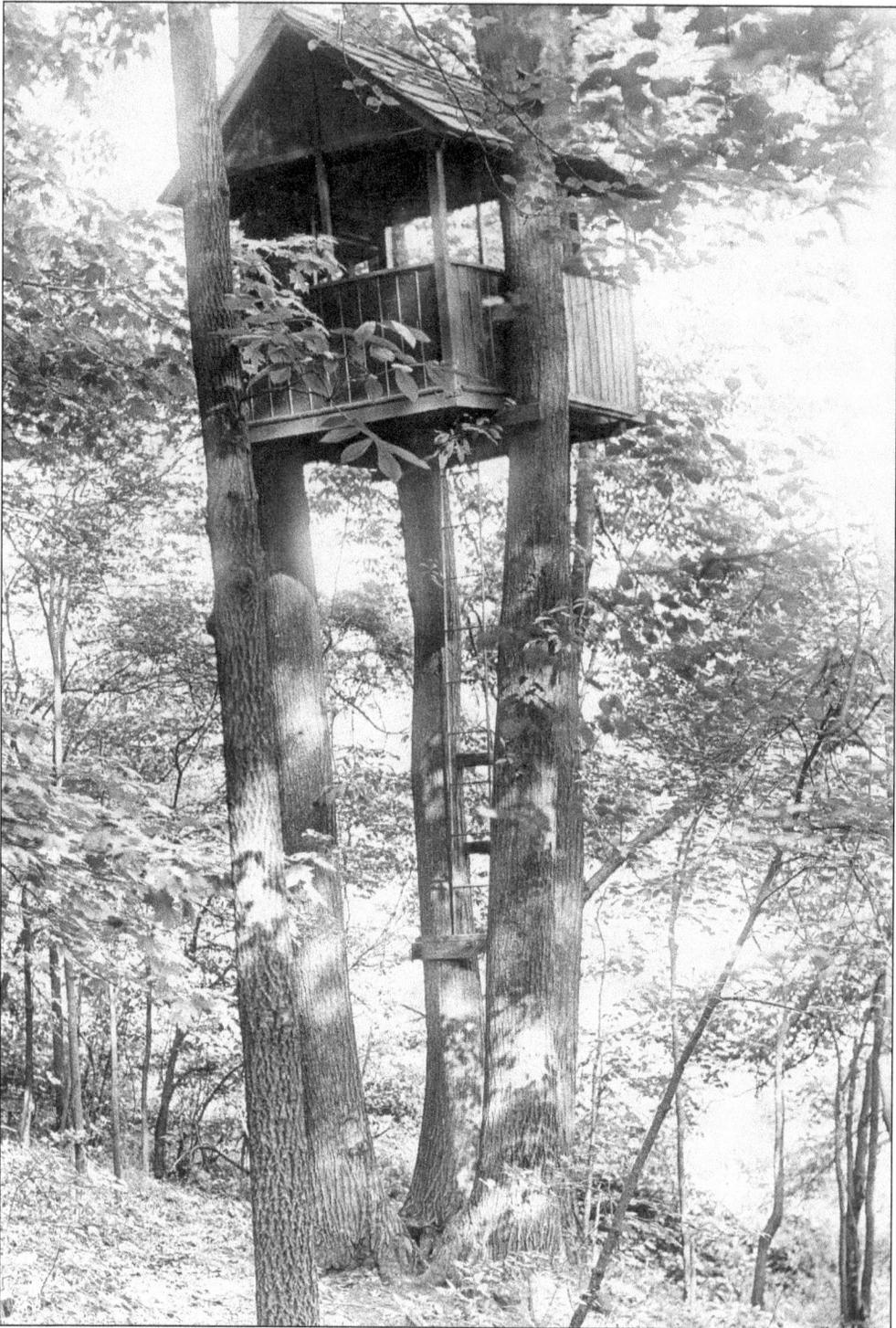

The Loyal Odhner and Don Rose tree house was located off Quarry Road in the wooded area just beyond the cathedral. These two intrepid and venturesome young men spent time during the summer ensconced in their avian perch. The photograph dates from *c.* 1910.

Following the completion of most of the cathedral, Raymond Pitcairn turned to the construction of a new house built to his tastes and incorporating the designs and construction processes learned from his earlier experiences. Glencairn was constructed between 1928 and 1939 on a section of the Cairnwood grounds. Raymond was a keen collector of medieval art and stained glass, and many of the pieces in his outstanding collection were incorporated into Glencairn. Photographed during the construction *c.* 1938, the house would be only six inches shorter than the cathedral but, due to the elevation of the ground, would seem much larger.

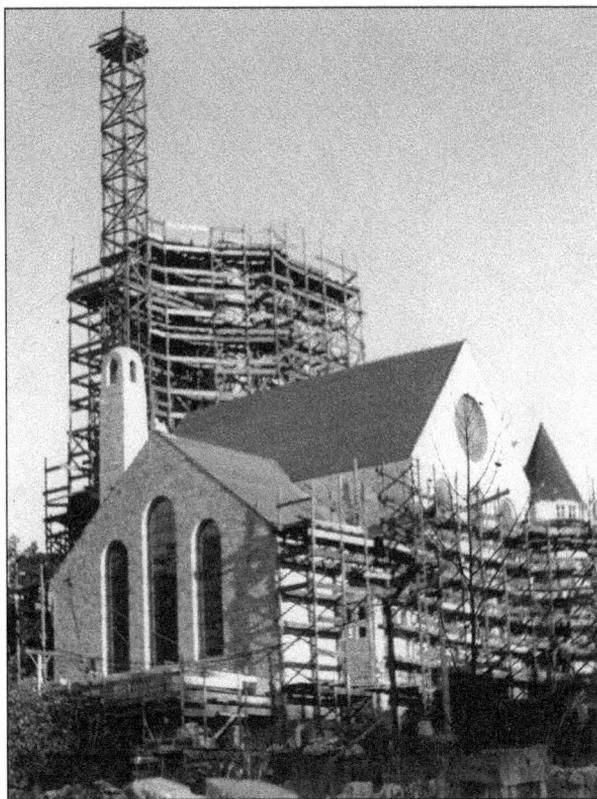

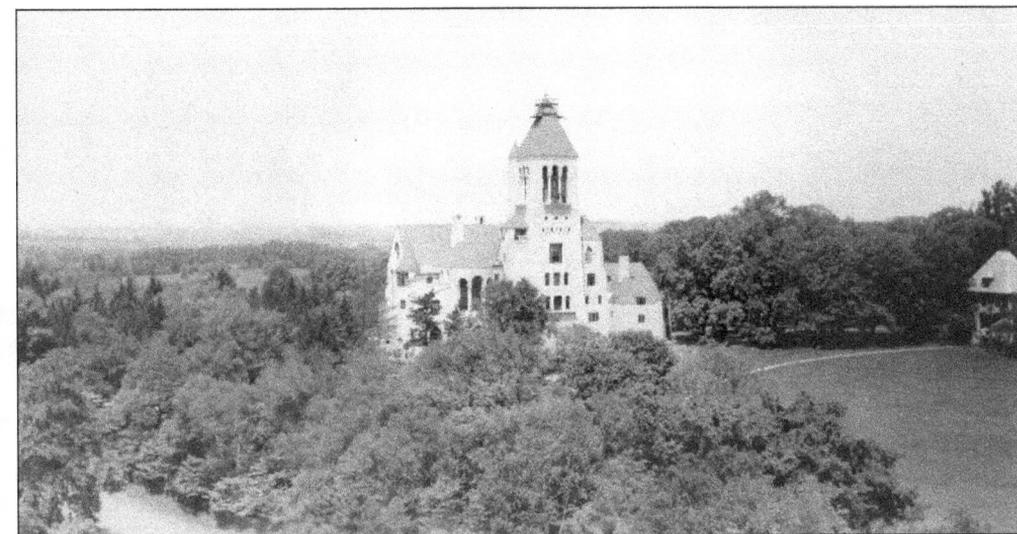

Glencairn has a commanding view of the surrounding countryside. The center section of the tower roof rises on a hydraulic system (no longer in operation) to provide even loftier views of the area. Upon completing his home, Raymond Pitcairn's interests turned to politics and civic affairs. He was a longtime supporter of the Republican party and was a personal friend of President Dwight D. Eisenhower. He remained active in the community until his death in 1966. His wife, Mildred Pitcairn, remained in the house until her death in 1979, at which time Glencairn was given to the Academy of the New Church. In 1982, it opened as a museum.

123

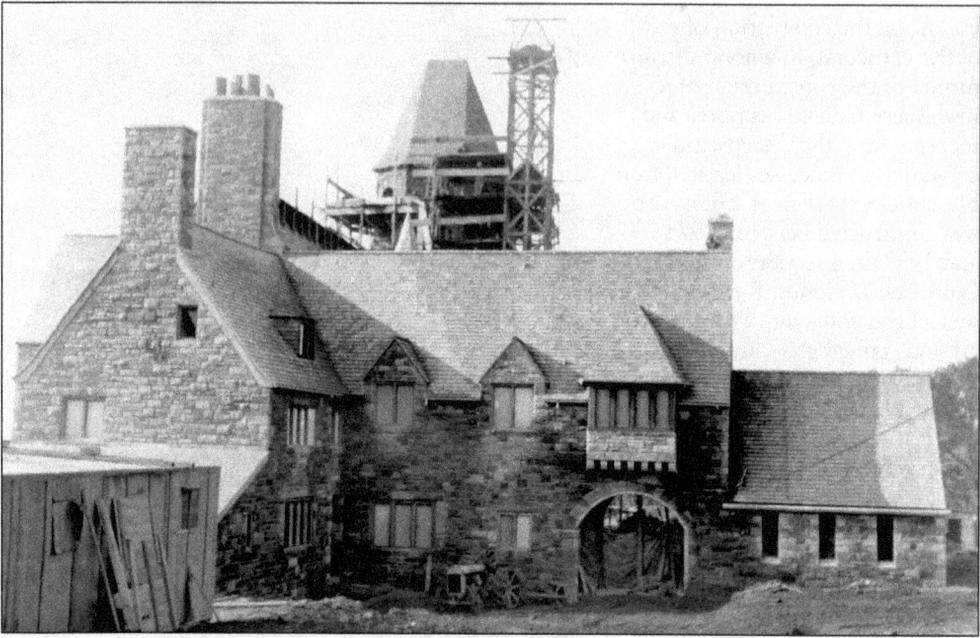

Cairncrest was the home of the Clara and Harold Pitcairn family. Harold's brother Raymond Pitcairn likely oversaw the design and construction of the home, which was built between 1925 and 1928. It is possible that architect Wetherill P. Trout of Philadelphia was involved in the initial design phases. Cairncrest is the most comprehensive country estate of the Pitcairn homes, with support buildings and an expanse of grounds around it.

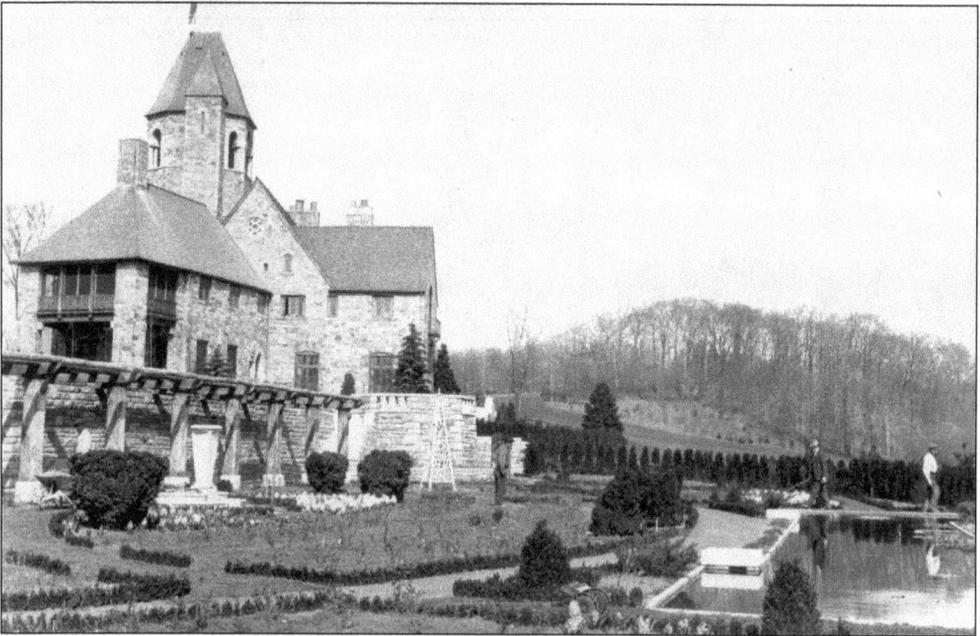

The formal gardens at Cairncrest were laid out in a series of terraces. Following the deaths of Harold Pitcairn in 1960 and Clara Pitcairn in 1964, the property was given to the General Church and is now used by the Church of the New Jerusalem as its international headquarters. The lower gardens have long since been abandoned.

Harold Pitcairn is best known for his invention and development of the autogiro, a precursor to the helicopter. Pitcairn received his first helicopter-related patent in 1925, and following the sale of his airmail company in 1929, he and his staff devoted the next 14 years to developing and manufacturing the autogiro. Several of the greats in aviation history were entertained at Cairncrest, including Orville Wright, Charles Lindbergh, and Amelia Earhart. The Stone Room in the basement of the house was the center for the planning and decisions of his aviation enterprises. In 1931, Pitcairn and his associates were awarded the 1930 Collier Trophy, the highest honor in aviation. Pitcairn received the trophy from President Herbert Hoover following a landing of the autogiro by Pitcairn's associate James Ray on the south lawn of the White House. Amelia Earhart set an altitude record of 18,415 feet in one of his autogiros as well as a distance record. In 1942, Pitcairn allowed the U.S. government to use his plans, designs, and patents to be incorporated into the helicopter. After the war, the government refused to pay royalties for the patents' use, thus prompting one of the largest and longest patent lawsuits in American history. In 1977, 27 years after Pitcairn's death, the lawsuit was settled in Pitcairn's favor for over $31 million.

Theodore Pitcairn was the middle son of John and Gertrude Pitcairn. Early in life, he took a deep interest in religious matters. He attended seminary after college and became a minister in the New Church. In the 1920s, he purchased land that earlier had been the farm of A.R. Mann and then of C. Bradford Fraley, which lay to the west of his brother Harold Pitcairn's property. This view is from across the Pennypack Creek looking toward the barn that stood where the chapel of the Lord's New Church now stands.

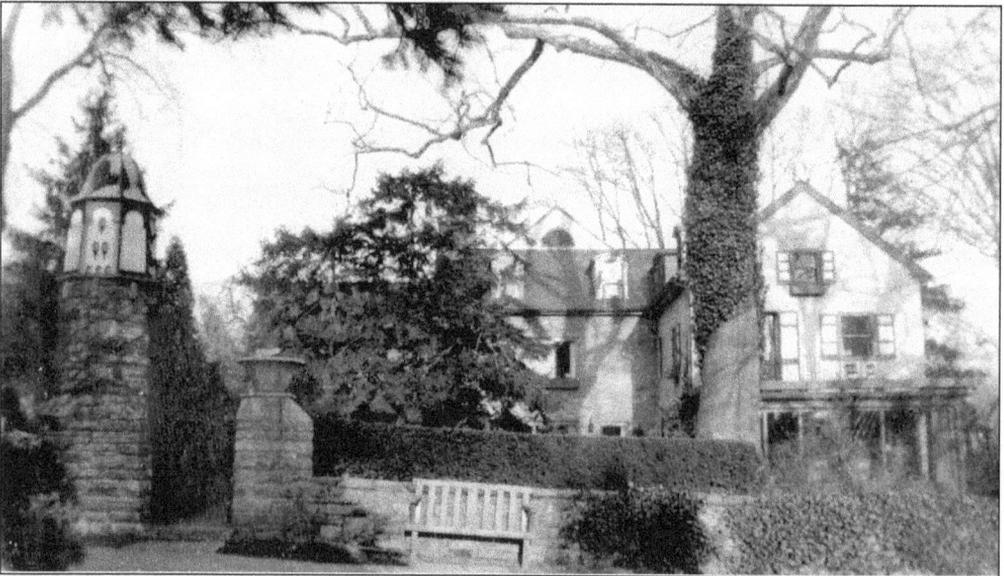

Theodore Pitcairn hired Philadelphia architect George Howe to convert the old Mann farmhouse into a suitable residence. A sizable addition and an underground garage were built. His estate was known as Dientjehame. The house was completed in 1927.

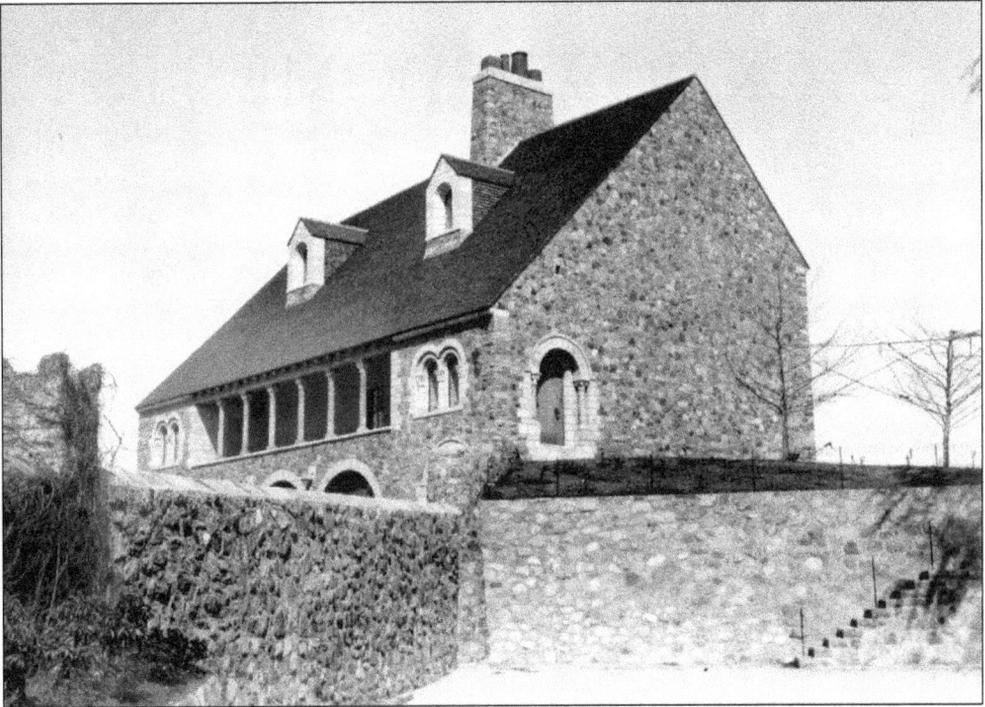

Howe designed a studio located midway between the house and the farm buildings for the artist Philippe Smit. In 1937, Theodore Pitcairn led a split within the New Church over doctrinal issues. His followers formed the Lord's New Church, a distinct sect within the Swedenborgian faith. The studio was converted into the church's chapel, a function it still serves today.

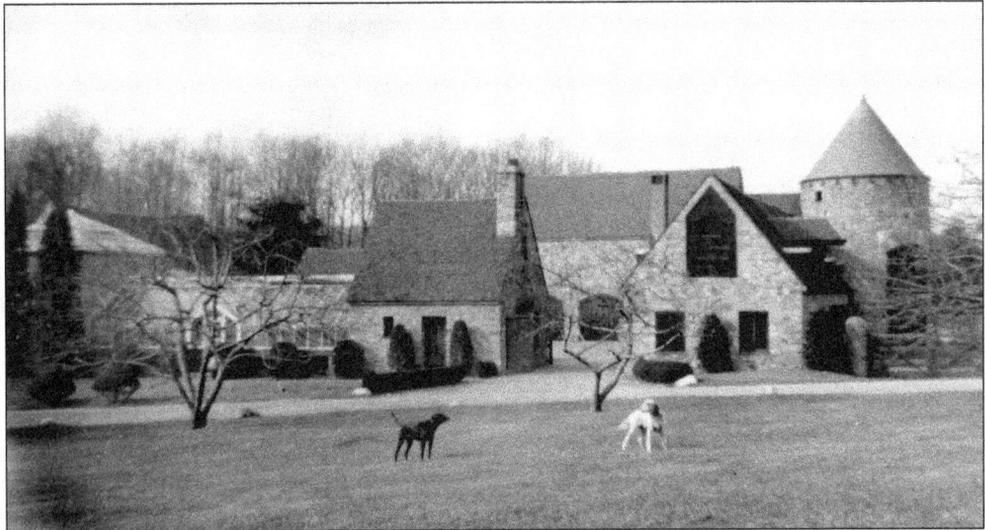

After the main house was completed, Howe designed a farm group at the other end of Dientjehame in the French Country style. The massive farm group, completed in 1930, remains to this day one of the best-designed in America. In 1948, the southern section of the farm group suffered a fire but was rebuilt. Upon Theodore's death in 1973, his property was given to the Lord's New Church. The farm group now serves as the church's administrative hub as well as a community center.

ACKNOWLEDGMENTS

The Old York Road Historical Society is once again pleased to partner with Arcadia Publishing in producing this final book of three covering the communities along and adjacent to the Old York Road in the eastern portion of Montgomery County. The society extends its thanks to Amy Sutton and Peter Turco at Arcadia for their support of this three-part vision.

The society's book committee worked diligently to gather the valuable information and many wonderful photographs that make this book such a significant contribution to our local historical record. The committee was comprised of Janet M. Chapman, Martha C. McDonough, Aubrey C. Odhner, Joyce H. Root, David B. Rowland, Nadine Synnestvedt, and Mildred M. Wintz, Ed.D. Society archivist and librarian Joyce Root deserves added praise for her indefatigable efforts in researching and writing a large portion of the text. We are also grateful to society member Stephen H. Silverman for his assistance.

For all three books, and especially for this endeavor, the final success is due to many persons throughout the area who have shared their knowledge, cooperation, and encouragement. Valuable assistance was provided by the following: Katherine Barnes, John C. Bowen, Mr. and Mrs. James Connelly, John H. Deming Jr., Francis J. Devlin, Dorothy D. Eastwood, Larry Eastwood, Harriet Ehrsam, Mr. and Mrs. Charles T. Engelman, Norman Fesmire Jr., Mr. and Mrs. Robert Genzlinger, Diahnne Glenn, Mr. and Mrs. Robert L. Gray III, Kelly Greenleaf, Mr. and Mrs. Richard B. Harris, Carol Henderson, Col. and Mrs. Joseph E. Herkness, Andrew M. Herman, Raymond W. Humphreys, Henry Jacquelin, Bruce Laverty, Kenneth A. Marley, Mr. and Mrs. John McCauley, Mr. and Mrs. Howard H. McConnell Jr., Rev. Lowell M. McCown, Joanne McKeown, Miriam Mitchell, Stephen H. Morley, Andrew G. Nehlig, Carroll Odhner, Mr. and Mrs. Leon S. Rhodes, Alice E. Ridgway, Mr. and Mrs. Lincoln Roden III, Mark Schmerling, David Shannon, Elise Simons, Robert M. Skaler, Donald Synnestvedt, Rima Synnestvedt, Joseph A. Thomas, and Audrey F. Wistar.

The Old York Road Historical Society is most appreciative to those individuals and institutions that loaned images for inclusion in this book. In addition to the various photographic collections of the Old York Road Historical Society, images have come from the following individual and institutional collections: Mr. and Mrs. Robert Abel, Academy of the New Church Swedenborg Archives, Mr. and Mrs. William Buick, Janet M. Chapman, John H. Deming Jr., John F.X. Fenerty, William C. Fischer, Lynn Genzlinger, Vera Powell Glenn, Mr. and Mrs. Robert L. Gray III, Carl Gunther, Elizabeth M. Hallowell, Robert M. Harper, Andrew M. Herman, Kenneth A. Marley, Martha C. McDonough, Joanne McKeown, Millbrook Society, Penn State Abington, Raymond and Mildred Pitcairn Archives at Glencairn Museum, Bonita W. Rivera, St. John's Episcopal Church, Stephen H. Silverman, Gloria H.A. Smith, Charlotte P. Stuempfig, Anne Tinari, Union Library Company of Hatborough, Upper Moreland Historical Association, Women's Board of Abington Memorial Hospital, and Mirya Yardumian.

www.ingramcontent.com/pod-product-compliance
Lightning Source LLC
Chambersburg PA
CBHW050702110426
42813CB00007B/2061